World Views

World Views

TOPICS IN NON-WESTERN ART

LAURIE SCHNEIDER ADAMS

John Jay College and the Graduate Center
City University of New York

Boston Burr Ridge, IL Dubuque, IA Madison, WI New York San Francisco St. Louis
Bangkok Bogotá Caracas Kuala Lumpur Lisbon London Madrid Mexico City
Milan Montreal New Delhi Santiago Seoul Singapore Sydney Taipei Toronto

Higher Education

WORLD VIEWS: TOPICS IN NON-WESTERN ART
Published by McGraw-Hill, a business unit of The McGraw-Hill
Companies, Inc., 1221 Avenue of the Americas, New York, NY
10020. Copyright © 2004 by Laurie Schneider Adams. All rights
reserved. No part of this publication may be reproduced or dis-
tributed in any form or by any means, or stored in a database or
retrieval system, without the prior written consent of The
McGraw-Hill Companies, Inc., including, but not limited to, any
network or other electronic storage or transmission, or
broadcast for distance learning.

1 2 3 4 5 6 7 8 9 0 DOW / DOW 0 9 8 7 6 5 4 3

Vice president and editor-in-chief: *Thalia Dorwick*
Publisher: *Christopher Freitag*
Senior sponsoring editor: *Joseph Hanson*
Development editor: *Caroline Ryan*
Editorial assistant: *Torrii Yamada*
Marketing manager: *Lisa Berry*
Production services manager: *Jennifer Mills*
Production service: *Fairplay Publishing Service*
Manuscript editor: *Carol Flechner*
Art director: *Jeanne M. Schreiber*
Cover designer: *Joan Greenfield*
Interior designer: *Linda Robertson*
Art manager: *Robin Mouat*
Photo research manager: *Alexandra Ambrose*
Photo researcher: *Robin Sand*
Production supervisor: *Rich DeVitto*

The text was set in 9/11.5 Versailles by Professional Graphics,
Inc., and printed on acid-free, 70# Sterling Ultra Litho Dull by
R. R. Donnelley & Sons Company.

Front cover: Promenade of Qin Shi Huangdi (221–206 B.C.), Tsin
dynasty emperor, in a palanquin. From *The Lives of the Emperors
of China*. Qing dynasty. 17th century. Watercolor on silk. Biblio-
thèque Nationale, Paris, France. © Giraudon / Art Resource, NY.
Back cover: Carved board (Malu-Sambun). Kaminimbit village,
East Sepik River, Papua New Guinea. Collected before 1924.
Painted wood. Museo Missionario Etnologico, Vatican Museums,
Vatican State. © Scala / Art Resource, NY.

The credits for this book begin on page 143, a continuation of the
copyright page.

Library of Congress Cataloging-in-Publication Data
Adams, Laurie.
 World Views: Topics in Non-Western Art / Laurie Schneider
 Adams.—1st ed.
 p. cm.
 Includes bibliographical references and index.
 ISBN 0-07-287202-0
 1. Art, Asian. 2. Indian art. 3. Art, Primitive. I. Title.
N7260.A32 2003
709—dc21 2002041050

www.mhhe.com

Contents

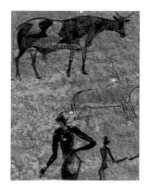
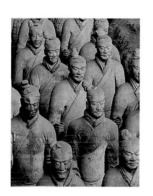

4

Buddhist Art in India and China (1st–7th Centuries A.D.) 34

5

The Expansion of Islam 47

6

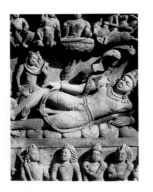

Buddhist and Hindu Developments in East Asia (6th–13th Centuries) 59

7

Mesoamerica and the Andes (1500 B.C.–A.D. 1500) 78

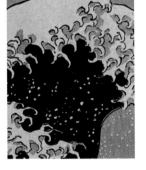
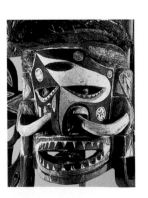

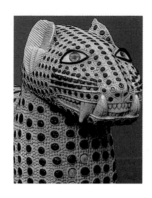

11

Africa: The Royal Art of Benin

Preface

This series of brief, illustrated discussions of topics in non-Western art is designed to accompany the *History of Western Art;* however, this full-color text is also available for individual classroom adoption. The works represented here are the tip of a much larger iceberg, for each culture has its own history, customs, myths, and styles. Since it is impossible to cover all areas of the world in sufficient depth in a single, small volume, *World Views* offers a limited selection of works from a very wide field.

We begin with some examples of preliterate rock art— Aboriginal Australian, Saharan, and Native American. The next section considers aspects of pre-Buddhist China, the development of calligraphy, and later Chinese painting. From the ancient cultures of the Indus Valley in modern-day Pakistan, we proceed to Buddhist India and China, and the expansion of Buddhism to Japan. We consider the image of the Buddha in China, India, Afghanistan, Sri Lanka, and Thailand. In India, we also consider the impact of Hinduism and the Hindu temple, and, in Cambodia, an example of the synthesis of Buddhist and Hindu trends.

The section on Mesoamerica surveys several cultures, from the colossal Olmec heads to the Inkas, who built Machu Picchu, in modern Peru. Most histories of Western art include Islamic Spain; here, therefore, we go beyond Islam in Europe, discussing its expansion and its main architectural expression—the mosque. In addition, we consider the figurative court styles of Persian miniature painting and of the Islamic Mughal dynasty that flourished in seventeenth-century India.

World Views: Topics in Non-Western Art also discusses aspects of non-Western art from cultures that directly influenced Western artists in the nineteenth and twentieth centuries. For example, the woodblock prints of Edo-period Japan influenced the Impressionists and Post-Impressionists. A particular subset of African art—that of the Benin kingdom—is considered along with a few representative examples of Oceanic and Native American art. The art of these non-Western cultures made a significant impact on the artistic avant-garde of Western Europe and America, which was seeking new forms of expressions outside its own traditions.

Hopefully students will take away from this discussion a sense of the enormous variety of world art and culture, and will continue to study these subjects in greater depth. As the world gets smaller, it also gets bigger, for we are forced to encounter the differences as well as the similarities between people and the ideas that motivate them. By opening such cultural and artistic windows, it is possible that we can be united by similarities even as we learn to appreciate differences.

Several people have been extremely helpful in producing this text. Georgia Riley de Havenon contributed sections on Andean and Aztec art. George Corbin (Professor of Art History at Lehman College and the Graduate Center, CUNY) reviewed and corrected sections on African, Native American, and Oceanic art, and Patricia Karetzky (O. Munsterberg Chair of Asian Art, Bard College) reviewed the sections on Asian art. Their assistance was immensely helpful. I am also grateful to Carol Flechner for expert copy editing, to Linda Robertson and Roberta Flechner for the interior design and layout, to Robin Sand for picture research, to Jeannie Schreiber for art direction, to Jennifer Mills and April Wells-Hayes for production management, and to John Adams for assistance at all stages of the process.

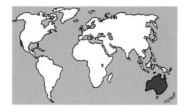

1

Rock Paintings and Petroglyphs

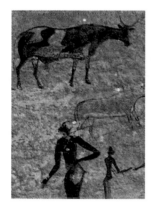

Cultures around the world have been drawn to cave walls and rock faces as surfaces for making images. Rock paintings and rock carvings have been produced before and after the Stone Age in Europe. Some of these appear to share qualities seen in the Paleolithic cave art of western Europe. There is often uncertainty in dating works created by such cultures and in pinning down the antiquity of their mythological traditions.

Rock Paintings of Australia

(c. 30,000/20,000 B.C.–the Present)

In the outback of Australia, hunting-and-gathering societies, called Aboriginal, have had an unusually long history. Dating of Aboriginal rock art is often very difficult, if not impossible, due to the placement of the shallow rock sites and the fact of disturbance of the sites over the years by successive reuse. However, most of the more complex types of rock art are usually dated from about 9000 B.C. to the present. The vast majority of these were probably painted during the past two thousand years. Australia is an island that had been relatively isolated from the rest of the world until the eighteenth and nineteenth centuries. Nevertheless, there are remarkable visual similarities between European Paleolithic and Aboriginal rock paintings, including handprints, naturalistic animals, and hunting scenes.

Aside from these works, our knowledge of ancient Aboriginal mythology, ritual, tradition, and social customs comes from contemporary Aborigines. Their society is divided into clans that "own" certain myths and sacred images. Myth and imagery thus assume a concrete value and are considered to be cultural possessions. They have a totemic, or ancestral, significance, and it is thus possible that many of the animals represented in Australian rock art are, in fact, totems of particular clans.

The ancestral character of Australian Aboriginal art and religion is related to what has been translated into Western languages as the "Dreaming." This phenomenon is not a sleep dream, but rather a mythological plane of existence. For Aborigines, "Dreamtime" is the order of the universe and encompasses cosmological time from its beginning to an indefinite future. Included in Dreamtime are the ancestors who created and ordered both the world and the human societies that populate it. Dreamtime is accessible through the performance of certain rituals—such as creating rock paintings—accompanied by singing and chanting. In the Aboriginal Dreaming, therefore, is contained a wealth of cultural mythology, much of which is revealed in the visual arts.

The Wandjinas, or Cloud Spirits, found in the Kimberley Mountain region of Northwest Australia, for example, appear in numerous rock pictures, usually painted in black, red, and yellow on a white ground (fig. **1.1**). These creatures combine human with cloud forms and are ancestral creators from the Dreamtime. According to Aboriginal myth, Wandjinas made the earth, the sea, and the human race. They are depicted frontally with large heads, massive upper bodies, and lower bodies that taper toward the feet. Around their heads are feathers and lightning. Their faces typically lack mouths, although the eyes and nose are present. If Wandjinas are offended, they unleash lightning and cause rains and flooding, but they can also bring fertility.

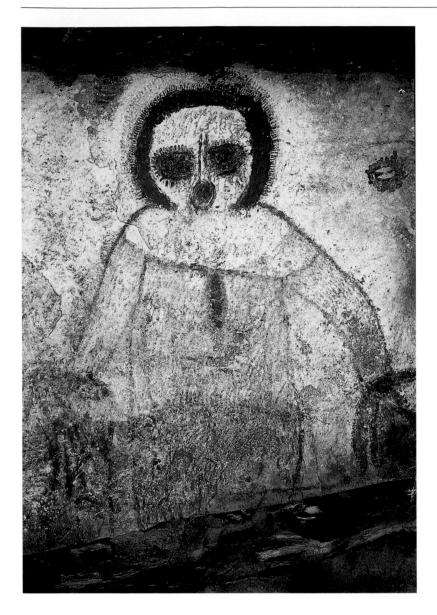

1.1 Wandjina, Rowalumbin, Barker River, Napier Range, Kimberley, Australia. These rock paintings were discovered in 1837 by an expedition led by George Grey. He described his first view of the Wandjinas as follows: "They appeared to stand out from the rock; and I was certainly rather surprised at the moment that I first saw this gigantic head and upper part of a body bending over and staring down at me."[1]

1.2 Mimi hunters, Kakadu National Park, Arnhem Land, Northern Territory, Australia. Rock painting. In the Mimi style, as here, figures are painted in red ocher. These hunters carry spears and boomerangs.

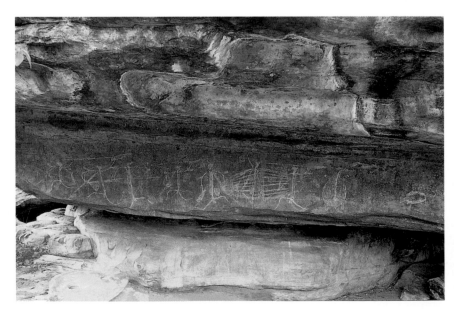

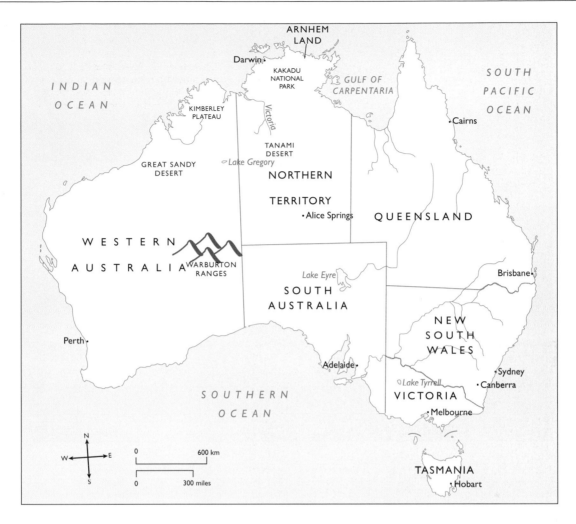

Map of Australia.

Paintings of them are believed to have special powers and, therefore, are approached with caution.

The oldest identifiable style of Aboriginal rock painting, referred to as the Mimi style, is found in Arnhem Land in northern Australia (fig. **1.2**). Mimi, in Aboriginal myth, are elongated spirits living in rocks and caves and are so light that they can be blown away and destroyed by the wind. If a Mimi entices a man to its cave and tricks him into eating its food or sleeping with a Mimi woman, then the human turns into a Mimi and cannot return to his human condition. Mimi are often represented hunting, as they are in figure 1.2, and are believed to have taught hunting to the Aborigines. Note the disproportionate elongation of the running Mimi figures compared to the relative naturalism of the turtle and fish paintings on the right side of the composition.

The kangaroo, which is indigenous only to Australia and adjacent islands, is a frequent subject of Aboriginal rock art. Kangaroos have been hunted for thousands of years, probably as a source of food. Those represented in figure **1.3** are trying to escape from a group of male and female hunters. That the kangaroos are hopping is clear from their poses—the one in the center has just landed and tilts slightly back on its feet; the kangaroo on the left leans forward as if to regain its balance. In paintings such as this, Aboriginal artists used two relatively different styles: a naturalistic one for animals and a schematic one for humans.

The kangaroo in figure **1.4** is a good example of the **polychrome** "X ray" style. It is rendered in brown and white as if displaying the inner organic structure of bone and muscle. Because of its flattened pose, it is stylized rather than naturalistic. The fish-shaped head reflects the appearance of aquatic animals in Aboriginal rock iconography that took place following a rise in sea level around 8000 B.C. The skeletal figure on the right is the fearsome Lightning Man surrounded by an electrical circuit.

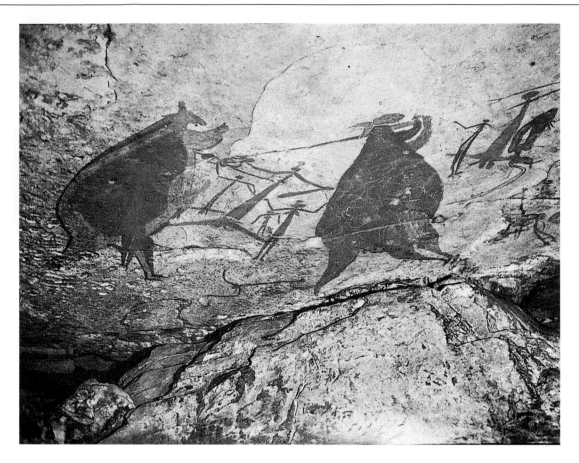

1.3 Men and women hunting kangaroos, Unbalanya Hill, Arnhem Land, Northern Territory, Australia. Rock painting.

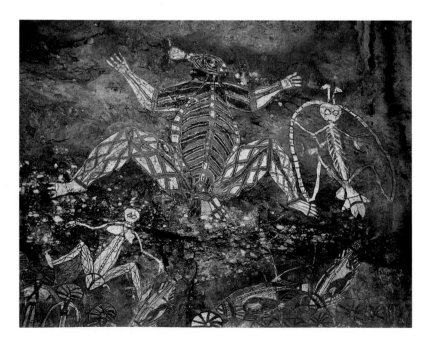

1.4 Kangaroo with Lightning Man, Nourlangie Rock, Kakadu National Park, Arnhem Land, Northern Territory, Australia. Rock painting. In Dreamtime, the Lightning Man, called Namarrkon or Namarragon, lived in the sky and carried a lightning spear. He tied stone clubs to his knees and elbows so that he would always be prepared to hurl thunder and lightning. For most of the year he lived at the far ends of the sky, absorbing the light of the Sun Woman. When the wet season came, he descended to the earth's atmosphere in order to keep an eye on the human race. When displeased, he hurled spears of lightning across the sky and onto the earth. Some 30 miles (48 km) east of Oenpelli, there is a taboo Dreaming site where Namarrkon is said to have settled. This site is avoided by Aborigines, who fear his wrath.

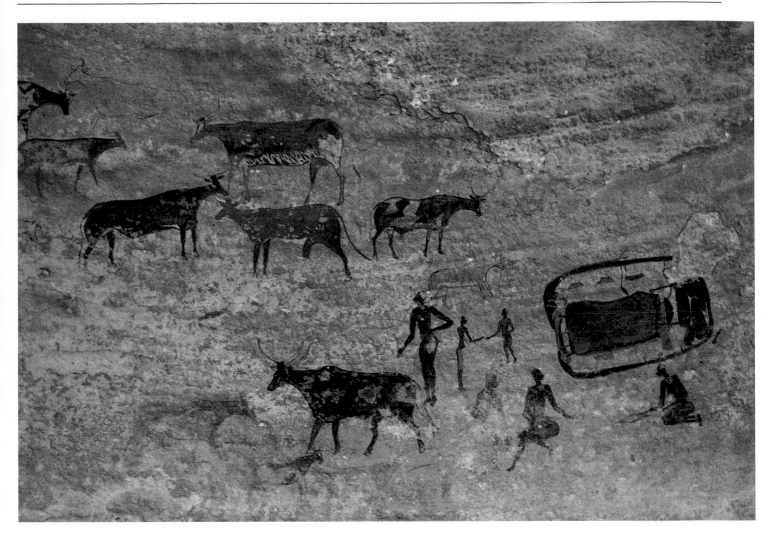

1.5 Saharan rock painting, Tassili, Algeria, Cattle or Pastoralist period, 5th–4th millennium B.C. Photo: Sonia Halliday, Weston Turville, United Kingdom.

The Sahara (5th–4th Millennium B.C.)

Many examples of rock art have been found throughout the African continent, but they are difficult to date. One example from the Sahara, thought to belong to the fifth or fourth millennium B.C., appears to parallel the cultural developments of the Mesolithic period (c. 8000–5000 B.C.) in western Europe (see fig. **1.5**). This was the period of transition from nomadic hunting and gathering to agriculture. The scene shows human figures and domesticated cattle from the Tassili, in modern-day Algeria. Both the human figures—which resemble contemporary cattle herders in parts of Africa—and the animals are rendered with considerable naturalism and freedom of movement.

Note that, in contrast to the Australian examples, the Saharan animals are tame. They wander freely among the human figures, who seem to be going about their daily routines in peaceful coexistence with the cattle. Although the artist does not indicate a ground line, there is a sense of three-dimensional space as the animals appear to stand on a natural, horizontal surface. At the lower right of the illustration, the seated and kneeling human figures are shown as if in an actual landscape.

Native American Petroglyphs of the Plains

(Late 17th–Early 20th Centuries)

Before contact with Europeans, hunting-and-gathering societies in North America coexisted with agricultural communities that lived in year-round villages. Among the hunting peoples of the Plains, where animal migrations were an annual occurrence, there is evidence of rock

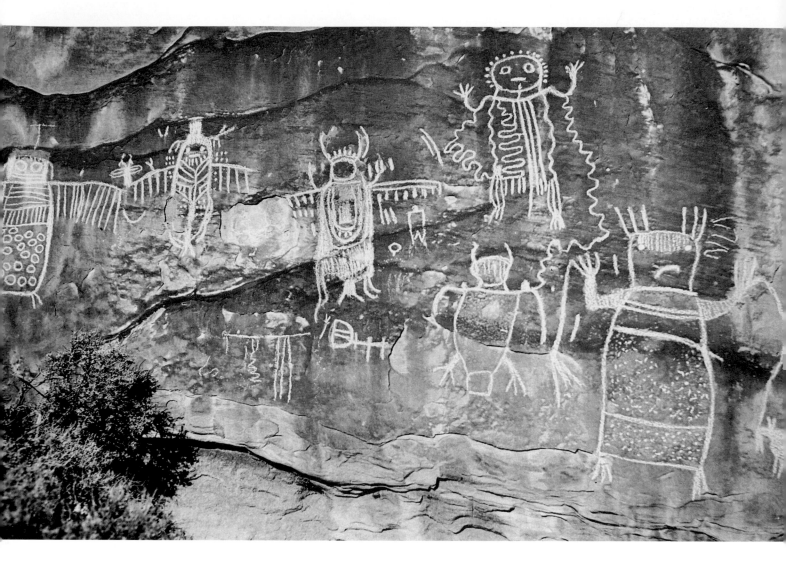

1.6 Petroglyphs, Plains culture, pre-European contact period, c. 1650–1800. Dinwoody, Wyoming. Photo: T. W. Daniels. Courtesy of the Department Library Services, American Museum of Natural History, New York.

carvings (**petroglyphs**) depicting hunting magic and shamanistic practices. Petroglyphs are typically incised into the rock surface, creating light images on a dark background. The petroglyphs found in Dinwoody, Wyoming, from the pre-European contact period are an example (see fig. **1.6**).

The figures depicted here combine human with animal and bird features. They stand upright, like humans, but also have wings, horns, and feathers. This merger of human and animal motifs suggests the transformations of the shaman, who was believed capable of communication with the gods. The frontal pose of the figures makes them confront viewers directly and enhances the impression of their supernatural powers over the nonspirit world.

2

Topics in Chinese Art

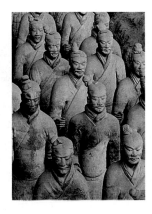

Precursors: Neolithic to the Bronze Age (c. 5000–221 B.C.)

In contrast to the Mediterranean world, whose civilizations rose and fell (that of Egypt lasted the longest), China has maintained a cultural continuity from the Neolithic era to the present. Although the origins of Chinese culture are obscure, legends refer to an early Bronze Age Xia dynasty and to stages in civilization brought about by heroes known as the Five Rulers.

There is evidence that between the fourth and third millennia B.C. pottery production in China was thriving. Crude Mesolithic pottery had been replaced by thin-walled, wheel-thrown wares: first, earthenware with black and red painted decoration, and then polished black vessels. By the third and second millennia B.C., jade was being imported from Siberia and carved into stylized animal figurines and other ceremonial objects.

Bronze was first used in second-millennium-B.C. China in the fertile valley of the Yellow River (see map, page 10). Its importance as both medium and symbol in ancient China cannot be overestimated (see box and fig. 2.1). As a material, bronze was of great value. It denoted power and was associated with the aristocracy, who monopolized its manufacture, use, and distribution. Social rank was measured by the number and size of bronzes one owned. Bronze was also used for weapons, which led to new success in warfare, and productivity in general increased as a result of improved metal tools. Ritual objects—preferably made of bronze—served the dead as well as the living, and bronze vessels containing offerings were dedicated to deceased ancestors. These were often used by shamans, who were members of the ruling aristocracy. They performed sacrifices to spirits and ancestors who, in turn, were believed to protect the living. In times of war, the ritual bronzes were melted down and made into weapons to be recast into vessels when peace returned.

The two main Bronze Age dynasties were the Shang (c. 1700–1050 B.C.) and the Zhou (c. 1050–221 B.C.). The Shang was a complex agricultural society with a class system, an administrative bureaucracy, and urban centers. City walls were made of earth, and there is evidence of some monumental architecture in the later Shang period. Of particular note are rectangular halls, over 90 feet (27.40 m) in length, with interior pillars arranged symmetrically. The Shang dynasty also produced the earliest form of China's **calligraphic** writing system. This is known from inscriptions on oracle bones used in divination rites in the mid-second millennium B.C. (see page 15).

The four-ram wine vessel (fig. 2.2) is a good example of Shang dynasty bronze casting in the Anyang region of modern Henan Province. Four rams, decorated in low relief with an abstract motif of crested birds, project from the body of the vessel, their legs forming its base. Above the rams, around the vessel's shoulder, are four horned

Major Periods of Early Chinese History	
BRONZE AGE	
Shang dynasty	c. 1700–1050 B.C.
Zhou dynasty	c. 1050–221 B.C.
IRON AGE	
Qin dynasty	221–207 B.C.

Bronze: The Piece-Mold Method

Bronze is an alloy of copper and tin. Although the earliest manufactured metal objects were made exclusively of copper, it was soon discovered that adding tin increased its hardness, lowered its melting point, and made it easier to control.

In the Stone Age, most artifacts had been made from easily portable materials such as bone, clay, and stone. The introduction of bronze was a watershed in China, as in other civilizations, and precipitated a significant shift in the nature of its society. Sources of copper and tin had to be discovered, the ore mined, and the metal extracted. This was a huge undertaking as far as copper was concerned since its ore yields only a tiny proportion of refined metal. Elaborate kilns and fires of great intensity were needed to melt the large batches of metal. Cooling the finished objects to avoid cracks and other defects required constant supervision. Such tasks could be accomplished only in a society that was settled (i.e., nonnomadic) and in which labor was specialized.

The Chinese produced bronze vessels in twenty-seven basic shapes by an indigenous technique derived from pottery making. This differed from the lost-wax method popular in Greece and elsewhere. First, a clay model of the vessel was made, and then it was encased with an outer layer of damp clay. When the outer layer dried, it was cut off in sections and fired to form a mold. Meanwhile, a thin layer of the model was removed and became the core of the mold. The sections of the mold were reassembled around the core and held in place by bronze pegs (or **spacers**). Molten bronze was then poured into the space between the mold and the core through a pouring duct. The thickness of the final object was a function of the difference in size between core and mold. When the bronze had cooled, the mold and core were removed and the surface of the bronze was polished with abrasives.

Ancient Chinese bronzes remain unsurpassed in the technical virtuosity of their ornamentation. Decoration was an integral part of the casting process, created by designs on the inner surface of the mold. Portions of especially complicated pieces were cast separately and fitted together. This piece-mold

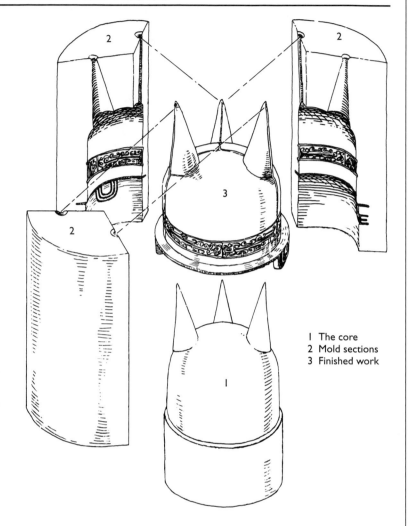

1 The core
2 Mold sections
3 Finished work

2.1 Diagram showing the Chinese system of bronze casting.

process made it possible to cast vessels of enormous size with elaborate surface ornamentation. It was not until the late Bronze Age that the Chinese began to cast bronze by the simpler lost-wax process, which permitted more flexibility of design but required more finishing after casting.

dragons. The entire surface is enlivened by curvilinear patterns that create an unusual synthesis of naturalism and geometric abstraction. While the insistence on symmetry (fig. **2.3**) arrests formal movement, the surface patterns animate the object.

The Zhou originated in modern Shansi. A predominantly warrior culture, they conquered the Shang and established a feudal state that lasted for eight hundred years. The chief god was conceived of as heaven (*tian*) and as the father of the Zhou king, reinforcing his imperial

power. The late Zhou period produced the two great philosophies of China, Daoism and Confucianism (see box). In the arts, the Zhou continued and elaborated Shang styles and techniques, especially in bronze. Whereas Shang forms can usually be identified, Zhou forms, though reminiscent of natural shapes, are elusive.

During the late Zhou dynasty, China underwent several centuries of social upheaval. There is evidence of new influence from the animal art of the Scythian

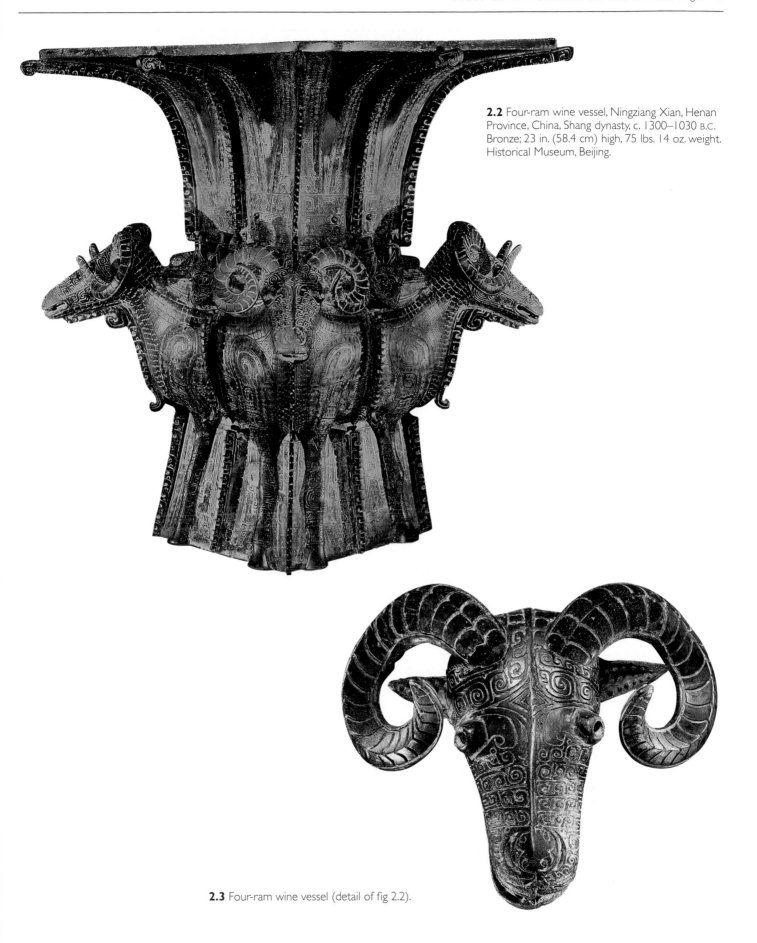

2.2 Four-ram wine vessel, Ningziang Xian, Henan Province, China, Shang dynasty, c. 1300–1030 B.C. Bronze; 23 in. (58.4 cm) high, 75 lbs. 14 oz. weight. Historical Museum, Beijing.

2.3 Four-ram wine vessel (detail of fig 2.2).

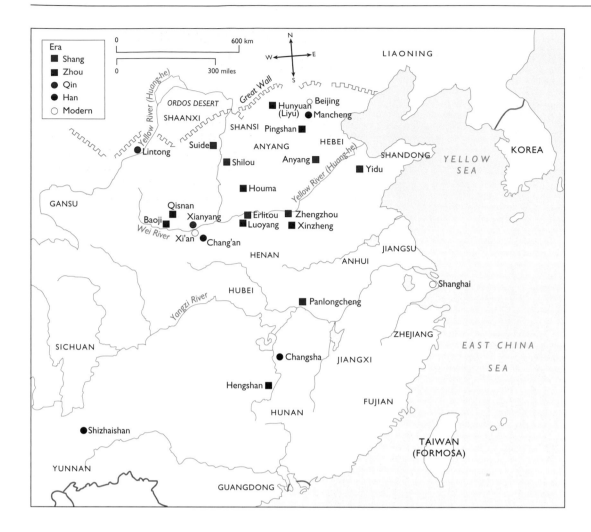

Map of archaeological sites of China.

nomads, particularly in the **interlace** patterns and motifs characterized by metaphorical transitions from organic to geometric forms. This type of shifting imagery can be seen in a late Zhou **finial** (an ornament at the top of an object) rendered in the shape of a dragon (fig. **2.4**), a masterpiece of formal complexity as the dragon both bites, and is bitten by, a bird.

The emperor Shihuangdi began his reign as the centuries of upheaval known as the Warring States period (475–221 B.C.) came to an end. His wish to perpetuate his life after death had a long tradition in China. Until the fourth century B.C., in the late Zhou dynasty, rulers continued to be buried with their belongings and their animals. Slaves and servants, relatives and other members of the nobility were ritually killed in order to accompany the deceased. By the end of the Bronze Age in China, however, human sacrifice for burials had ceased. Clay and wooden figures, or *minqi* ("substitutes"), were used instead.

Chinese Philosophy

Daoism and Confucianism were the two great philosophies of ancient China. Daoism is based on the *Daode jing*, a text attributed to its legendary founder, Laozi, and thought to have been written in the fourth century B.C. It teaches individualism and transcendence through direct connection with the natural world. According to the *Daode jing*, "*Dao* [the Way] invariably does nothing and yet there is nothing that is not done."[1] Confucius (whose Chinese name is Kongzi, 551–479 B.C.), on the other hand, emphasized strict adherence to social conventions and rituals—based on those of the Shang and Zhou dynasties—for the proper functioning of the state. Confucius's teachings were collected in the *Analects,* among whose maxims is "Devote yourself earnestly to the duties due to men, and respect spiritual beings, but keep them at a distance. This may be called wisdom."[2] These two disparate philosophies have been reflected in Chinese art for the past two thousand years.

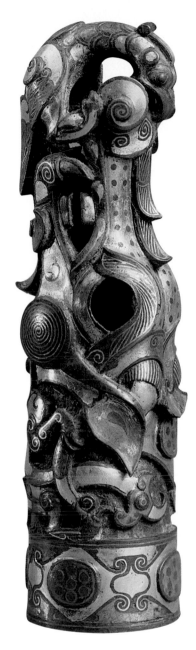

The Tomb of Emperor Qin

(Late 3rd Century B.C.)

In 1974, a group of peasants in the Chinese province of Shaanxi discovered evidence of an ancient burial hidden near an enormous mound of earth (fig. **2.5**). Subsequent archaeological excavations revealed this to have been the burial of Shihuangdi, who became known as Emperor Qin (ruled 221–207 B.C.) after the states he ruled. He was the first emperor of a united China, and it is from his name, Qin (pronounced *ch'in*), that the name China is derived. A later historian described Shihuangdi's tomb chamber (which has not yet been opened) as

> filled with [models of (?)] palaces, towers, and [a] hundred officials, as well as precious utensils. . . . Artisans were ordered to install mechanically triggered crossbows set to shoot any intruder. With quicksilver the various waterways of the empire, the Yangtze and Yellow Rivers, and even the great ocean itself were created and made to flow and circulate mechanically. The heavenly constellations were depicted above and the geography of the earth was laid below. Lamps were fueled with whale oil so that they might burn forever without being extinguished.[3]

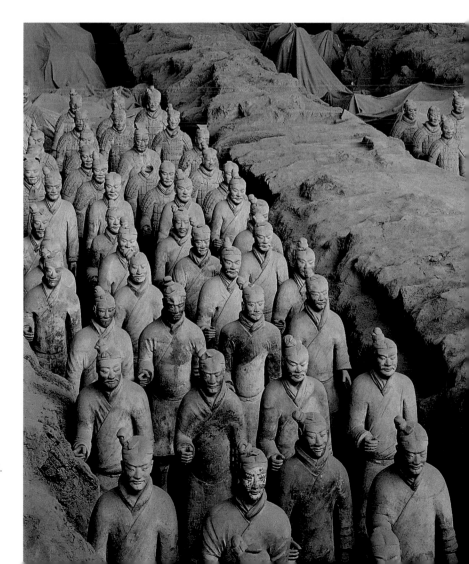

2.4 Dragon finial, from Qin-Zun, China, late Zhou dynasty, 3rd century B.C. Bronze inlaid with gold and silver; 5 ft ⁵⁄₁₆ in. (1.64 m) high. Cleveland Museum of Art.

2.5 Bodyguard of Emperor Qin, from the tomb of Emperor Qin, Lintong, Shaanxi Province, China, Qin dynasty, 221–207 B.C. Terra-cotta.

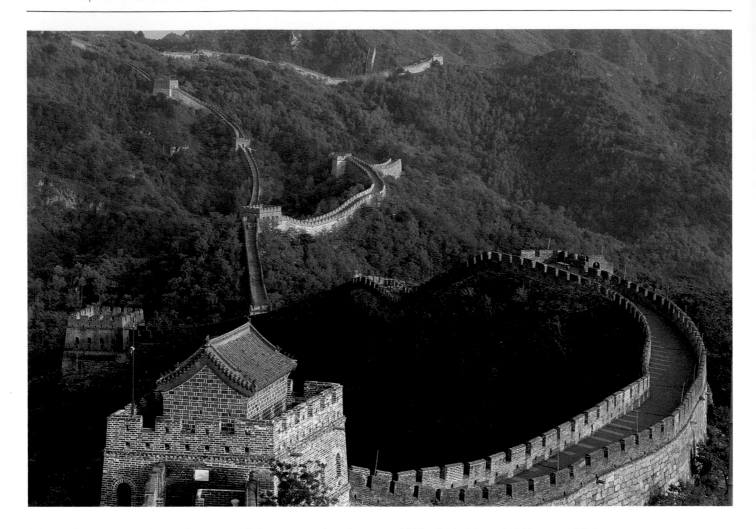

2.6 The Great Wall, near Beijing, China, begun 3rd century B.C. Length approx. 1,500 miles, height and width approx. 25 ft. Photo: J. Sohm/The Image Works.

While not every detail of this account has been confirmed, it is certain that Shihuangdi unified China in the late third century B.C., installed himself as emperor, financed monumental building campaigns and the arts with a view to solidifying his political position, and strengthened the country. Among his lasting accomplishments was the codification of the law, which he was famous for ruthlessly enforcing. He standardized weights, measures, and currency, established a written language, and adopted a canon for imperial art. His administrative system and division of China into provinces has lasted to the present day. He constructed a national network of roads, which facilitated the efficient mobilization and movement of troops. Emperor Qin also commissioned monumental palace architecture, and most of the Great Wall of China was built during his reign.

Parts of the Great Wall were already in place, but Qin ordered its reconstruction and completion as another

means of unifying the country. It also discouraged invasion along the borders. As a feat of engineering, the Great Wall was prodigious. All told, the wall extended some 1,500 miles. Figure **2.6** shows a small section of the wall and its watchtowers outside of modern Beijing.

Around 700,000 people labored for fifteen years to build the Qin emperor's tomb complex. According to the historian's account cited above, Qin tried to take the entire universe with him—not just his friends, family, and possessions. In fact, he took approximately 7,000 life-sized painted terra-cotta warriors and horses, which were equipped with real chariots and bronze weapons. Their purpose was to provide Shihuangdi with a military bodyguard in the afterlife (see fig. 2.5).

The hierarchy of military rank from infantryman to officer is represented in Emperor Qin's soldiers, deployed outside the burial chamber according to contemporary battle strategy. Although the figures conform to ideal

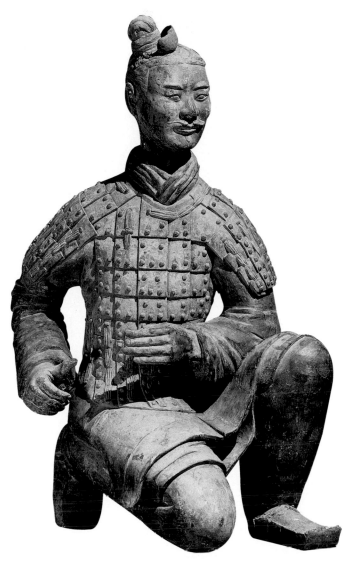

2.7 Kneeling archer, from the tomb of Emperor Qin (trench 10, pit 2), Lintong, Shaanxi Province, China, Qin dynasty, 221–207 B.C. Terra-cotta; life-sized. Shaanxi Provincial Museum.

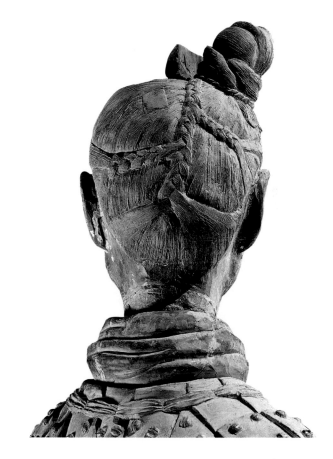

2.8 Kneeling archer (detail of fig 2.7).

types, they convey a sense of personality that is just short of portraiture. The hollow torsos are supported by sturdy cylindrical legs. Small details made separately were stuck to the surface while the clay was still wet. When the statues dried, they were fired, painted, and set on bases.

One of these, a terra-cotta kneeling archer (fig. **2.7**), shows the warrior holding his bow and wearing plated armor and a kilt. His raised cheekbones and eyebrows, along with the slight suggestion of a smile, give him an air of individuality despite his conventional pose. The detail of the back of his head (fig. **2.8**) shows incised lines, representing hair that has been tightly pulled into a topknot and strands of braids. Also visible are the modeling marks,

made by the artist's thumbs—at the back of the neck and in the folds of the scarf. The statue of an officer (figs. **2.9** and **2.10**) is upright, his hands held in a ritual gesture. He frowns slightly, as if weighing an important tactical decision, and his high rank is denoted by height and costume. In addition to an armored tunic, he wears a double robe with wide sleeves and an elaborate headdress tied under his chin. The terra-cotta cavalryman (fig. **2.11**) is shorter and more plainly attired. He wears the short robe and vest that made riding easier and replaced the long robe worn before 300 B.C. He stands at attention and holds the reins of his horse, whose saddle replicates the leather and bronze of a real saddle.

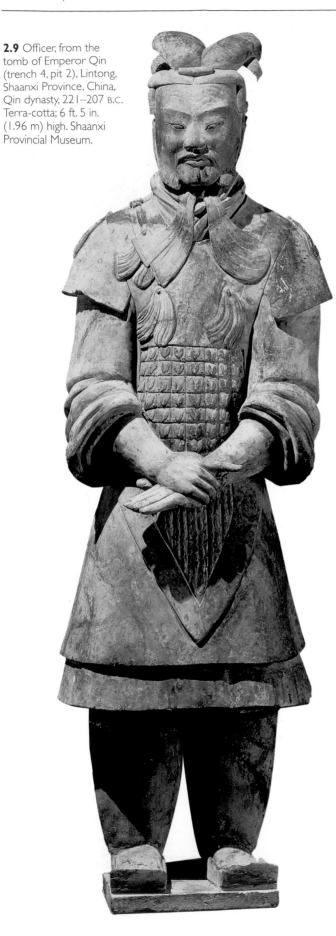

2.9 Officer, from the tomb of Emperor Qin (trench 4, pit 2), Lintong, Shaanxi Province, China, Qin dynasty, 221–207 B.C. Terra-cotta; 6 ft. 5 in. (1.96 m) high. Shaanxi Provincial Museum.

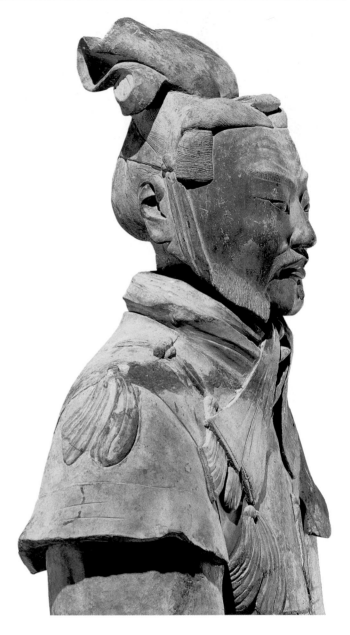

2.10 Officer (detail of fig. 2.9).

At the time of writing, Emperor Qin's burial chamber remains to be excavated, partly because it is thought to have been booby-trapped to protect against vandals. The burial chamber was located below streams and sealed off with bronze as another protective device. The emperor's 7,000 bodyguards, like the army that defended his imperial power, served as guardians of his body.

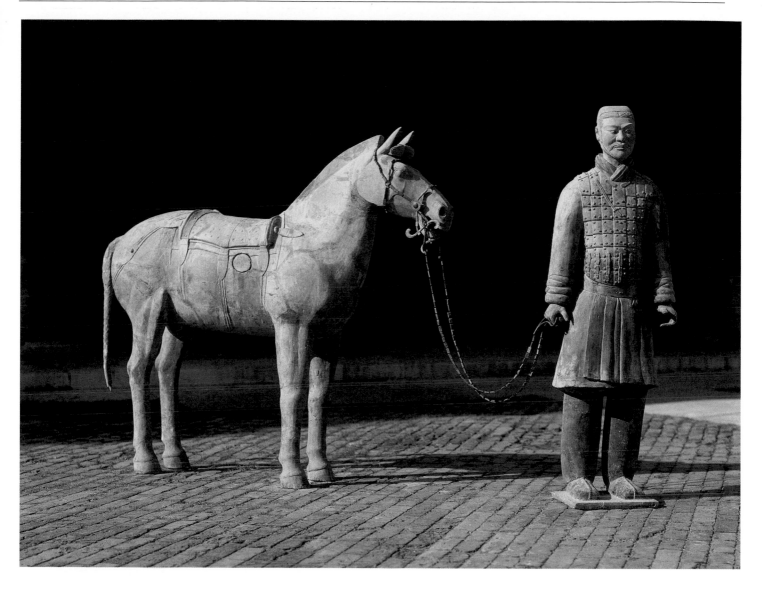

2.11 Cavalryman, from the tomb of Emperor Qin (trench 12, pit 2), Lintong, Shaanxi Province, China, Qin dynasty, 221–207 B.C. Terra-cotta; man 5 ft. 10 in. (1.79 m) high, horse 5 ft. 7½ in. (1.69 m) high. Shaanxi Provincial Museum.

Chinese Characters, Calligraphy, and Painting

(1700 B.C.–18th Century A.D.)

Chinese Characters

The Chinese writing system uses characters that represent entire words instead of letters in an alphabet. These characters have been written and read—in columns, running from top to bottom and right to left—for at least 3,000 years. Because of the sophistication of the earliest known characters, their prototypes may have originated as long ago as 4000 B.C., when they were applied to perishable materials such as textiles and leather. At Anyang, China's first city and capital of the Shang dynasty (c. 1700–1050 B.C.), archaeologists found characters written on oracle bones used in divination. Archivists at the Shang court wrote with brush and ink on slices of bamboo or wood that were then bound into books.

Figure **2.12** shows the evolution of oracle script into seal script (still used for carved seals today) and finally into the same characters' standard modern forms. Many of the

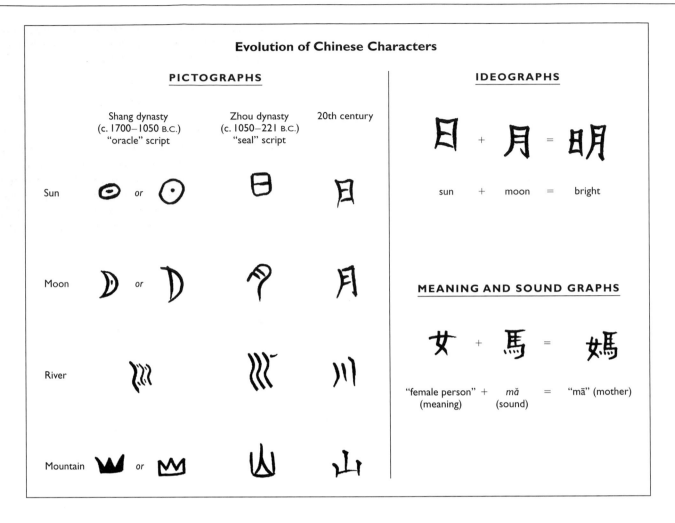

2.12 Chinese characters showing pictographs (oracle and seal script), ideographs, and meaning/sound graphs.

4,500 Shang characters known, of which one-third have been identified, were **pictographs** (literally "written pictures"), or stylized renderings of specific objects: the sun is circular; the moon is a partial circle (showing its changing shape in contrast to that of the sun); rivers consist of wavy lines; and mountains have three peaks pointing upward. Other characters called **ideographs** (literally "written concepts") were more abstract, representing ideas through combinations of pictographs. The combination of sun and moon, for example, forms the idea of brightness.[4]

Chinese characters have become less pictorial over the centuries. Today about 90 percent of the 10,000 commonly used characters (out of a repertory of nearly 50,000) are composed of elements that convey meaning coupled with elements indicating pronunciation. Thus the combination of the character for "female person" with a character for the sound *ma* creates the notion of "mother." There are five traditional styles in which the characters have been written for at least 2,000 years.

Calligraphy

In China, calligraphy—literally, "beautiful writing"—is among the most valued art forms. From the third century B.C., there is evidence of a highly developed calligraphic tradition flourishing among the intellectual elite at the Chinese courts. In addition, the importance of literature in China created an interest in the beauty of the appearance of the written characters as well as in their content. Figure **2.13** is an example of calligraphy from the Wan-li period (1573–1620). It shows the pictorial quality created by the artist's skill with brush and ink, for even without knowing the meaning of the text we can appreciate the graceful elegance and dynamic, animated lines of the characters.

In this case, the poem is dedicated to a master who gave the author a rare antique brush, the porcelain handle of which was for the imperial family. It is not only about a brush, therefore, but it is also composed with a brush, merging form with content and the medium with the mes-

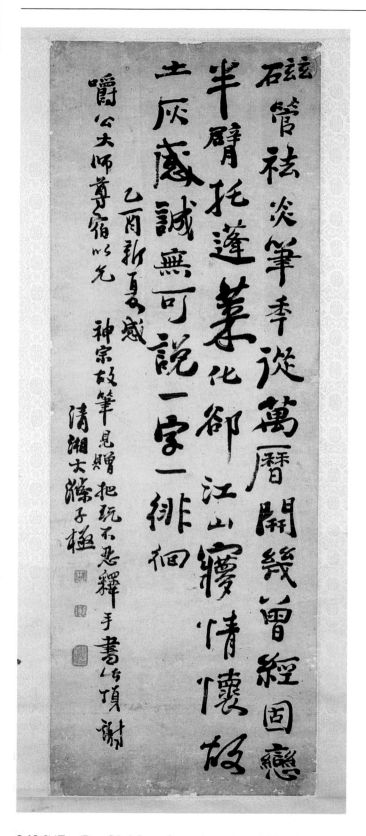

2.13 Shi Tao (Dao Qi), *A Poem Concerning an Imperial Porcelain-Handled Brush*, Wan-li period, 1573–1620. Hanging scroll, ink on paper; 43 × 15⅜ in. (109.2 × 39.1 cm). Accession no. 1965/2.75, The Margaret Watson Parker Art Collection, University of Michigan Museum of Art, Ann Arbor.

sage. The larger characters comprise the poem, and the smaller ones at the left are the artist's inscription. The red marks are the artist's seals and epithets. He signs himself "man of purity," "an old solitary man," "a dull wit," and "eldest son."

The artist, Shi Tao (or Dao Qi; 1630–1707), was a major calligrapher and a member of the imperial family during the Ming dynasty (1368–1644). He was orphaned in 1644, when the Manchu took control of the Ming capital in Peking (now Beijing). But he was rescued by a servant and given refuge in various temples, where he was educated by monks. He was famous in China for his mystical view of nature, reflected in the essay describing his philosophy of the "first line." By this he meant a primordial brushstroke, marking the beginning of the creative process.

The eighteenth-century painter Zheng Xie (or Zheng Ban-qiao) (1693–1765) came from an impoverished family and found work as a teacher. He did not become a full-time artist until he retired from his bureaucratic career as district magistrate in Shandong. His reputation for images of bamboo can be seen in figure **2.14**, in which sharp curvilinear blacks overlap strokes of softer brushwork. The formal relationship of the foliage to the calligraphy is enhanced by the characters containing the artist's vertical inscription at the far right. He says that the painted orchids and bamboo are not of this world, but of the green mountains, where they are free to grow.

At the lower right, the red seal identifies the collector of the work whereas the artist's red seals are on the left. These include the *tzu*, the name assigned by the master artist to his student when the latter reaches maturity, and the *hao*, the name chosen by the artist for himself. In this case, the *tzu* means "to overcome weakness" and the *hao* means "wood-plank bridge."

Perspective in Chinese Landscape Painting

China is a huge country with a spectacular landscape that inspired an impressive body of paintings. Chinese landscape painting conveys a spiritual attitude toward the unbounded vastness of nature. First experienced and then recorded by the artist, landscape is seen as a means of evoking a contemplative response in the viewer. The presentation is typically leisurely, as if allowing the viewer to wander through the image, apprehending it from different vantage points. One way in which the artist achieves this is by creating a shifting perspective system.

The Northern Sung painter Li An-Zhong of the late eleventh through the early twelfth century exemplifies the taste for delicate, poetic landscapes (fig. **2.15**). In contrast to the Western preference for linear perspective, aerial perspective, although not unknown in the West, is more prevalent in the Far East. In aerial perspective, there is no single vanishing point or viewpoint.

The observer's position may be elevated so that the landscape is seen from above. Forms meant to be closest

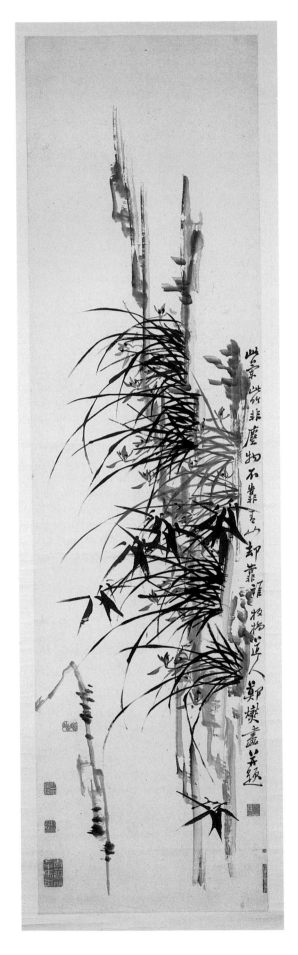

2.14 Zheng Xie, *Bamboo and Orchids,* Ching dynasty, 1644–1911. Hanging scroll, ink on paper; 71⅜ × 19 in. (180.0 × 48.2 cm). Accession no. 1970/2.7, The Margaret Watson Parker Art Collection, University of Michigan Museum of Art, Ann Arbor.

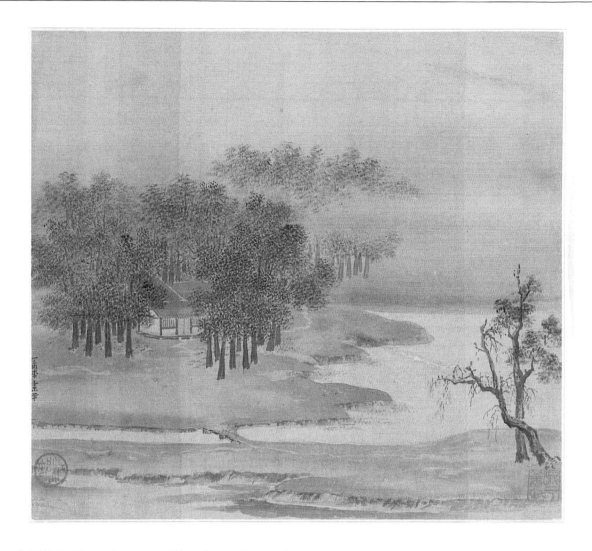

2.15 Li An-Zhong, *Cottages in a Misty Grove in Autumn*, Northern Song dynasty, early 12th century. Album leaf. Cleveland Museum of Art, Cleveland, Ohio.

to the picture plane are more clearly delineated—as in *Bamboo and Orchids* (see fig. 2.14)—and more thickly painted. Thus, the trees at the lower right of *Cottages in a Misty Grove in Autumn* are dark, with visible knots in the trunks. The background mountains are washed out and fade into the sky. The group of densely packed trees around the cottages is clear and thick, except where veiled by waves of mist. We have an elevated view of the land and water and a head-on view of the cottages and their surrounding trees, and we look up at the looming mountains in the distance.

3

South Asia
The Indus Valley Civilization
(to the 3rd century A.D.)

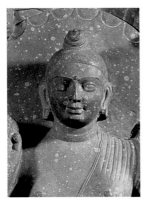

In 326 B.C., Alexander the Great led his armies into the northwest corner of South Asia (see map)—parts of modern Afghanistan, Pakistan, and India —then a part of the Achaemenid Empire. In so doing, he was eroding the power of Greece's traditional enemies—the Persians. In the second century B.C., Indo-Greeks ruled to the south, and, later, the Roman Empire established outposts in South Asia. Building upon a much older network of land and sea trade routes, the unprecedented territorial expansion of Greece and Rome created new contacts linking the Mediterranean and western Europe with parts of the East.

Transmitting cultural influence in the opposite direction —from East to West—were Buddhist missionaries sent to Greece and the Middle East in the third century B.C. by the Indian emperor Ashoka (ruled c. 273–232 B.C.). Merchant caravans traveled along the Silk Road, the 5,000 miles (8,052 km) of linked trade routes that stretched from China to Rome by the first century B.C. (see map, page 21). From China, they transported great quantities of finished goods such as silk, bronzes, ceramics, and lacquerware. Wool and linen textiles, glassware, and valuable raw materials went eastward from the Mediterranean world. As a result of such exchanges, certain styles and motifs infiltrated Eastern art from the West, while others flowed in the opposite direction.

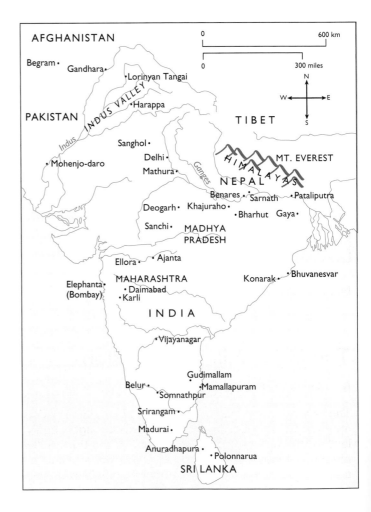

Map of South Asia.

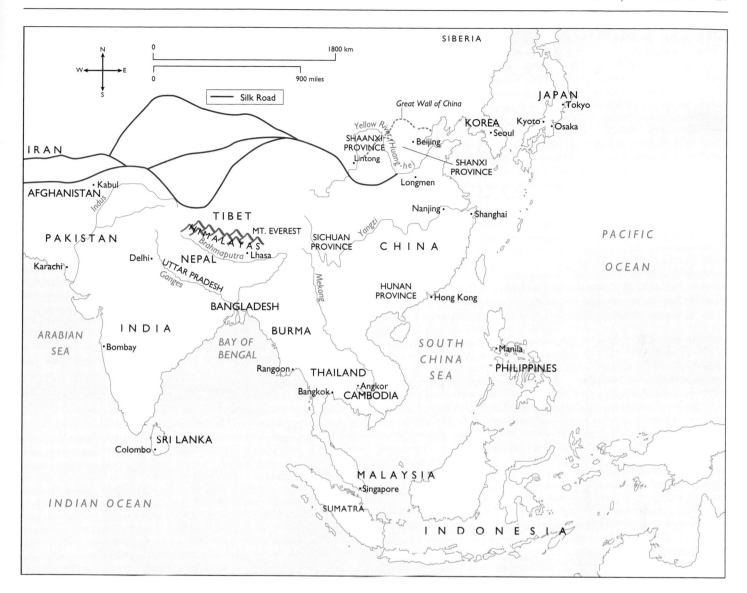

Map of the Buddhist world.

The Indus Valley Civilization

(c. 2700–1750 B.C.)

The valley of the Indus River is located in modern Pakistan and northwest India, covering a vast area roughly equivalent to that of western Europe. Early in the third millennium B.C., Indus Valley culture evolved from a nomadic to a settled, urban civilization. Compared with Mesopotamia and Egypt, which were also centered around rivers, the Indus Valley culture adapted to a wider variety of natural environments. The first of hundreds of Indus Valley sites to be excavated (in the 1920s) were Mohenjo-daro and Harappa, which appear to have been artistic centers. The high point of Mohenjo-daro culture came in the second half of the third millennium B.C., during which time its population peaked at around 50,000. In addition to monumental architecture, archaeologists found evidence of houses, mostly two stories high, made of mud-brick and of more durable baked brick. The excavations also uncovered sewage systems, bronze and copper tools, large painted vases made on a potter's wheel and fired, and sculptures of terra-cotta, copper, and stone. At Mohenjo-daro, as at most other large Indus Valley sites, streets in an eastern residential section were laid out according to a grid. The ruins of a citadel in the west suggest a need for defensive architecture. It is curious that so far there is no evidence of religious or royal architecture, whether temples, tombs, or palaces. The existence of writing, like urbanization, distinguishes Indus Valley society from other cultures of the region.

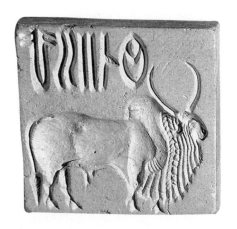

3.1 Square stamp seal showing a zebu, from Mohenjo-daro, Indus Valley, c. 2300–1750 B.C. White steatite; 1½ in. (3.81 cm) high. National Museum of India, New Delhi.

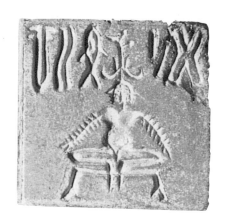

3.2 Square stamp seal showing a yogi, Indus Vall[ey] civilization, c. 2500–1500 White steatite; approx. 1¼ in. × 1¼ in. (3.2 × 3.2 National Museum of Ind[ia] New Delhi.

Glyptic art, which was popular in Sumer and Akkad, is found in the Indus Valley civilization and, to some scholars, indicates contact with Mesopotamia. But Near Eastern seals are cylinders rolled across a soft surface, while those of the Indus Valley are square and held by a knob at the back. They were stamped face down to make an impression. Whereas Mesopotamian seals were indented so that the images they made were raised, the Indus Valley seals were carved in relief so that their stamped images were indented. The example in figure **3.1**—one of some 2,000 seals depicting a range of subjects—represents a humped bull, or zebu, standing in a square field with an inscription incorporated into the overall design. The animal's stylized beard and thin, curved horns have a linear quality, while a sense of natural bulk is conveyed in the body, especially the hindquarters. Such rendering of organic form has remained typical of South Asian art.

Also characteristic is the iconography of the bull, which is often presented—as in Mesopotamia—in connection with human figures. The male figure is seated in what seems to be a meditative yoga pose. He is sometimes horned and ithyphallic (having an erect and prominent phallus), which is probably symbolic of his power and fertility (fig. **3.2**).

No monumental paintings are known from the Indus Valley civilization. Most of the few examples of Indus Valley sculpture from Mohenjo-daro and Harappa reflect the same full-bodied style that characterizes the bull seal, but there are rare examples of more stylized images. A work such as the *Bearded Man* (fig. **3.3**) from Mohenjo-daro is reminiscent of Mesopotamian art and seems to combine Sumerian qualities with indigenous South Asian forms. Like the humped bull in figure 3.1, it is a synthesis of compact monumentality, stylization (the beard, hair, ears, and trilobed drapery pattern), and organic quality in the struc-

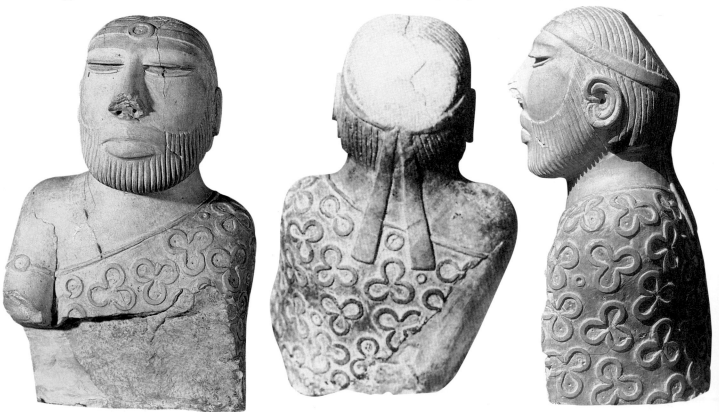

3.3a, b, c *Bearded Man*, from Mohenjo-daro, Indus Valley, c. 2000 B.C. Limestone; 7 in. (17.78 cm) high. National Museum of India, New Delhi.

ture of the face (especially the lips and nose). The figure's heavy-lidded, inward gaze, however, contrasts sharply with the wide-eyed stare characteristic of Mesopotamian statues.

Entirely different in their aesthetic effect, and more lifelike, are the nude sculptures (figs. **3.4** and **3.5**), which have more in common with later South Asian art. The *Dancing Girl* (fig. 3.4) from Mohenjo-daro is nude except for a necklace and armbands that may have had a ritual purpose. Despite her thin proportions, she conveys a lifelike quality that derives both from the forms themselves (the indication of bone under the left shoulder, for example) and from the convincingly relaxed pose.

The nude male torso (fig. 3.5) differs from the *Dancing Girl* in its massive proportions and compactness. Its quality of **prana** (the sense that the image itself is filled with living breath) typifies South Asian sculpture. Although it is less than 4 inches (10 cm) high, the torso has the aesthetic impact of a much larger work. The original meaning and function of this figure is not known, nor is the purpose of the small circles in the shoulders to which arms may have been attached.

The Indus Valley civilization declined around the middle of the eighteenth century B.C., perhaps owing to a combination of floods, invasions, and political overextension.

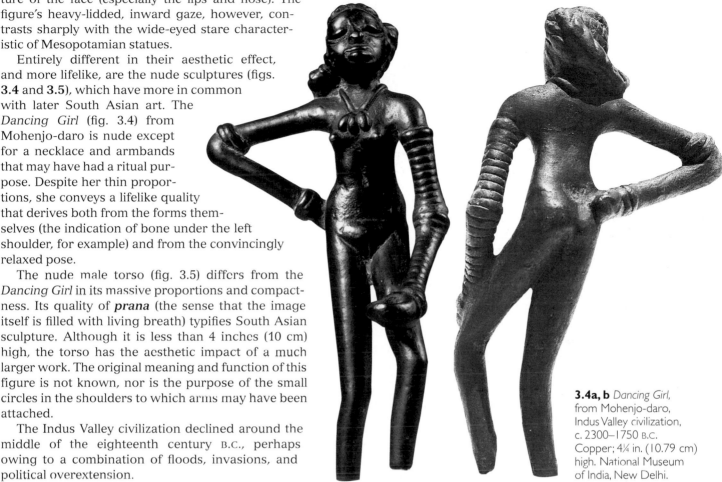

3.4a, b *Dancing Girl*, from Mohenjo-daro, Indus Valley civilization, c. 2300–1750 B.C. Copper; 4¼ in. (10.79 cm) high. National Museum of India, New Delhi.

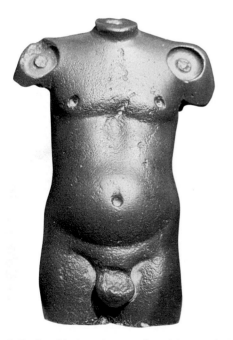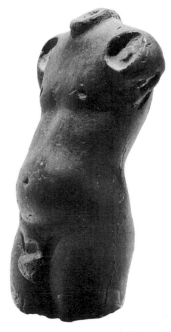

3.5a, b, c Nude male torso, from Harappa, Indus Valley, c. 2000 B.C. Red sandstone; 3¾ in. (9.52 cm) high. National Museum of India, New Delhi.

The Vedic Period (c. 1600–322 B.C.)

Around 1600–1500 B.C., waves of semi-nomadic Indo-European (Aryan) peoples invaded the Indus Valley and the surrounding regions from the northwest. There is no archaeological record of Aryan cities, burials, or works of art. Most of what we know about the invaders, who spoke an early version of Sanskrit, comes from their sacred literature, the Vedas (see box below). One of the later Vedic texts, the Upanishads, describes the Aryan social hierarchy that became the Hindu caste system (see box at right). Descriptions in the Vedas of Aryan conquests are consistent with the archaeological evidence of fortified cities (citadels) found in the Indus Valley. Likewise, Vedic references to phallic worship by the local population appear to be confirmed by certain images from Harappa and Mohenjo-daro.

The founder of Buddhism, Shakyamuni Buddha, was born Prince Siddhartha Gautama in the mid-sixth century B.C. Buddha's teachings were a reaction against the traditional Vedic religious hierarchy controlled by Brahmin priests. Two main Buddhist traditions emerged, both stressing the virtues of compassion and selflessness. One emphasizes the importance of breaking the cycle of reincarnation and achieving *nirvana,* and the other, the attainment of enlightenment for everyone. The latter accepts several buddhas in addition to Shakyamuni, as well as **bodhisattvas** (see page 26). The first tradition promoted an ascetic, meditative path to spiritual growth, whereas the other taught that prayer and faith could also be routes to salvation. Despite its virtual disappearance from India by the tenth century, Buddhism eventually spread throughout Asia. The first of the Buddhist traditions was adopted primarily in Sri Lanka and Southeast Asia, and the second in China, Japan, and Korea.

The Upanishads

The Upanishads, composed c. 800–600 B.C., are literally "knowledge derived from sitting at the feet of the teacher." These are the final set of Vedic texts. Instead of emphasizing priesthood and ritual, as the second set does, the Upanishads are philosophical and speculative. They illuminate the inner meaning of the earliest Vedas and explore the nature of knowledge and truth.

Individuals undergo numerous births in the cycle of different lives (*samsara*). In what form one is reborn depends on his or her *karma*—accumulated "credit" or "debt" created by a person's good or bad actions. Karmic status reflects one's position in the social hierarchy, known as the caste system. There were four castes: at the top were Brahmin priests, followed by warriors, farmers, and artisans. Lower yet were those without a caste—the "outcasts." Acceptance of one's proper place within this system leads, through a series of progressively better lives, to liberation (*moksha*) from the cycle of rebirth. *Nirvana* is the union of the liberated individual soul with Brahmin, the cosmic soul.

The Early Vedas

The Vedas (from the Sanskrit verb meaning "to know") are collections of Aryan religious literature. For thousands of years, the Vedas were transmitted orally from one generation of Brahmin priests to the next, syllable by syllable. The earliest, which date to the beginning of the second millennium B.C., invoke the Vedic gods in thousands of hymns chanted at sacrificial rituals. A second set codifies ritual practice and serves as handbooks for priests. Vedic priests sacrificed to the gods at fire altars. The fire itself embodied the god Agni (cf. "to ignite"), whose smoke carried offerings upward to the other deities. Agni was born when two sticks of wood were rubbed together, and he was therefore a natural product of the very material he consumed. Indra, the warrior god, personified thunder. Varuna was the guardian of cosmic order, and Rudra (the Howler) destroyed the unrighteous. Uma was the goddess of dawn, and Surya was the sun who crossed the sky in a chariot (as in Greek mythology). Soma, a polymorphous deity associated with an intoxicating elixir, was born from the foam of the sea, and Yama was the god of death.

3.6 *Birth of the Buddha*, relief from Gandhara, India, 2nd–3rd century. Gray schist; 15 in. (38 cm) high, 16½ in. (42 cm) wide. Ashmolean Museum, Oxford. Queen Maya stands under a *sal* tree in the Lumbini Grove and holds one of its branches. She is surrounded by human and divine attendants. To her right, the Vedic god Brahma receives the infant Siddhartha as he emerges from her side.

to his goal, he ended his fast and adopted a moderate Middle Way. Then, in 537 B.C., while meditating under a *pipal* tree, Siddhartha resisted the seductive temptations of the demon Mara and achieved enlightenment. Henceforth this tree was known as the sacred *bodhi* ("enlightenment") tree, and its site as *bodhgaya* (literally, a "place of enlightenment").

Siddhartha, having become a buddha ("one who has awakened"), was now known as Shakyamuni ("the sage of the Shakya clan"). He preached his First

The Origin of Buddhism

(6th Century B.C.)

Prince Siddhartha Gautama is believed to have been born around 563 B.C. in what is now Nepal. According to legend, his mother, Queen Maya, gave birth to him through her side, while reaching up to touch a *sal* tree in the Lumbini Grove (figs. **3.6** and **3.7**). Siddhartha's father, the head of the Shakya clan, was told in prophecies that his son was destined either to rule the world or to become a great spiritual leader. In accordance with his own preference, Siddhartha's father raised his son in the sequestered atmosphere of the court. But at the age of twenty-nine, Siddhartha ventured outside the palace walls and encountered the suffering of humanity—disease, old age, and death. Disturbed by what he saw, he renounced materialism, left his wife and family, and rode out to find enlightenment.

At first, Siddhartha became an ascetic and a beggar, devoting himself to meditation. He practiced extreme austerities while continuing his quest for knowledge. But after six years, starving and no closer

3.7 *Dream of Queen Maya*, from Madhya Pradesh, India, Shunga period, 2nd century B.C. 19 in. (48.3 cm) high. Relief from a *vedika* of the Bharhut stupa, Indian Museum, Calcutta. Queen Maya's dream of a white elephant was interpreted as precognition of her pregnancy with Prince Siddhartha. The perspective of this scene defies our experience of natural reality, giving it a shifting quality. We see Maya from above, while the elephant floating over her is in profile and the attendants at the side of her bed are in back view. Both the content of the relief and its style thus have a dream-like quality.

Sermon in the Deer Park at Sarnath, which set in motion the Wheel (*Chakra*) of the Law (*Dharma*), and founded Buddhism. He spent the remainder of his life traveling and preaching his new philosophy. In 483 B.C., the last great miracle of Shakyamuni Buddha's life, the *Mahaparinirvana*, occurred: when he died, at the age of eighty, he was cremated, and his remains shone like pearls.

In social terms, Buddhism can be seen as an attempt to reform the rigidity of the caste system. Shakyamuni Buddha taught the Four Noble Truths as the basis of *Dharma*, according to which life is suffering (1), caused by desire (2). But one can overcome desire by conquering ignorance (3), and pursue an upright life by following the Eightfold Path (4):

1. Right understanding
2. Right goals
3. Right speech
4. Right behavior
5. Right calling
6. Right effort
7. Right alertness
8. Right thinking

In order to escape suffering, Shakyamuni Buddha advocated extinguishing all desire and all sense of self through meditation and spiritual exercises, which his disciples codified. Shakyamuni established the world's first monastic communities (the *Sangha*), and, after his death, Buddhist monasteries proliferated. Missionary monks spread Buddhist doctrine throughout the world.

Mirroring the multiplicity of Vedic deities, many buddhas emerged around the figure of Shakyamuni. Complementing these were wise and compassionate supernatural beings called bodhisattvas (from the Sanskrit for "enlightenment" and "existence"). Bodhisattvas delay their own buddhahood in order to help others attain enlightenment. In art they are identified by their princely attire, and they often flank a buddha. In later periods, the importance of Shakyamuni Buddha was overshadowed by cults of various buddhas and bodhisattvas, especially in the Himalayas and the Far East.

Buddhist Architecture and Sculpture

The Maurya Period (c. 321–185 B.C.)

Some eight hundred years after the Aryan invasion, urban culture began to reappear in northern India. The first ruler to unify a large territory after his revival was Chandragupta Maurya, who founded the Maurya dynasty in 321 B.C. From this point on, historical records increase. Chandragupta's grandson, Emperor Ashoka (ruled c. 273–232 B.C.), was one of South Asia's greatest kings, uniting almost all of the Indian subcontinent and parts of central Asia. A dozen years into his reign, at the peak of his military success, he renounced warfare and embraced the nonviolent

message of Buddhism, which he promoted throughout his empire and beyond.

Ashoka erected a number of monumental monolithic stone pillars, 50 feet (15.20 m) high. They are thought to have been derived from a Vedic royal tradition of free-standing wooden poles crowned by copper animals, perhaps associated with early tree worship. Like the *bodhi* tree, under which Shakyamuni attained enlightenment, such pillars probably represent the axis of the world. This axis was believed to link heaven and earth, separating as well as connecting them. On these pillars, as on rocks and stone tablets, Ashoka inscribed edicts on Buddhist themes that reflected his political, social, and moral philosophy. Ashoka's pillars were thus legislative documents in stone; they are crowned by symbols intended to associate the emperor with the gods.

Artistically, the pillars are significant because their capitals constitute the earliest surviving body of Buddhist monumental sculpture. The lion (fig. **3.8**) and bull (fig. **3.9**) capitals seem to continue the two iconographic and stylistic traditions evident nearly two thousand years earlier in the Indus Valley. Four lions joined at the back face outward toward east, west, north, and south. They are rigid and emblematic, their whiskers, manes, and claws stylized. There are strong similarities to the art of Achaemenid Persia in the general concept of animal capitals as well as in the particular stylizations. The Mauryas apparently borrowed portions of their imperial iconography from the more established empire to the west. In contrast, the bull capital is both iconographically and stylistically South Asian. Like the bull in the Mohenjo-daro seal and the nude male torso from Harappa, the capital is more organically modeled. Massive and fleshy, with a suggestion of underlying bone and muscle structure, it conveys the sense of a living animal.

These capitals demonstrate the Buddhist assimilation of earlier artistic conventions. As in the Near East and Egypt, lions in India are royal animals, and Shakyamuni Buddha himself was referred to as the "lion" of his clan. The bull, as in the Indus Valley seals, denotes fertility and strength. Both the lion and the bull stand on a circular *abacus,* which surmounts a bell-shaped element in the form of lotus petals (signifying purity). The meaning of the decorations in relief on the sides of the *abaci* has been debated by scholars. But the wheel on the lion's *abacus* is certainly Buddha's Wheel of the Law, which was set in motion during his first sermon. Wheel and lion are vertically aligned and, therefore, visually linked to denote the power (the lion) of the Buddha's teaching (the Law, or *Dharma*). The *abacus* of the bull capital is decorated with plant and water designs that refer to the fertility of nature. There can be no doubt that this iconography was intended to proclaim the power and prosperity of the empire. Together with the edicts on the shafts of the pillars, the lion and bull also stand for the power of the Buddha's message.

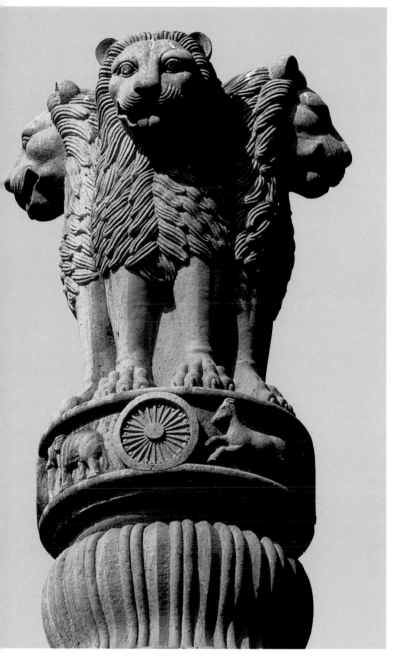

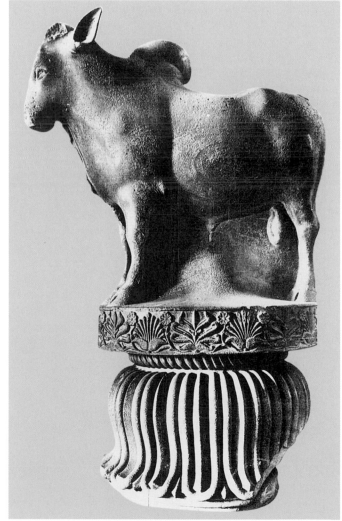

3.8 Lion capital, Ashokan pillar, from Sarnath, Uttar Pradesh, India, Maurya period, mid-3rd century B.C. Polished chunar sandstone; 7 ft. (2.13 m) high. Museum of Archaeology, Sarnath. According to tradition, the Buddha, in the Deer Park at Sarnath, set in motion the Wheel of the Law (*Dharmachakra*) in his first sermon expounding the Four Noble Truths.

3.9 Bull capital, Ashoka pillar, from Rampurva, Bihar, India, Maurya period, 3rd century B.C. Polished chunar sandstone; 8 ft. 8 in. (2.66 m) high. National Museum of India, New Delhi.

The Shunga Period (c. 185 B.C.–A.D. 30)

At the end of Ashoka's reign, India was once again ruled by small republics and local dynasties. One of the latter, the Shungas of central India, enlarged Ashoka's Great Stupa at Sanchi, India's most characteristic Buddhist monument (figs. **3.10** and **3.11**). According to Buddhist texts, when the Buddha died (the *Mahaparinirvana*), he was cremated, and his ashes were divided and enshrined in eight **stupas,** or burial mounds. Emperor Ashoka further divided these relics among 84,000 legendary stupas that either have disappeared or have been incorporated into later structures. Stupas thus came to stand for the *Mahaparinirvana*, the last of the four great miracles of Shakyamuni's life. The hemispherical form of the stupa, however, predates Buddhism and, like the monumental pillars, has cosmological significance. Originally, remains or other relics were placed in a hole in the ground into which a pillar was set, and then earth was mounded around the pillar to prevent plundering. With the development of Buddhism under Ashoka, these mounds evolved into monumental stupas.

The Great Stupa at Sanchi, in Madhya Pradesh (see figs. 3.10 and 3.11), was begun in brick during the reign of Ashoka and evolved further during the Shunga period. The large hemisphere, or dome, is mainly a product of the first century A.D. This stupa is the largest of three that survive at the Sanchi complex, which is reconstructed in figure **3.12**. The interiors of the stupas were filled with rubble and presumably contained Shakyamuni's relics.

As is true of Western religious architecture, the stupa creates a transition between one's material and temporal life on earth and the cosmos beyond. The stupa's dome (the **anda,** meaning "egg") symbolizes the dome of heaven. It supports a square platform (the **harmika**), enclosed by a railing (the **vedika**), through which a central axis pillar projects. Attached to the pillar are three umbrella-shaped **chattras,** royal symbols that honor the Buddha. The configuration of the enclosure recalls pre-Buddhist nature worship and the ancient South Asian practice of enclosing a sacred tree with a wooden fence.

Surrounding the stupa is a stone *vedika* 11 feet (3.40 m) high, based on wooden fences. The *vedika* is punctuated at the cardinal points by gateways, *toranas,* 35 feet (10.20 m) high. These were added in the first century A.D. and also derived from wooden prototypes. An Ashokan pillar and staircase mark the main (southern) entrance to the sacred compound. The north *torana* (fig. **3.13**) consists of two rectangular posts, on top of which four elephants and riders support three architraves linked by vertical elements. It is completely covered with relief sculpture. At the top of

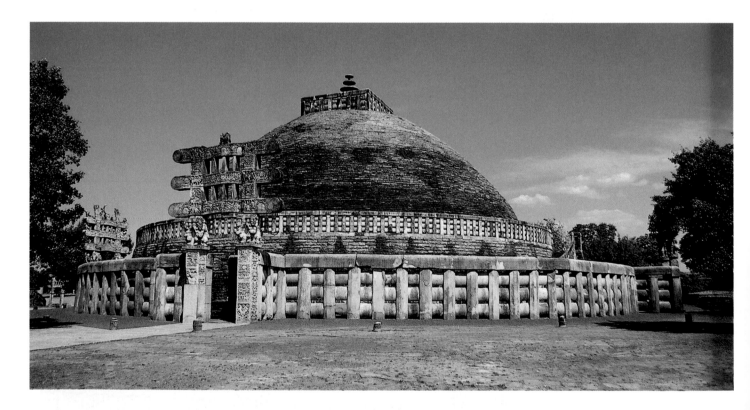

3.10 Great Stupa at Sanchi, Madhya Pradesh, India, Shunga and early Andhra periods, 3rd century B.C. Diameter over 120 ft. (40 m). The cosmological significance of the stupa's organization is evident in its relationship to the worshiper. On entering one of the four *toranas*, one turns left and circumambulates the hemisphere in the direction of the sun (clockwise). In this symbolic passage enclosed by the tall *vedika*, worshipers leave their worldly time and space and enter a spiritual realm. In so doing, they replicate Shakyamuni Buddha's departure from the world, the *Mahaparinirvana.*

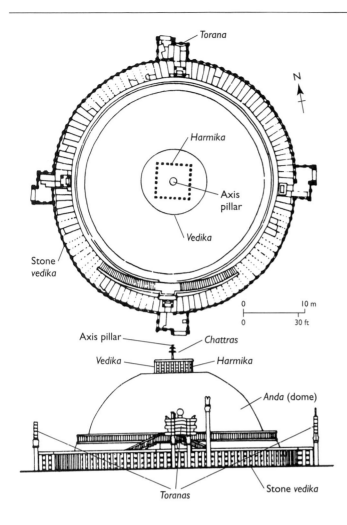

3.11 Plan and elevation of the Great Stupa at Sanchi. The outline of the building is a perfect circle, which Buddhists consider an ideal shape. The stupa was designed as a *mandala*, or cosmic diagram. The square at the center refers to the *harmika* on the roof, and the small circle inside the square indicates the axis pillar supporting the *chattras*. The dark outer circle is the *vedika*, and the four rectangular attachments are the *toranas*, oriented to the cardinal points of the compass and reflecting the identification of the stupa with the cosmos.

the *torana*'s posts, two *Dharmachakra* (Wheels of the Law) support tripartite forms symbolizing the *Triratna*—the Three Jewels of Buddhism: the Buddha himself, the *Dharma* (his Law, or Teaching), and the *Sangha* (the Buddhist monastic community). The architrave sections directly over the gateway sculptures depict Indian folktales, processions, and battles.

They also depict *jatakas* (stories of the Buddha's previous lives) as well as events in the life of Shakyamuni. There are scenes of Buddhist worship and ceremonies. In one of these, Ashoka ritually waters the sacred *bodhi* tree, which stands for the Buddha himself. As is characteristic of early Buddhist art, the Buddha is represented **aniconically**— that is, his presence is indicated only by means of symbols. Instead of being represented in human form, he appears in metonymic form—as something with which he is associated, such as the *bodhi* tree, his throne, his honorific umbrella (related to the *chattras* at the top of a stupa), or a stupa itself. Another sign of Buddha's presence in art is a pair of footprints that refer to his first baby steps. These, in

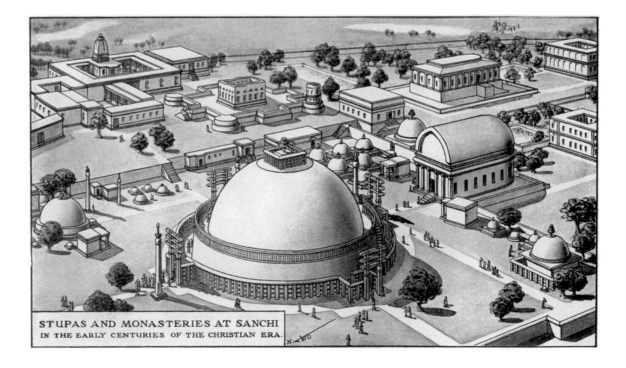

3.12 Reconstruction drawing of the Sanchi complex.

turn, were associated with an earlier tradition in which a god-king encompasses the world in a few strides.

At Sanchi, the *toranas* are decorated with representations of **yakshas** and **yakshis,** indigenous pre-Buddhist fertility deities, male and female, respectively (fig. **3.14**). The *yakshi* on the bracket both swings from and is entwined in a mango tree, which bursts into life at her touch. Such images are the source for the depiction of Queen Maya giving birth to Siddhartha in the Lumbini Grove (cf. fig. 3.6). The form of the *yakshis* at Sanchi, like the theme itself, is related to the ancient Indian predilection for sensual, organic sculpture. The voluptuous breasts and rounded belly suggest early pregnancy. The seductive pose is called **tribhanga,** or "three-bends posture." Together with the prominently displayed pubic area, this pose promises auspicious abundance to worshipers.

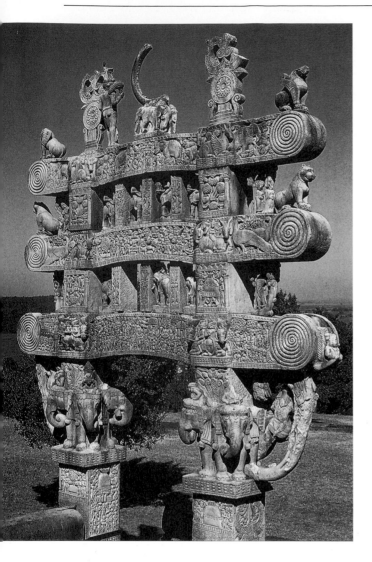

3.13 North *torana* at Sanchi, Shunga and early Andhra periods, 1st century B.C.

3.14 *Yakshi*—to the right of the elephant—from the east *torana* at Sanchi, Shunga and early Andhra periods, 1st century B.C. The presence of *yakshis* in Buddhist art reflects assimilation of indigenous Indian motifs into Buddhist iconography.

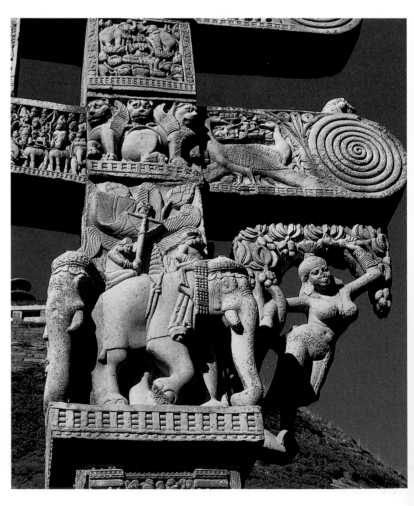

The Kushan Period

(c. A.D. 78/143–3rd Century)

During the first century A.D., central Asian nomads called the Kushans controlled the area designated as Gandhara, which comprises parts of northern India, Afghanistan and Pakistan, and Mathura (their northern capital). The first extant images of the Buddha in human form date from this period. At the time, Vedic religion still retained enormous popular appeal, partly because of its anthropomorphic gods. As a result, Buddhist artists began to develop an iconography in which buddhas and bodhisattvas are shown in human form.

The move toward representing the Buddha as a man in the Kushan period is first reflected in the Gandharan and Mathuran schools of art. Traveling along the Silk Road that linked Rome with the East were travelers and merchants who brought Roman artifacts (gems, coins, small sculptures) to northern India, accounting for Western elements in Gandharan images of buddhas and bodhisattvas. As a result, Gandharan artists were familiar with styles and motifs from other areas. It seems that both Greek and Roman artists had worked earlier around Gandhara, accounting for Hellenistic elements in Gandharan images of buddhas and bodhisattvas.

The two most typical images of the Buddha in Gandharan sculpture show him standing or sitting, often with a large halo or sun disk behind his head. In figure **3.15** he is shown wearing a monk's robe, whose deeply carved, rhythmically curving folds recall depictions of togas in Roman sculpture. The statue's organic quality, with its rounded abdomen, is descended from the indigenous artistic tradition of the *prana*-filled nude male torso from Harappa (fig. 3.5).

The *Standing Buddha* displays some traditional identifying physical features of Buddhist iconography. Many of these allude to his role as a spiritual ruler. The hair conforms to the shape of the head and is formed into the **ushnisha,** or topknot. This denotes the Buddha's great wisdom and is one of the thirty-two auspicious marks of a buddha or an emperor. On the forehead, the **urna,** or whorl of hair, is stylized as a small circle. The earlobes are elongated from the weight of heavy royal earrings, which are absent because Siddhartha cast aside his princely jewelry when he set out on his spiritual quest (bodhisattvas, in contrast, are shown wearing royal ornaments since they are not yet buddhas). The figure's formal unity derives from repeated curves and circles.

The same emphasis on curvilinear forms characterizes the *Seated Buddha* (fig. **3.16**). The Buddha's hands rest peacefully on his lap, forming the gesture (**mudra**) of meditation (**dhyana**) in which the hands are held palms up, one resting on the other. *Dhyana mudra* denotes the intense inner focus through which Shakyamuni attained enlightenment. On either end of the throne is a lion—in keeping

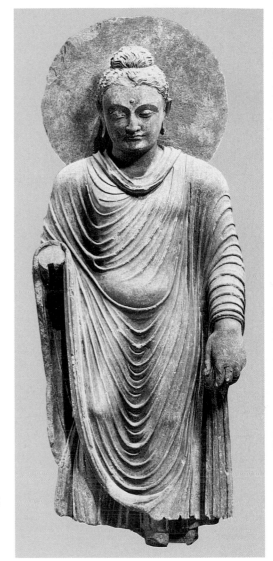

3.15 *Standing Buddha,* from Gandhara, Afghanistan or Pakistan, Kushan period, 2nd–3rd century. Gray schist; 3 ft. 3 in. (98 cm) high. Museum für Indische Kunst, Berlin.

with the ancient tradition of lions guarding royal or sacred personages—symbolizing Shakyamuni Buddha himself. The face of this seated Buddha, like that of the standing example, is (aside from the fuller lips) reminiscent of beardless Greek and Roman Apollonian types.

Gandharan Buddhist architecture also reflects contemporary religious developments. For example, the model of a second-century stupa at Loriyan Tangai in Gandhara (fig. **3.17**) is more elaborate than the simple hemisphere at Sanchi. Here, a square base supports layered round tiers that end in a small dome. Rising from the dome is an inverted trapezoidal platform that supports a column of *chattras*. In contrast to the relatively plain plaster surface of the Sanchi stupa, the stone masonry at the Gandharan stupa is covered with relief sculpture. Hellenistic influence is apparent in specific features such as the Corinthian pilasters and niches formed by round arches.

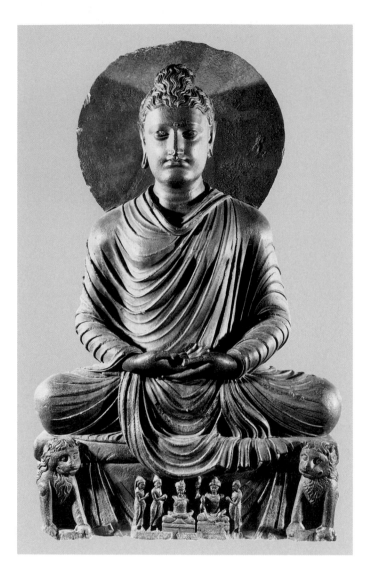

3.16 *Seated Buddha,* from Gandhara, Afghanistan or Pakistan, Kushan period, 2nd century. Gray schist; 3 ft. 7½ in. (1.10 m) high. Royal Museum of Scotland, Edinburgh.

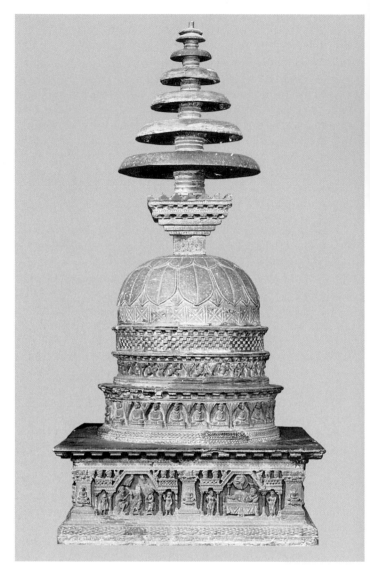

3.17 Model of a stupa from Loriyan Tangai, Gandhara, Afghanistan or Pakistan, Kushan period, 2nd century. Gray schist; 4 ft. 9 in. (1.45 m) high.

The degree of Westernization in Gandharan art can be seen by comparison with the indigenous South Asian style prevalent at Mathura, south of Delhi. A *Seated Buddha* (fig. **3.18**) from Mathura, for example, has different proportions: an hourglass figure, with broad shoulders and a thin waist. The figure's taut, *prana*-filled body is fleshier, its physiognomy less Western, and its drapery folds so finely carved that the cloth appears nearly transparent. The hair is not loose and wavy, but instead is pulled tightly into a topknot—the *ushnisha*—in the shape of a snail shell.

This representation of the Buddha shows him meditating under the *bodhi* tree at the very moment of his enlightenment. The branches are carved in low relief behind the Buddha's halo, and his facial expression reveals an inner calm. He raises his right hand in the **abhaya mudra** gesture, which means "have no fear." Compared with Gandharan figures of the Buddha, the Mathuran example communicates more actively with worshipers. Standing behind him are richly dressed attendants with **chauris** (fly whisks), another royal sym-

bol honoring the Buddha. Above are wise celestial beings flying toward Shakyamuni to worship him. Like his Gandharan counterpart, the Mathura Buddha sits on a lion throne, the unusual third lion in the center echoing his own dynamic frontal form.

Having established itself in South Asia, Buddhism spread throughout Southeast Asia and the Far East. During the Gupta period (fourth–seventh centuries) and its aftermath, Buddhist art in India would undergo remarkable new developments.

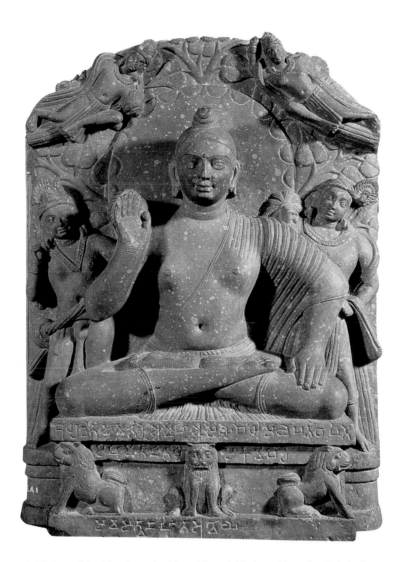

3.18 *Seated Buddha*, from the Katra Mound, Mathura, Uttar Pradesh, India, Kushan period, early 2nd century. Spotted red sandstone; 2 ft. 3 in. (69 cm) high. Government Museum, Mathura.

4

Buddhist Art in India and China (1st–7th centuries A.D.)

Rock-Cut Architecture

Toward the end of the first millennium B.C., in the low cliffs of western India, there developed a new type of monastic architecture. Mountainsides were chiseled out to create caves that were imitations of freestanding wooden buildings. Most were located near well-traveled trade routes. These caves are of two main types: living spaces for monks, called **viharas,** and large, basilica-like spaces for congregational worship focused on a stupa. The latter are called ***chaitya* halls.** *Viharas* generally consist of small, windowless cells surrounding a broad room used by the monks for eating, recitation, studying, and other communal activities. From the fifth century A.D., *viharas* often had small shrines opening off the main space that contained sculptures of the Buddha. Early Buddhist caves provide the only physical record of the appearance of the more perishable wooden structures on which they were modeled. There are approximately a thousand such Buddhist sanctuaries dating from the late second century B.C. to the mid-second century A.D. Some evidence indicates that the caves were furnished inside and out with wooden balconies, doors, rafters, and other architectural elements. The interior walls, illuminated by oil lamps, were decorated with mural paintings and tapestries.

The most famous examples of rock-cut architecture in India are located in what is now the state of Maharashtra. In keeping with Buddhist practice, these monastic sites were removed from the center of town but were accessible to travelers as well as to local inhabitants. Inscriptions identify the caves' patrons as lay people, monks and nuns, and kings.

Chaitya halls were remarkably similar in both architectural design and religious purpose to later Christian basilicas. A comparison of the interior of the *chaitya* hall at Karli (figs. **4.1** and **4.2**), which dates from c. A.D. 50–70, with the basilica of Santa Sabina of 423–432 in Rome (fig. **4.3**) highlights the similarities as well as the differences.

Both have a triple entrance and a long central nave with a semicircular apse at the far end opposite the entrance. The apse is the most sacred area in the *chaitya* hall, as in the basilica. The nave of the *chaitya* hall is preceded by a shallow space, or **veranda,** which is similar to the narthex of the basilica. Framing the nave of each are rows of columns, which separate the nave from its side aisles. These, in turn, continue around the apse to form an ambulatory. By circumambulating the stupa (inside the apse of the *chaitya* hall), the Buddhist worshiper replicates the circular path of reincarnation in the quest for *nirvana*.

Often, remains or relics of a Christian saint were buried below the apse of the basilica in an underground **crypt.** Similarly, the apse of the *chaitya* hall contains a stupa, the funerary structure originally placed over the remains of Shakyamuni Buddha. And when worshipers enter the *chaitya* hall—as well as the basilica—they are drawn to the spiritual focal point by the formal arrangement of space and mass.

The *chaitya* hall differs from the basilica in several ways. Instead of a flat ceiling, that of the *chaitya* hall is barrel-vaulted. Its designation as "elephant-backed" reflects the association of the form with organic structure. The curved rafters visible in figure 4.1 are the original wooden elements used to replicate the prototype, rather than to serve a structural purpose. The columns are thicker than those at Santa Sabina and are composed of a

4.1 *Chaitya* hall, Karli, Maharashtra, India, c. A.D. 50–70. Granite; nave 45 ft. (13.72 m) high. The term *chaitya* originally meant a mound or sacred place. It came to mean "place of worship" and was applied to the structure that housed a stupa—itself originally a hemispherical mound.

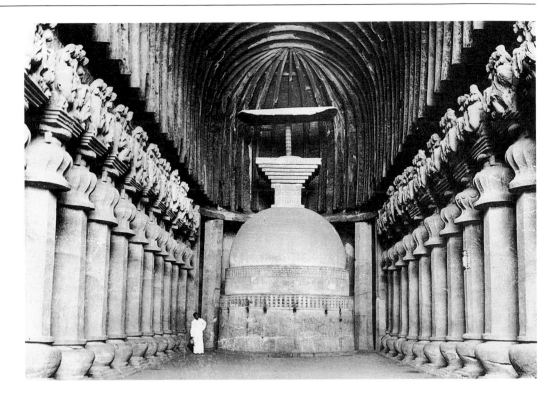

1 Stupa
2 Column
3 Aisle
4 Main hall (nave)
5 Entrance
6 Ambulatory
7 Apse
8 Veranda

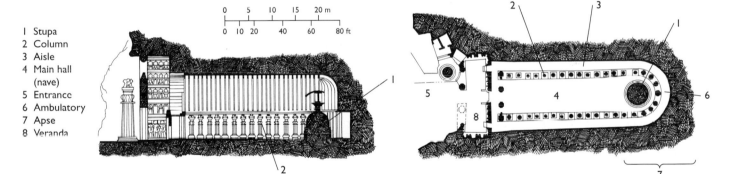

4.2 Plan and section of the *chaitya* hall, Karli, Maharashtra, India.

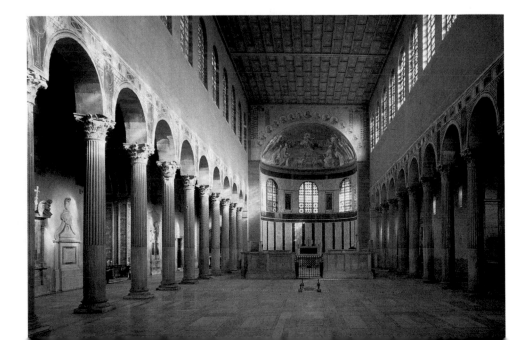

4.3 Interior of Santa Sabina, Rome, 423–432.

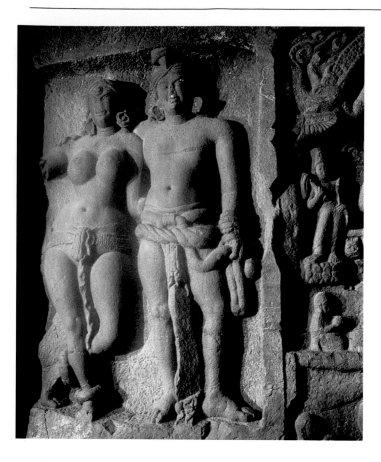

4.4 *Mithuna* from the façade of the *chaitya* hall, Karli, Maharashtra, India, c. A.D. 50–70.

base (in the shape of a water jar), a thick shaft, and a capital, whose bell shape is similar to that on Emperor Ashoka's pillars. Above each bell capital at the Karli *chaitya* hall are two elephants and four riders facing the nave.

Aside from the capitals, there is no sculpture inside the *chaitya* hall at Karli. The veranda, however, is covered with large-scale reliefs; two of the most impressive flank the entrance (fig. **4.4**). They show a royal **mithuna** (loving couple), whose style embodies an ideal of Indian sculpture that would continue for another nine centuries. Although they are made more monumental by the compact space they inhabit, their poses and gestures are casual and relaxed. The woman stands with her left leg bent behind her right, assuming the sensuous **tribhanga** (three-bends pose) of the Sanchi *Yakshi*. Both the man and the woman convey the impression of specific people, possibly donors.

Gupta Sculpture

The Gupta Empire, which flourished in the fourth to seventh centuries, dominated the Ganges Valley and extended into the west and south. Its rulers encouraged developments in art and literature that lasted well beyond the period of their political sway. Though the Guptas were proponents of Hinduism, their patronage of the arts fostered the expansion of Buddhist art as well.

The Gupta *Preaching Buddha* from Sarnath in northern India (fig. **4.5**) exemplifies a new type of Buddha image that emerged in the late fifth century. Its iconography reflects the evolution of a canon for depictions of Buddhist figures and is a particularly successful synthesis of iconic and narrative form. The figure is severe and still. The eyelids are lowered, and the legs are folded into a yogic medi-

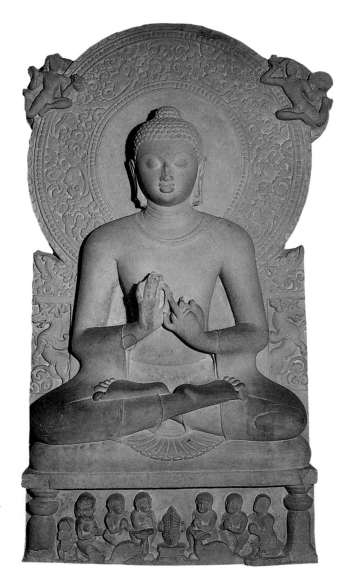

4.5 *Preaching Buddha*, from Sarnath, Uttar Pradesh, India, c. 475. Chunar sandstone; 5 ft. 3½ in. (1.61 m) high. The relief on the base of the throne shows the Wheel of the Law at the center. On either side are three disciples and a deer (referring to the Deer Park Sermon at Sarnath). Carved on the back of the throne are two rearing winged lions (leogryphs), which symbolize royalty. The halo is decorated with lotus motifs and flanked by celestial beings.

tation pose. The hands in *Dharmachakra mudra* symbolize the setting in motion of the Wheel of the Law. In addition to the *ushnisha, urna,* and elongated earlobes that were already part of the Buddha's iconography in the Kushan period, the Sarnath figure has many elements that evolved later. These include features drawn from nature such as the snail-shell curls, eyebrows "like an archer's bow," and shoulders "like an elephant's trunk." Another canonical detail is the three rings on the neck. In the indigenous tradition of the *prana*-filled nude male torso from Harappa (see fig. 3.5) and the *Standing Buddha* from Gandhara (see fig. 3.15), this figure radiates a sense of inner energy.

The Ajanta Caves

(Late 5th Century A.D.)

The artistic legacy of the Gupta dynasty is evident in the spectacular Buddhist monastic site at Ajanta (figs. **4.6** and **4.7**). Ajanta is southwest of Sanchi and northeast of Bombay, close to a strategic mountain pass connecting northern and southern India. Altogether there are thirty caves cut into a U-shaped river gorge, out of which *chaitya* halls and *viharas* were carved in two phases. The earliest dates from the first century B.C. to the first century A.D., and the rest from the second half of the fifth century, when the region was ruled by the Vakataka dynasty.

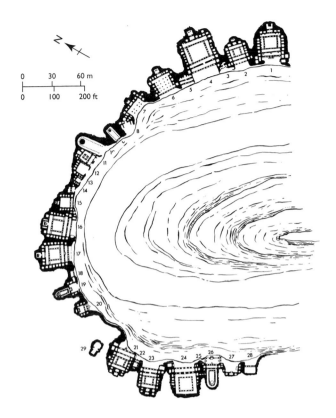

4.6 Plan of the Ajanta Cave complex, Maharashtra, India, c. 450–500.

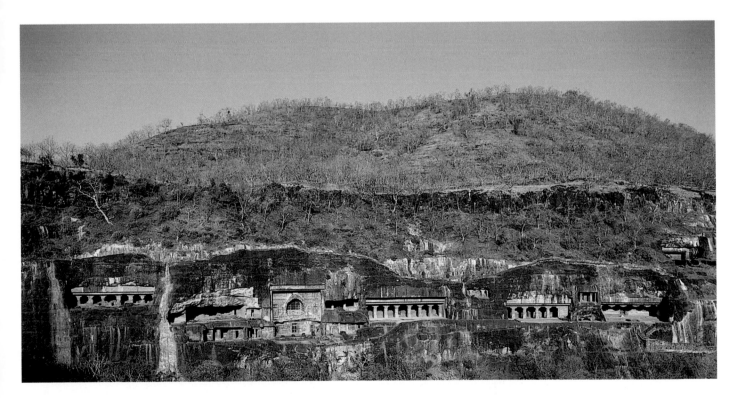

4.7 The Ajanta Caves, Maharashtra, India, c. 450–500.

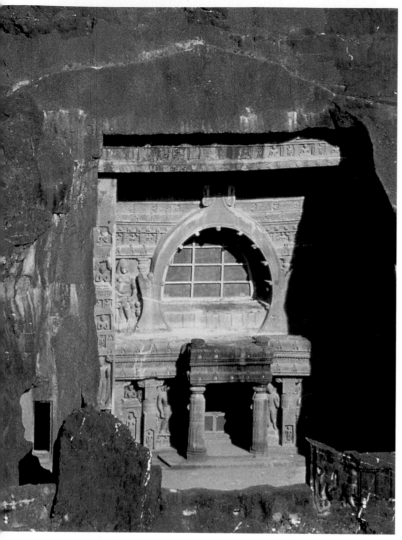

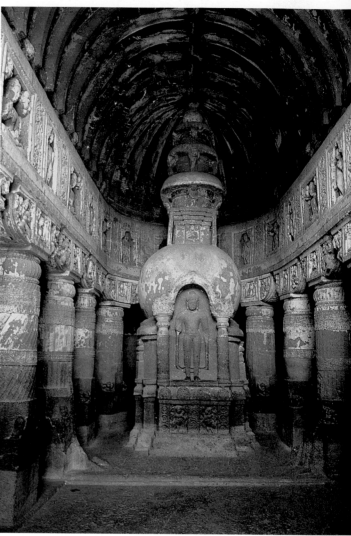

4.8 *Chaitya* hall entrance, Ajanta Cave 19, Maharashtra, India, c. 450–500.

4.9 *Chaitya* hall interior, Ajanta Cave 19, Maharashtra, India, c. 450–500.

The two later *chaitya* halls at Ajanta are more elaborate than the earlier one at Karli. The entrance to the *chaitya* hall in Cave 19 (fig. **4.8**) is particularly well preserved. The view illustrated here shows the large lunette-shaped **chaitya arch** window through which light illuminates the cave and shines on the stupa. Compared with the interior of the earlier *chaitya* hall at Karli, much more sculpture and certain architectural features—such as the thick columns with "squashed cushion" capitals supporting a cornice and an upper row of carved reliefs—have been added (fig. **4.9**). The walls are covered with small-scale, repeated painted images of enthroned buddhas with their attendant bodhisattvas.

The stupa is also decorated with reliefs, and its proportions have grown taller and thinner. A monumental statue of Shakyamuni Buddha stands in a niche framed by pillars supporting a *chaitya* arch. Both the axis pillar and *chattras* have become more complex.

Some of the greatest examples of monumental Indian painting survive in four of the Ajanta *viharas* (see box, page 40). Secular paintings from this period are mentioned in texts, but they have not survived. The Ajanta frescoes constitute monumental religious programs with political significance. Their use of rich colors and displays of opulence were intended to align political power with religious devotion. A large scene, *Prince Distributing Alms* (fig. **4.10**), illustrates this combination. Despite the generosity of the prince, motivated as it is by his piety, his elaborate entourage, including horses and guards—as well as his rich attire—expresses his love of worldly splendor and his ability to command it.

The famous *Padmapani*, or "Lotus Bearer" (from *padma,* meaning "lotus," and *pani,* meaning "hand"), is one of a pair flanking the entrance to the shrine at the rear of the *vihara* in Cave 1 (fig. **4.11**). The detail of the head in figure

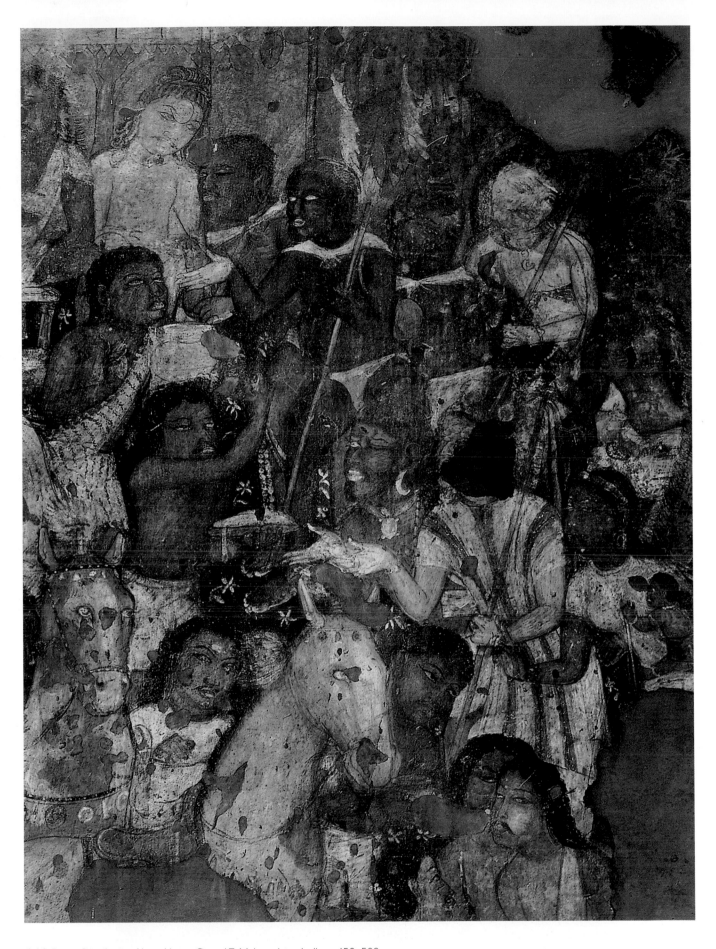

4.10 *Prince Distributing Alms,* Ajanta Cave 17, Maharashtra, India, c. 450–500.

Indian Mural Painting

Recent microscopic analysis of the Ajanta murals shows that cave walls were covered with three layers of plaster. The final layer was tinted or painted to create a white ground for the paintings. The paint itself is a kind of tempera, which was probably made by mixing powdered mineral pigments with a gluey binder. Outlines were drawn in reddish brown, and forms were filled in with paint. Blue was rarely used, suggesting that its source was an expensive, imported mineral, perhaps lapis lazuli. Black pigment is thought to have been made from soot.

In addition to texts detailing artistic practice, one of the early sources of information on painting technique in India is the Gupta-period commentary on the *Kamasutra,* a Hindu treatise on the art of love. This describes the language of pose and gesture, the expression of mood and feeling, and the rendering of objects three-dimensionally.

4.11 *Padmapani,* Ajanta Cave 1, Maharashtra, India, c. 450–500.

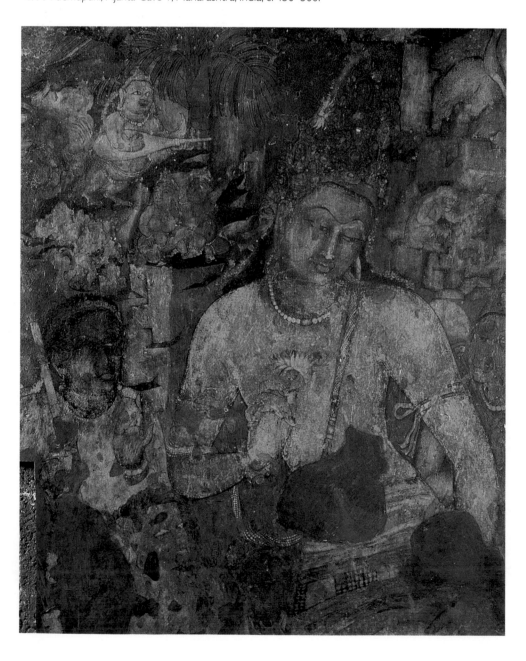

4.12 reveals the sensuous naturalism of Indian art also evident in the *Yakshi* at Sanchi (see fig. 3.14). The *Padmapani* in the *tribhanga* pose, regally attired and attending the Buddha, is primarily a great emperor serving an even greater lord.

The imposing figure of the *Padmapani* reflects the continuing Indian interest in naturalism, which can be seen in the use of shading to convey organic form—for example, the underside of the chin, the curves of the shoulder and neck, and the natural depressions of the face. In contrast to the Byzantine depiction of spirituality conveyed by flat, vertical planes, frontality, and iconic confrontation with the worshiper, the Ajanta murals convey it by an inner, meditative tranquility.

Even in a devotional scene, such as the *Worship of the Buddha* (fig. **4.13**) from a pillar in Ajanta Cave 10, the figures turn as if in three-dimensional space. The sense of a natural setting is suggested by the floral designs and the fact that the Buddha's throne is at an oblique angle. Although the halo is flat, the head is rendered in three-quarter view.

4.13 *Worship of the Buddha*, from Ajanta Cave 10, Maharashtra, India, c. 450–500. Photo: Robert E. Fisher.

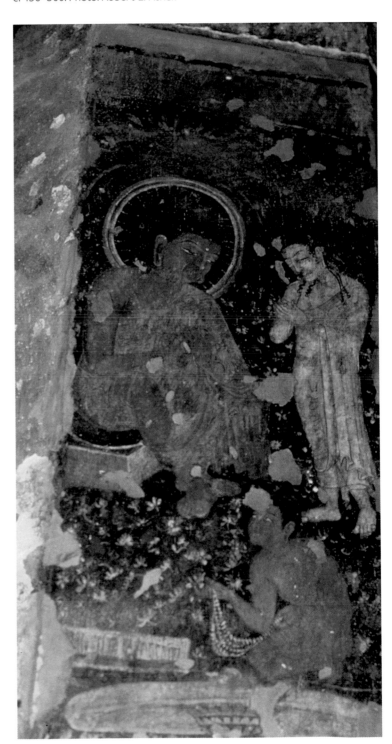

4.12 *Padmapani* (detail of fig. 4.11).

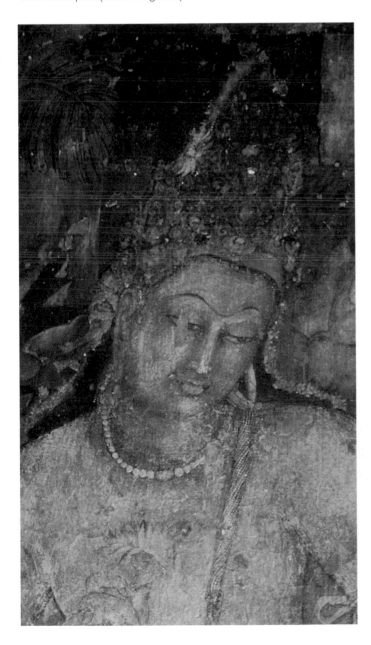

Buddhist Expansion in China

(2nd–7th Centuries A.D.)

Buddhism declined in India, where it would become nearly extinct by the thirteenth century. This was due partly to a revival of Vedic religion, which has a complex association with the development of Hinduism. But Buddhism spread throughout much of the rest of Asia, where it has remained a dominant cultural force. It was transmitted along the Silk Road throughout central Asia to China in about the first century A.D. and gained a foothold during the Han dynasty (c. 202 B.C.–A.D. 220). Beginning in the second century A.D., Buddhist texts (sutras) were translated from their original Indian languages, Sanskrit and Pali, into Chinese. Only then was Buddhism recognized in China as a school of thought distinct from Daoism. Over the next few centuries, Buddhism brought with it new artistic techniques and styles from central Asia, India,

Iran, and the Mediterranean world. The eclectic nature of Chinese art at this time reflects the continuing exchange of goods and ideas. Contemporary accounts, particularly those of Buddhist pilgrims, vividly describe what the travelers saw.

By the fifth century A.D., when China was under the dominion of the Northern Wei dynasty (386–535), Buddhist art flourished in China. The early Wei rulers were originally from central Asia, and, to consolidate their position in China, they promoted Daoism and Buddhism rather than Confucianism, the established state doctrine. Like Ashoka, the Northern Wei presided over monumental building projects, using religion and religious art in the service of political power.

Their first great artistic program was at Yungang, in Shansi Province. Caves were cut into the cliffs and colossal statues carved from the existing rock (fig. **4.14**). At Yungang, the influence of hundreds of central Asian Buddhist caves—themselves based on Indian *viharas* and *chaitya*

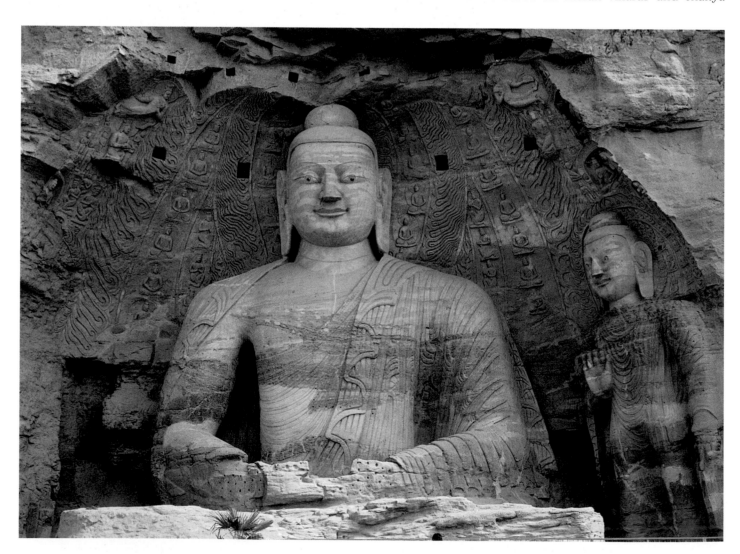

4.14 Colossal Buddha, from Cave 20, Yungang, Shanxi Province, China, c. 460–490. 45 ft. (13.70 m) high. For over thirty years, thousands of stoneworkers created such sculptures and carved out cave temples and cells in the Yungang cliffs. The project was proposed to the Wei rulers in A.D. 460 by the monk Tanyao.

4.15 *Buddha with Disciples,* from the Binyang Cave, Longmen, Henan Province, China, early 6th century.

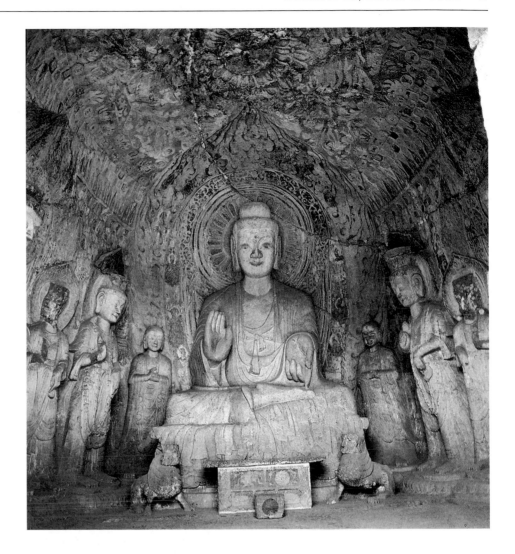

halls—is clear. The monumental stone Buddhas carved from these sandstone cliffs also show traces of the Gandharan style, which was transmitted along the Silk Road.

The Buddha in figure 4.14 bears some resemblance to Gandharan sculpture, particularly in the smooth hair and the flowing drapery over both shoulders. But the Yungang Buddha is psychologically more remote. All trace of Indian sensuousness has disappeared. The figure retains canonical features such as the *ushnisha,* elongated earlobes, and monk's robe, but the drapery folds are flatter and more stylized. The combination of the figure's colossal size and impassive gaze seems to elevate this Buddha to a spiritual plane that is beyond human time and place.

In 494 the Northern Wei moved their court southward to Luoyang. There in the heartland of China they encountered the native (Han) Chinese culture. By this time the belief in the Buddha of the Future seemed more relevant to Buddhists than the distant historic one, Shakyamuni Buddha. The pious prayed to the Buddha of the Future and later to Amitabha, the Buddha of the Western Paradise, for relief from the cycle of reincarnation through a less difficult route to nirvana. These Paradise sects promised

enlightenment in a resplendent paradise, attainable by anyone through faith rather than exclusively through the rigors of monastic life. As in India, the popularity of Shakyamuni was rivaled by these new Buddhas, and many theological changes are noticeable in the art. Artists created new images that depict the paradises of Maitreya and Amitabha with attendant bodhisattvas, celestial musicians, and angels, as well as the resplendent lotus throne of a thousand petals of Buddha Vairochana (the supreme cosmic Buddha).

When the Northern Wei moved south, they took up a second major artistic program in the caves at Longmen. There the *Buddha with Disciples* (fig. **4.15**) from the Binyang Cave is the focal rock-cut image inside the inner chapel. Shakyamuni sits cross-legged on a platform 19 feet (5.79 m) wide. His throne is guarded by the lions of royalty, and he is flanked by disciples. He no longer bows his head and lowers his eyelids to convey a state of inward meditation. Instead, in accordance with the Lotus Sutra (one of the canonical Buddhist texts) he gazes at worshipers, communicating directly with them. This active connection is reinforced by his enlarged hands: the right is held up in *abhaya mudra* (the "have no fear" gesture), and the left

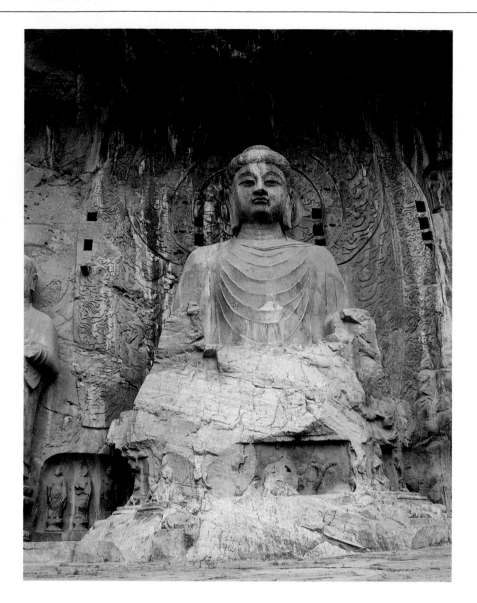

4.16 *Vairochana Buddha,* Longmen Caves, Henan Province, China, 672–675. Natural rock; approx. 49 ft. (14.90 m) high.

points downward. The figure's proportions are more elongated than at Yungang.

Shakyamuni's robe is now a Chinese garment. Its cascading folds are stylized as waterfalls and fishtails. In contrast to the relatively three-dimensional treatment of drapery at Yungang, this Buddha's robe is flatter and more linear; it is composed of repeated patterns. Such stylistic differences reflect the assimilation of foreign models into a more purely Chinese style. Similarly, the Longmen Buddha's full-cheeked, square-jawed facial type, with its almond-shaped eyes and smiling rosebud mouth, is distinctively Chinese. The flat, elaborately carved **mandorla** that surrounds the throne is filled with flames symbolizing the light of the Buddha's spirit.

The best example of the Longmen style was created under the Tang dynasty (618–906), when China was again united and the arts flourished. As Buddhism developed in Tang China, the belief that buddhahood could be attained in the world grew in importance. Mystical rituals were intended to connect the earthly, material world with the formless, absolute world and to guide individuals along the path to spiritual awareness.

Figure **4.16** depicts *Vairochana Buddha,* the embodiment of Shakyamuni's spiritual nature and the most popular of the Five Great Buddhas of Wisdom. The figure's colossal size and simply rendered form enhance the Buddha's otherworldly quality. The original lotus throne, which has been lost, was conceived of as having one thousand petals, each corresponding to a single Buddhist cosmos with 100 million Buddhist worlds. Vairochana (meaning "Resplendent") personifies the creativity of Buddhist *Dharma* and the Buddhist view of the universe. In one tradition—Huayan—Vairochana is the Universal Buddha. By association with him, China's emperors legitimized their claim to power.

Images of the Buddha beyond India and China

Buddhism and its art spread eastward to China and Japan along the Silk Road. One of the most colossal examples of the latter was the standing *Vairochana Buddha* at Bamiyan, in modern Afghanistan (fig. **4.17**).

The figure of the Buddha was set in a niche carved out of a mountain so that it seemed to emerge from the natural rock and preside over the countryside. Note that the thin linear drapery folds are related to those of the seated Longmen Buddha (see fig. 4.16). In both cases, the translucent garments create a sense that the figures are spiritually removed from the everyday human world. Both reflect a later development of the classically influenced Gandharan style of sculpture.

Buddism was brought along the sea routes from India to Sri Lanka (Ceylon) and Southeast Asia at the end of the third century B.C. In the royal city of Polonnaruva (eighth–thirteenth centuries), a number of colossal, rock-cut Buddhas were created according to the principles of Theravad (the Way of the Elders) Buddhism. This was the oldest form of the religion, which advocated worship of the historical Buddha and strict adherence to ascetic monasticism.

In contrast to the Bamiyan Buddha but wearing a similar robe with thin, flattened folds and reflecting Theravad Buddhism, the colossal statue of *Ananda Attending the Parinirvana of the Buddha* (fig. **4.18**) is shown lying down. His form is more elongated and his contours more graceful than the destroyed statue at Bamiyan. The Sri Lanka Buddha is a type of sleeping Buddha prevalent in Southeast Asia. The *Parinirvana* refers to the death of the Buddha, but the artistic motif can also denote meditation. Depicted in relief a short distance behind the Buddha's head is his disciple, Ananda, who may be attending his master's passage into the state of *nirvana*.

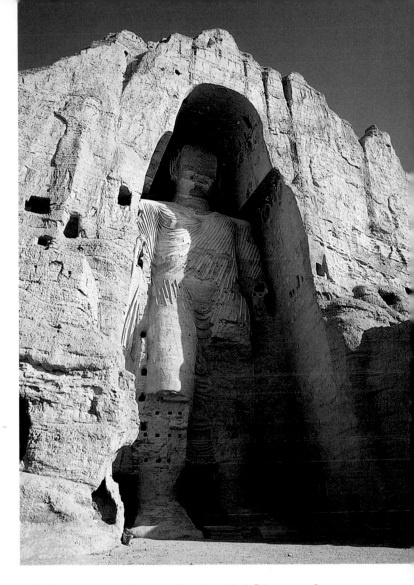

4.17 Colossal Buddha, Bamiyan, Afghanistan, 2nd–5th century. Stone; 180 ft. (55 m) high. In February 2001, this and other sculptures were blown up by the Taliban, a fundamentalist Islamic group that objected to the works because they were figurative and non-Muslim. Today the sculptures are known only through photographs, although there has been discussion about re-creating the destroyed works.

4.18 *Ananda Attending the Parinirvana of the Buddha*, Gal vihara, Sri Lanka, 11th–12th century. Granulite; 23 ft. (7 m) high, 46 ft. (14 m) long.

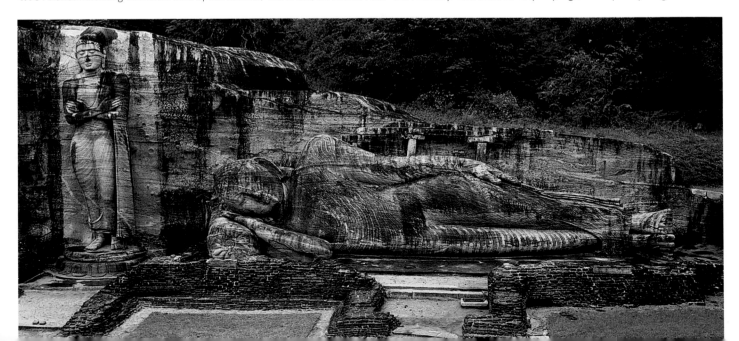

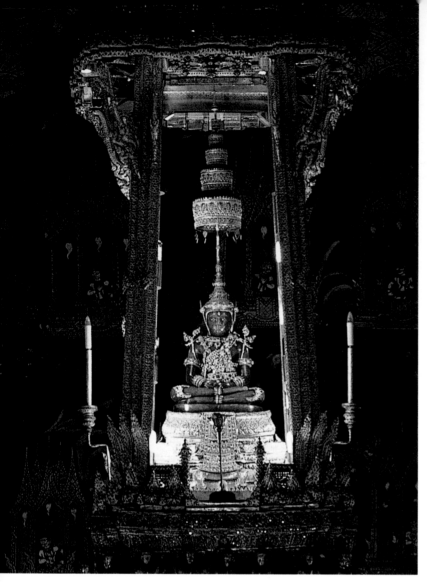

4.19 *Emerald Buddha*, ubosoth (ordination hall) of the Emerald Temple, Bangkok, Thailand, 15th century. Green jade or jasper; 2 ft. 6 in. (76.20 cm) high.

The fifteenth-century *Emerald Buddha* from Thailand shows another, elaborately jeweled Buddha image (fig. **4.19**). In this manifestation, the Buddha is also the king, for he wears the gold costume of royalty. Although actually carved from green jade or jasper, the statue was believed capable of imparting the magic power of the emerald to control nature to the Thai king who owned it. As an expression of the dual political and religious character of the *Emerald Buddha,* the king of Thailand clothed the figure two times a year—once as a king (as in this illustration) and once as a monk.

Old as the traditions of Buddhism and the image of the Buddha are, they are not immune to the creative transformations of modern art. In 1974, Korean-born composer and video artist Nam June Paik (b. 1932) produced his famous *TV Buddha* (fig. **4.20**). He uses modern technology and the contemporary medium of video to play on the Buddhist idea of inner contemplation as a route to spiritual well-being. This particular Buddha contemplates his reflection on the television screen, which is both a mirror image of himself and a projection of his interior calm. Formally, the rotundity of both the sculpture and the television set are a visual pun. The camera behind the set reminds us that we are looking at the Buddha looking at himself as he is projected from the video camera. It also reminds us that art, like Buddhist meditation, is about looking and seeing, and about apprehending interior as well as exterior meaning.

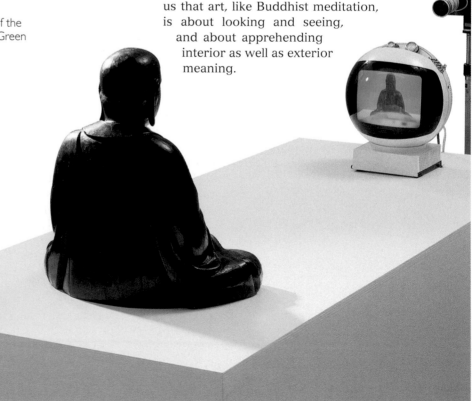

4.20 Nam June Paik, *TV Buddha*, 1974. Video with statue of the Buddha. Stedelijk Museum, Amsterdam.

5

The Expansion of Islam

Islam

One of the world's great religions, Islam literally means "surrender [to God]." It was founded by the prophet Muhammad, who was born in Mecca, in western Arabia, around 570. He and his followers fled to the more hospitable neighboring city of Medina in 622, a watershed event called the *Hijra* that marks the starting point of the Islamic calendar. Within two years of Muhammad's death in 632, his successor, the first caliph, or ruler, united Arabia under the new faith. Over the next twenty years, Islamic armies conquered large portions of the Byzantine Empire and the Middle East (see map, page 48). Controversy over the succession to the caliphate caused a political and religious schism in 661 that persists today. Islam is thus divided into two sects: Sunni Muslims and Shiite Muslims. As a result of aggressive campaigns of conquest and conversion, a century after its founding Islam stretched from Afghanistan in the east to Portugal, Spain, and southwestern France in the west, where it rivaled Christianity.

Islam carries a relatively simple and straightforward message: the unity of the community of Muslims ("those who submit") and their equality before Allah (God), who is single and absolute, and whose ultimate prophet was Muhammad. The holy book of Islam, the Koran (or Qur'an), is believed to be the word of Allah as revealed to Muhammad in a series of visions. Another set of texts, the Hadith, is a later compilation of traditions. Together, the Koran and the Hadith form the basis of Islamic belief and law. The Five Pillars of the faith are: (1) the affirmation that there is no God but Allah and that Muhammad is his messenger; (2) ritual prayer in the direction of Mecca five times a day; (3) almsgiving; (4) fasting and abstinence during the holy month of Ramadan; and (5) the *hajj,* an annual pilgrimage to Mecca that every devout Muslim strives to make at least once. A sixth pillar, *jihad,* calls on Muslims to fight non-Muslims, pagans, Jews, and Christians, forcing them to submit to Islamic rule and an Islamic state. This inspired armed conquests led by Muslims throughout the Mediterranean as far as Spain and France in the seventh and eight centuries.

The most recent of the world's three monotheistic religions, Islam accepts Moses, Jesus, and others as prophets and forerunners of Muhammad. Like Judaism, Islam discourages the making of images that might be worshiped as idols. Muslim artists thus concentrated their creative energies on the development of nonfigurative forms, not only delighting the eye, but leading the mind to the contemplation of God. As a result, they excelled at calligraphy and geometric patterning.

Islamic Calligraphy

"Handwriting is jewelry fashioned by the hand from the pure gold of the intellect," wrote an early authority on Islamic calligraphy.[1]

Since the Koran was originally revealed to Muhammad in the Arabic language, Muslims must read and recite from it only in Arabic. This has meant that, as Islam spread, Arabic language and Arabic script spread as well. Because of its close association with the sacred text, writing is the most honored art in the Islamic world. It is also the most characteristic, uniting the diverse and far-flung community of believers. Writing adorns not only books, but also ceramics, metalwork, textiles, and buildings. A great many calligraphic styles have developed over the centuries.

There are two main groups of scripts: the earliest, Kufic—similar to Western printed letters and used today mainly for headings and formal inscriptions—and cursive, which evolved from the twelfth century on. Figure **5.1** illustrates a page from a ninth- or tenth-century manu-

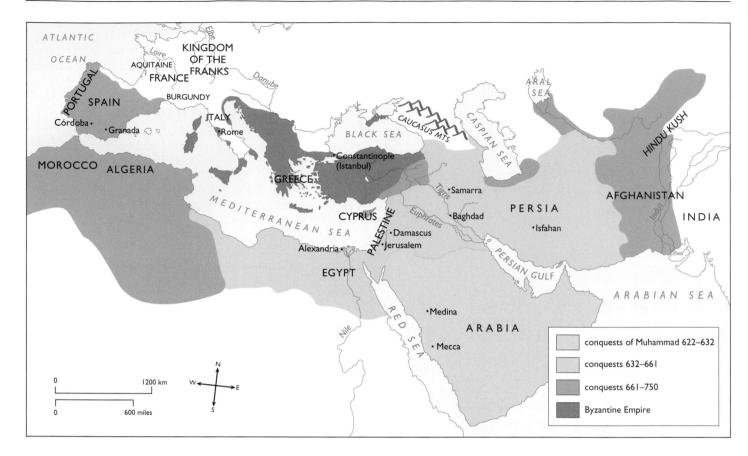

The expansion of Islam (622–c. 750).

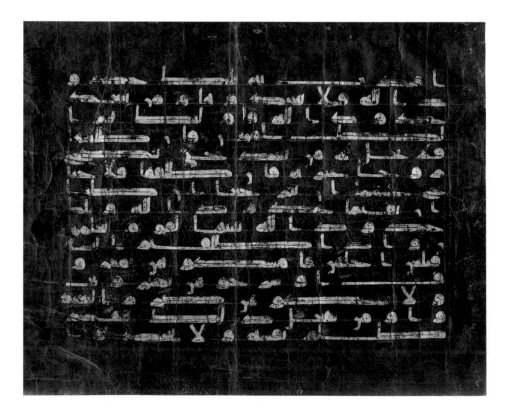

5.1 Page from the Kairouan manuscript of the Koran, written in Kufic, Tunisia, 9th–10th century. Ink, gold, and silver on blue-dyed parchment; 11⅓ × 14⅞ in. (28.73 × 37.62 cm). Arthur M. Sackler Museum, Harvard University Art Museum, Francis H. Burr Memorial Fund.

5.2 Illuminated **tugra** of Sultan Suleyman, c. 1555–1560. Ink, paint, and gold on paper; 20½ × 25⅜ in. (52 × 64.50 cm). Metropolitan Museum of Art, New York. Rogers Fund, 1938 (38.149.1). Photograph © 1986 Metropolitan Museum of Art.

script of the Koran written in Kufic. It shows the Islamic interest in linear complexity and designs. The abstract rhythms of Islamic calligraphy lend themselves to a variety of visual effects, from the simple strength of early Kufic script to the intricacies of Sultan Suleyman's imperial emblem (fig. **5.2**).

The Dome of the Rock, Jerusalem

The earliest extant Islamic sanctuary is the Dome of the Rock in Jerusalem (fig. **5.3**). The structure encloses a rock outcropping that is sacred to Judaism and Christianity as well as to Islam. Its exterior is faced with mosaics and marble. The building, which was inspired by circular Christian martyria (burial places), is a centrally planned octagon. Stylistically, the architectural ornamentation of the Dome of the Rock is a synthesis of Byzantine, Persian, and other Middle Eastern forms. Figure 5.3 illustrates the richness and complexity of the abstract patterning on the exterior and the brilliant impression made by the **gilded** dome.

This was precisely the effect desired by Caliph Abd al-Malik, who commissioned it. According to a tenth-century source, he wanted a building that would "dazzle the minds" of Muslims and thereby distract them from Christian buildings in Jerusalem.[2] In the caliph's view, the splendor of his sanctuary would symbolically "blind" Muslims, preventing them from "seeing" beauty in monuments built by other faiths.

Mosques

Although Muslims may pray anywhere as long as they face Mecca, religious architecture became an important part of Islamic culture. In the earliest days of Islam, the faithful gathered to pray in the courtyard of the prophet Muhammad's home. From this developed the primary architectural expression of Islam, the **mosque.**

5.3 Dome of the Rock, Jerusalem, late 7th century. Also known as the Mosque of Omar, this was constructed on a 35-acre (140.64 m²) plateau in east Jerusalem. Muslims traditionally regard it as the site from which Gabriel led Muhammad through the heavenly spheres to Allah. Jews know the plateau as the Temple Mount—the location of Abraham's sacrifice of Isaac and of the first Jewish temple, built by King Solomon in the 10th century B.C.

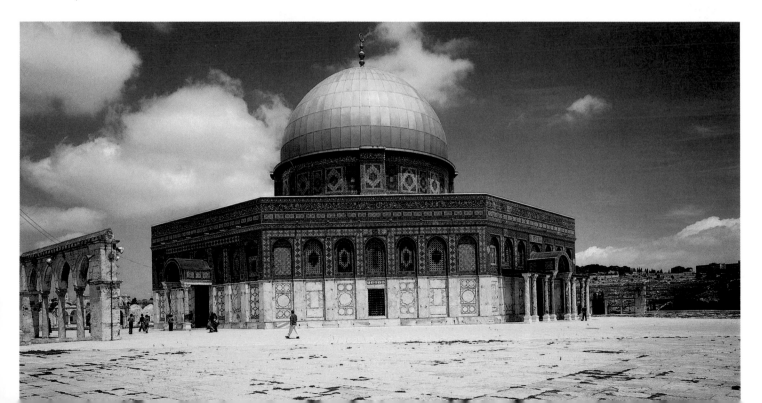

There are two main types of mosque: the *masjid* is used for daily prayer by individuals or small groups, while the larger *jami,* or Friday mosque, is used for congregational worship on Fridays, the Muslim sabbath. Although mosques around the world reflect local architectural traditions, most share certain basic features. These are a **sahn,** or enclosed courtyard (less common in later centuries), and a **qibla,** or prayer wall, oriented toward Mecca. The *qibla* frequently has a **mihrab** (small niche) set into it. *Jami* mosques also contain a **minbar,** a pulpit from which an *imam* (religious teacher) leads the faithful. By the end of the seventh century, Muslim rulers were beginning to build larger and more elaborate structures. The exterior of a typical mosque includes one or more tall minarets from which a *muezzin,* or crier, calls the faithful to prayer at the five prescribed times each day.

As Islam spread westward and won more converts, new mosques were needed. The biggest of these was located in Samarra, on the banks of the Tigris, in modern Iraq (fig. **5.4**). Built from 847 to 852 by Caliph al-Mutawakkil, the Samarra mosque is now in ruins. Nothing remains of the lavish mosaics and painted plaster that decorated the interior. The plan (fig. **5.5**) shows the location of the 464 supports of the wooden hypostyle roof. These were arranged in rows around a huge, rectangular *sahn.* An unusual feature of this mosque is the single, cone-shaped **minaret** that rises 60 feet (18.30 m) on the north side. A ramp connects it with the main building, and leading to the top is a spiral stairway.

In 1453, when Constantinople was conquered by the Ottoman Turks from central Asia, the city was renamed Istanbul. The Ottoman Empire grew rapidly, reached a peak in the sixteenth century, and lasted until 1922.

1 *Mihrab* niche
2 *Qibla* wall
3 Hypostyle hall
4 *Sahn*
5 Minaret

0 10 20 30 m
0 50 100 ft

5.5 Plan of the Great Mosque, Samarra, 847–852.

The leading Ottoman architect was Sinan the Great (c. 1491–1588), known as Koca (the Architect). His most important work in Istanbul, the mosque of Suleyman I (figs. **5.6** and **5.7**), was part of an imperial complex begun in 1550. By aligning the mosque with the horizon, Sinan

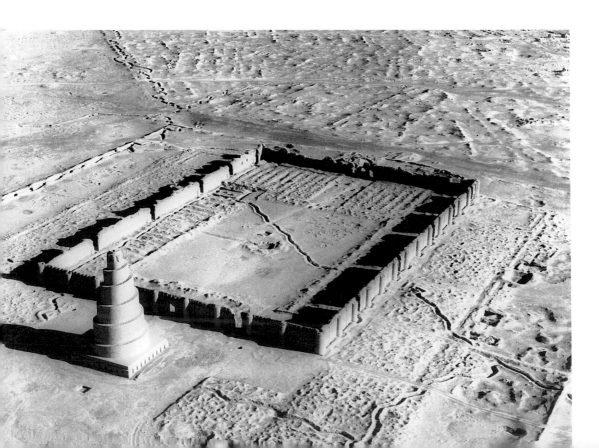

5.4 Great Mosque, Samarra (now in Iraq), 847–852. Approx. 10 acres. Note the ziggurat style of the minaret, possibly reflecting the impact of Near Eastern influences on Islamic religious architecture.

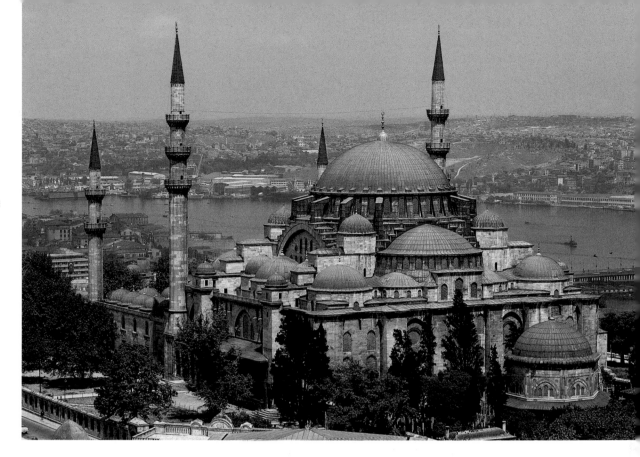

5.6 Sinan the Great, mosque of Suleyman I, Istanbul, Turkey, begun 1550. Sinan was a Greek who converted to Islam and, at the age of 47, became "Architect of the Empire." As supervisor of building in Istanbul and overseer of all public works, he was referred to as "Architect in the Abode of Felicity."

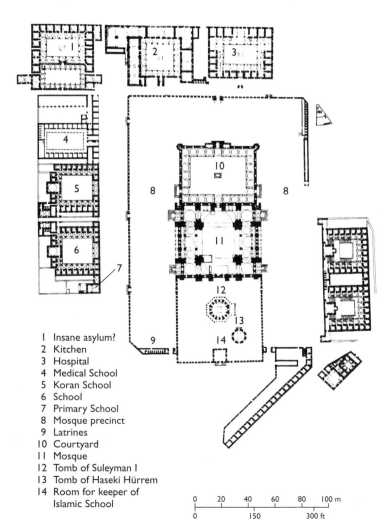

1 Insane asylum?
2 Kitchen
3 Hospital
4 Medical School
5 Koran School
6 School
7 Primary School
8 Mosque precinct
9 Latrines
10 Courtyard
11 Mosque
12 Tomb of Suleyman I
13 Tomb of Haseki Hürrem
14 Room for keeper of Islamic School

5.7 Plan of the mosque of Suleyman I and the imperial complex, Istanbul. In addition to the mosque, the vast complex includes seven colleges, a hospital and asylum, baths, two residences, a hostel, kitchens, tombs, a school, fountains, wrestling grounds, shops, and a courtyard. Altogether there are five hundred domes, of which the mosque's is the largest.

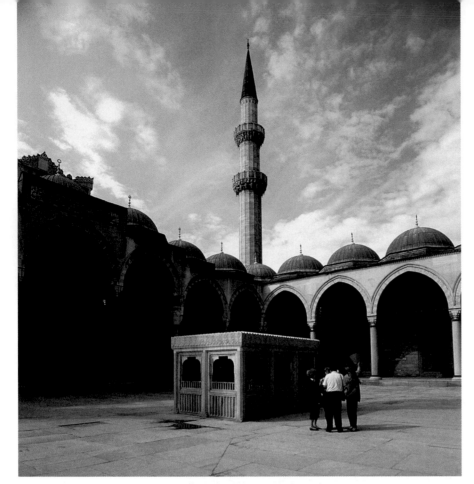

5.8 Courtyard (*sahn*) of the mosque of Suleyman I, Istanbul.

5.9 Interior of the mosque of Suleyman I, Istanbul.

5.10 The Luftullah Mosque, Isfahan, Iran, 1602–1616.

used the elevated site to enhance its monumental effect. His notion of an ideal geometric symmetry—particularly a circle inscribed in a square—is clear from the plan. His domes also express the symbolic significance of the circle as a divine shape with God at its center.

The large central dome, preceded by several levels of smaller domes and stepped, buttressed walls, seems to be bubbling up from the interior of the hill. Four minarets accent the exterior symmetry. The *sahn* (fig. **5.8**) is surrounded by a colonnade of arches, whose sizes correspond to the width of the twenty-four domes they support. The interior of the mosque (fig. **5.9**) has domes resting on

pendentives and many small windows, creating an impression of light streaming down from heaven. The *mihrab* was decorated with blue, red, and white ceramic tiles arranged to create elaborate floral designs.

The seventeenth-century Luftullah Mosque in Isfahan shows the shimmering, jewellike surfaces composed of intricate floral and calligraphic tilework (fig. **5.10**). These are reminiscent of knotted carpets, for which Persia (modern Iran)—which became part of the Islamic world in the seventh century—was renowned. Their colorful rhythms reflect the influence of nomadic textile traditions and of the Near Eastern taste for geometric patterns.

Persian Miniature Painting

In contrast to the usual nonfigurative conventions of Islamic art, Persian miniatures, especially those made for the courts, depict human figures in narrative settings. Persian court artists created a pictorial world rich in colors and patterns. Their impact is enhanced by variations in proportions and in shifting spatial viewpoints. Persian perspective can thus be both two- and three-dimensional within a single frame or scene. The artists preferred harmony of design to illusionistic representations of the natural environment. The bright, rich pigments of the miniatures come from an abundant use of gold, silver, and lapis lazuli. Bright vermilion was made by grinding cinnabar, and green came from malachite. Although many illuminations were commissioned by royal patrons, there was also a demand for commercially produced illustrated manuscripts.

A page from a commercial manuscript is illustrated in figure 5.11 and shows the shifting perspective typical of Persian miniatures. It depicts the enthronement of Kuyuk the Great Khan (ruled 1246–1248; grandson of Genghis Khan) at his camp near Qaraqorum, in Iran. At the right, Kuyuk sits in a three-dimensional pose on his throne but occupies a two-dimensional, unmodulated orange space. The table in front of him, on the other hand, is three-dimensional but is seen from above. At the left, two figures kneel on a carpet, which tilts as if suspended over the ground. A blue and white cloud overlaps the tree and alters the natural relation between landscape and sky. The irrational character of such spatial shifts, however, is subsumed by the brilliant color and intricate patterns of the image.

5.11 *Kuyuk the Great Khan*, from a Tarikh-i Jahangusha of Ata Malik ibn Muhammad Juvayni, Timurid, Shiraz, 1438. 10⅓ × 6⅔ in. (26.5 × 17.2 cm). British Museum, London.

The Mughal Dynasty of India

By the sixteenth-century, exploration financed in western Europe led to colonization, missionary activity, and trade with the Americas and the Far East. In Holland, Chinese and Japanese objects were imported through the Dutch East India Company. Although by and large any real understanding of these distant regions on the part of Europeans was minimal, Eastern motifs began to influence furniture design, and a general taste for the exotic emerged in Europe. These cultural exchanges were most meaningful in contacts with Mughal painters of seventeenth-century India (see map).

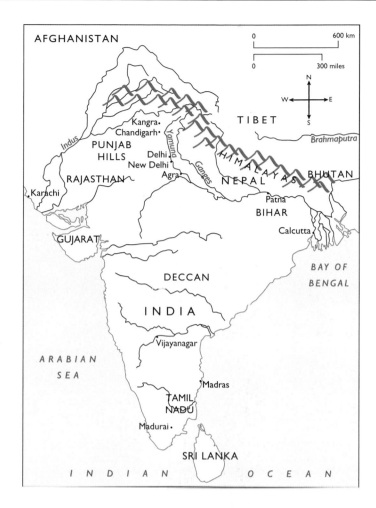

Map of 17th-century India.

Cross-Cultural Currents

The Mughal school of painting in India thrived under the enlightened patronage of three emperors: Akbar (ruled 1555–1603), Jahangir (ruled 1603–1627), and Shah Jehan (ruled 1627–1658). Descended from Genghis Khan, Akbar's Persian grandfather founded the Mughal dynasty in India. He brought with him Persian artists, with whom Akbar studied as a child. Although raised as a Muslim, Akbar did not subscribe to the Islamic prohibition against figurative art. He, therefore, had Hindu artists working at his court, and they produced figurative imagery.

Akbar wished to unite Hinduism with Islam and to synthesize both with Christianity. He endorsed the progressive notion that the divine status of a ruler depended on a just and fair administration. His advanced religious views and desire for political unity inspired him to collect European art.

Akbar's European collection influenced Mughal artists, who began to introduce Western perspective into their own work. The miniature of *Akbar Viewing a Wild Ele-*

phant Captured near Malwa (fig. **5.12**) combines Hindu shading, which forms the elephant's bulk, Islamic patterning, and elements of Western perspective. For example, the oblique angle of the castle's middle wall creates a three-dimensional effect. Reinforcing this is the depiction of the ground as convincingly supporting elephants, riders, and trees.

Although orthodox Muslims in India objected to Akbar's patronage of figurative art, his son Jahangir continued to encourage artists to study nature and European painting. In the *Allegorical Representation of the Emperor Jahangir Seated on an Hourglass Throne* (fig. **5.13**), the Baroque interest in the theme of time (the hourglass) is incorporated into an Islamic setting. The border designs, calligraphic lettering, and elaborate carpet that flatten the space are the result of Persian influence. The figures and hourglass, on the other hand, are rendered three-dimensionally and are shaded. Jahangir, surrounded by a large double sun and moon halo, greets four personages, who reveal his international outlook: a Muslim divine with a long white beard, a Muslim prince with a black beard, a delegate from the

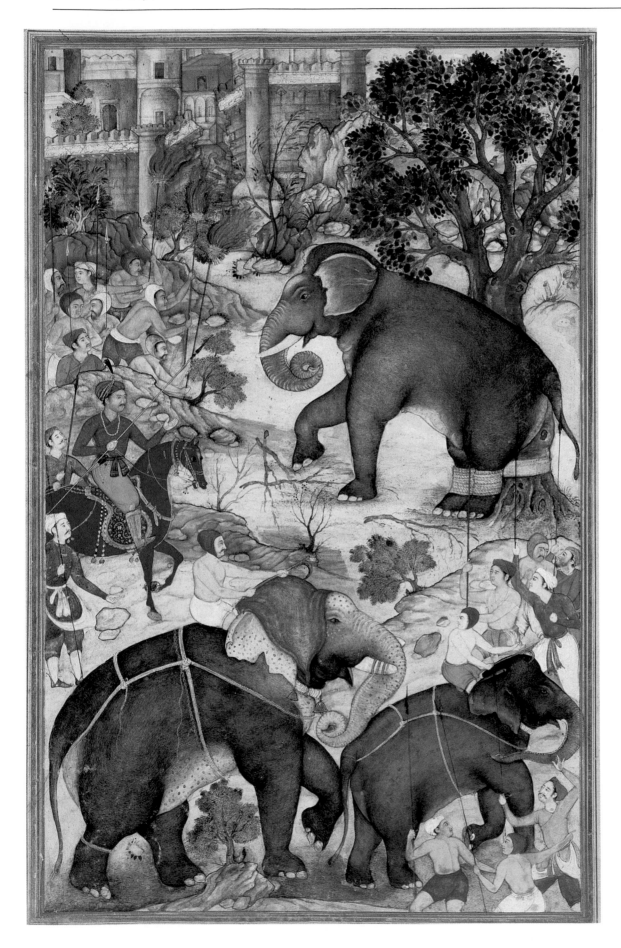

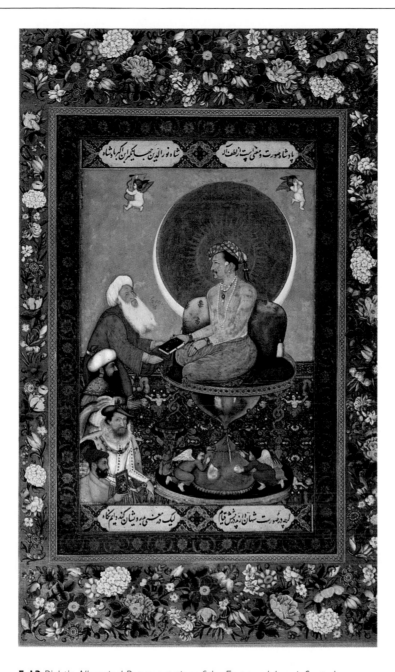

5.13 Bichtir, *Allegorical Representation of the Emperor Jahangir Seated on an Hourglass Throne*, early 17th century. Color and gold on paper; 10⅞ in. (27.60 cm) high. Courtesy of the Freer Gallery, Smithsonian Institution, Washington, D.C. (42.15V).

court of James I of England, and an artist holding up a picture. Two little angels copied from a European painting are writing on the hourglass a message wishing the shah one thousand years of life. Above and to the left, a Cupid carries a bow and arrow. To the right is another Cupid who covers his eyes, a reference to the Western notion of blind love.

The Taj Mahal

The masterpiece of Mughal architecture combines Hindu and Islamic features. The Taj Mahal (literally, "Crown of Buildings;" fig. **5.14**) was commissioned by Jahangir's son, Shah Jahan, as a memorial to his wife, Mumtaz Mahal, who died in 1631. The jewellike, graceful structure is set in

a garden and approached by four waterways, its ensemble signifying paradise and its four rivers. The mausoleum itself has a large cusped arch over a deep recess and stands on a podium with four elegant domed minarets, one at each corner. On either side of the mausoleum are two identical structures—a mosque and a secular building. Balancing the large central onion dome, which is a characteristic feature of Mughal architecture, are two smaller *chattris*—the parasol-shaped elements that are derived

from the *chattras* on early stupas (see fig. 3.11). The entire structure is perfectly symmetrical, which contributes to its calm, imposing impression. Elaborate curvilinear designs of inlaid semiprecious stones enhance the marble surface of the Taj Mahal.

When Shah Jahan died, the nonfigurative conventions of Islamic art reasserted themselves under his more conservative successors. Mughal artists then found new patrons among the Hindu aristocracy.

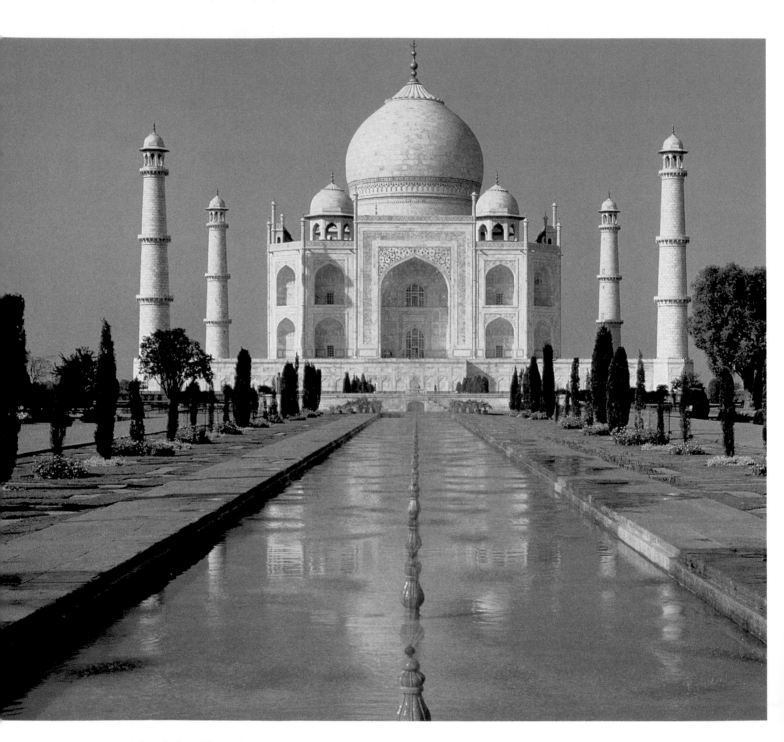

5.14 Taj Mahal, Agra, India, 1632–1648.

6

Buddhist and Hindu Developments in East Asia (6th–13th centuries)

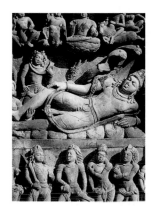

In 1210, the Mongols, central Asian nomads, who were feared in Europe as the Antichrist, began their conquest of China. Leading the so-called Mongol hordes was Genghis Khan. Fifty years later, his sons ruled a vast territory. By 1279, his grandson Kublai Khan had founded the Yuan dynasty and become its first emperor. This conquest resulted in a unification of China, which would be ruled by khans until 1368. Under Mongol control, China continued to trade with western Europe, exporting silk cloth, ceramics, and carpets. These relatively transportable items exposed Europeans to Far Eastern art forms and motifs that occasionally appear in Western art.

Buddhist Paradise Sects

The Buddhist Paradise sects responsible for the change in representation of the Buddha between the period of the Yungang caves and those at Longmen (see Chapter 4) fostered new pictorial imagery in painting. Spectacular examples of paradise iconography from the eighth century have been found in caves at Dunhuang. Nearly 1,000 miles (1,600 km) west of Yungang, the Dunhuang oasis was the easternmost stop on the Silk Road in central Asia (see map, page 63).

Buddha Preaching the Law (fig. **6.1**) from Cave 17 at Dunhuang shows the rich, bright colors used to express the wealth of Amitabha's Great Western Paradise. The

Buddha sits cross-legged under an elaborate canopy on a lotus throne, which symbolizes nirvana, his blue hair contrasting sharply with the bright orange of his robe. Four elegantly attired bodhisattvas sit at the corners of his throne. Behind the Buddha, to the left and right, are two sets of three monks who appear to turn in space. Their small size indicates their lesser status, and three of the six reinforce the Buddha's central position and iconic quality by focusing their gaze on him. The tiny female donor in the lower left corner had a male counterpart on the right, but all that remains is his hat.

Among the doctrines related to the Paradise sects was Tiantai, according to which everyone could achieve buddhahood. This belief derived from the Lotus Sutra's doctrine that faith, rather than deeds, could lead to salvation. The silk embroidery of *Shakyamuni Buddha Preaching on Vulture Peak* (fig. **6.2**) depicts the Buddha propounding the Tiantai Law as described in the Lotus Sutra. He stands under a canopy on a small lotus throne, surrounded by a mandorla, against a backdrop of rocks representing Vulture Peak. Two bodhisattvas stand on either side of him, with a pair of small lion guardians below. At the bottom of the image are tiny figures of donors.

The Pagoda

The interiors of many of the Yungang and Dunhuang caves contained multistoried towers. These became the characteristic Buddhist structure of the Far East (China, Korea, and Japan; also known as East Asia). Beginning in the seventh century, **pagodas**—as they were called by the Portuguese living in India—were a synthesis of Indian stupas and Chinese military watchtowers. Like stupas, pagodas have a reliquary function and a setting that leaves

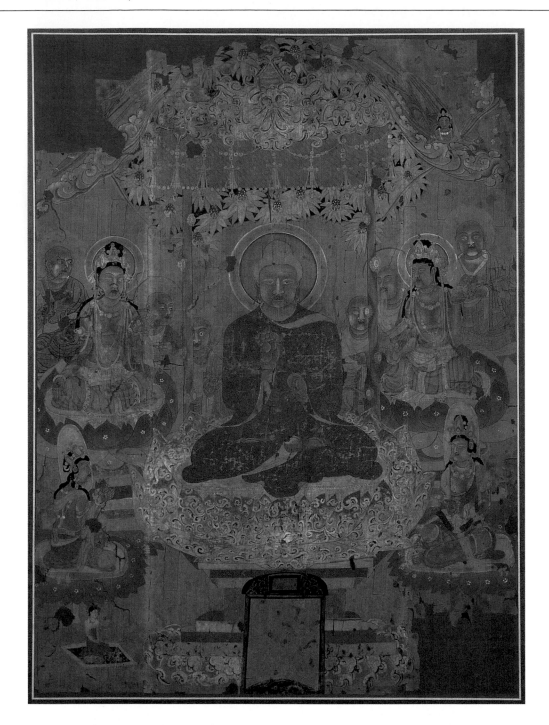

6.1 *Buddha* (*Shakyamuni or Amitabha*) *Preaching the Law,* Cave 17, Dunhuang, Gansu Province, China, early 8th century. Ink and colors on silk; 11 ft. 6 in. (3.50 m) high. British Museum, London. Both this Buddha image and the one in figure 6.2 were part of an important cache of manuscripts and art hidden by the monks of Dunhuang in the 11th century. It was discovered in 1907–1908 by Sir Aurel Stein, an English archaeologist, who sent as much of the hoard as he could to the British Museum in London. Many such banners were apparently produced in monastery workshops. They were sold to pilgrims as offerings to be laid in Dunhuang's famous Caves of the Thousand Buddhas. The blank space at the bottom of each image was intended for its donor's customized dedication inscription.

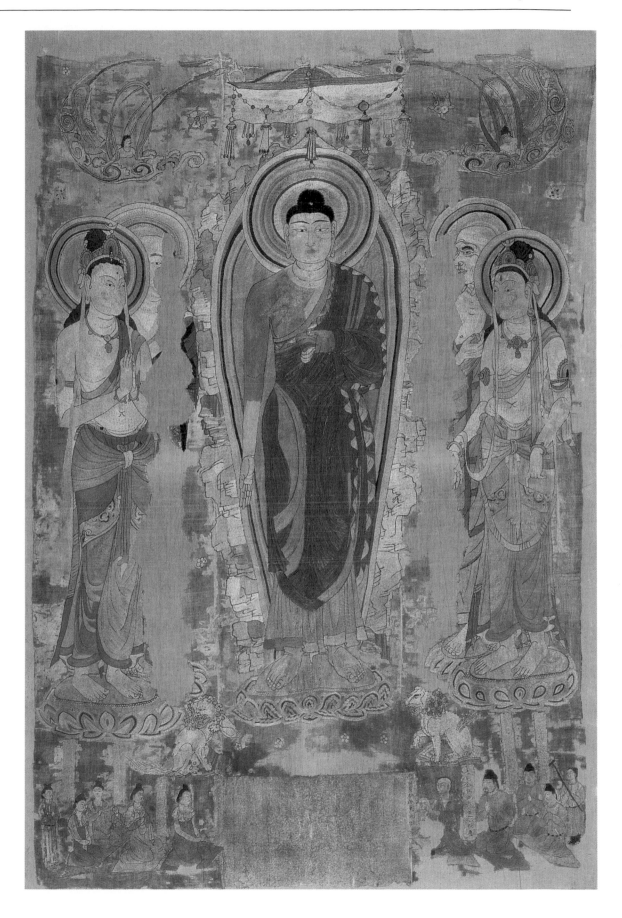

6.2 *Shakyamuni Buddha Preaching on Vulture Peak,* Cave 17, Dunhuang, Gansu Province, China, 8th century. Silk embroidery; 20 ft. (6.09 m) high. British Museum, London. This large image, created entirely of fine stitches in silk thread, demonstrates the high level of skill attained by Chinese embroiderers in rendering three-dimensional forms.

enough space for worshipers to circumambulate them, although later Far Eastern pagodas can actually be entered. The pagoda was conceived in sections that were stacked one on top of the other and tapered toward the top. Each section had an eavelike cornice projecting over it. A pyramidal form at the top was surmounted by a vertical element symbolizing the axis pillar of the World Mountain. Inside the caves, these spires merged into the roof.

The pagoda, a towerlike, freestanding structure, was made of wood, brick, or stone in several variations on the basic form. Some types were extremely elaborate. The individual tiers ranged from two to fifteen in number, although seven was standard. An early eighth-century pagoda with nine tiers is illustrated in figure **6.3**, while the mid-eleventh-century example in figure **6.4** has thirteen.

Very little early Chinese architecture survives, but its descendants are found elsewhere in the Far East. From early on, the pagoda was assimilated throughout East Asia into Buddhist architectural complexes, especially monas-

teries. Besides signifying the spiritual force of Buddhism, the pagoda was also believed to represent the passage of time. Relics embodied the past, the structure itself stood for the present, and its height signified the future aspirations of faith.

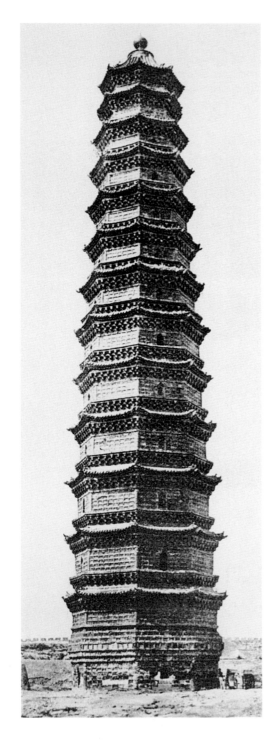

6.3 Pagoda, Yunshusu, Mount Fang, Hebei, China, early 8th century.

6.4 Pagoda, Kaifeng, Henan Province, China, mid-11th century.

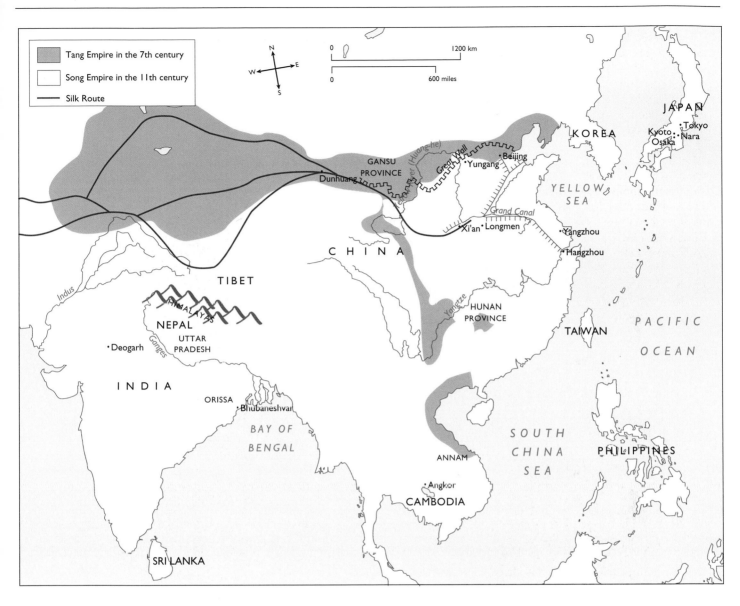

Map of East Asia.

The Buddhist Monastery: Horyu-ji

Buddhism reached Japan from China through images and sutras sent by the Korean kingdom of Pakche in the middle of the sixth century. Chinese culture was of great interest to Japan at the time. The imported religion flourished under the patronage of Japan's first great leader, Prince Shotoku (574–622). He founded what became the monastery of Horyu-ji (*ji* meaning "temple") in Nara (which from 710 to 784 was the capital of Japan), 25 miles (40 km) east of Osaka.

Horyu-ji's five-tiered pagoda (*Goju-no-to*), dating from the late seventh century, is a good example of a pagoda in a monastic community (fig. **6.5**). The gently sloping hills on the outskirts of Nara provide a natural enclosure for the monastery complex (fig. **6.6**), which not only is the earliest surviving Buddhist architectural group in Japan, but also includes the oldest wooden temple in the world. In addition to the pagoda, the small complex consisted of a **kondo** (the Golden Hall containing the golden image of worship; fig. **6.7**), a cloister, temples, living quarters for the monks, and a gate. The complex was arranged on an east–west axis that ran from the gate, between the *kondo* and the pagoda, to a refectory (now destroyed). The pagoda faces the *kondo,* creating a balance of asymmetrical structures.

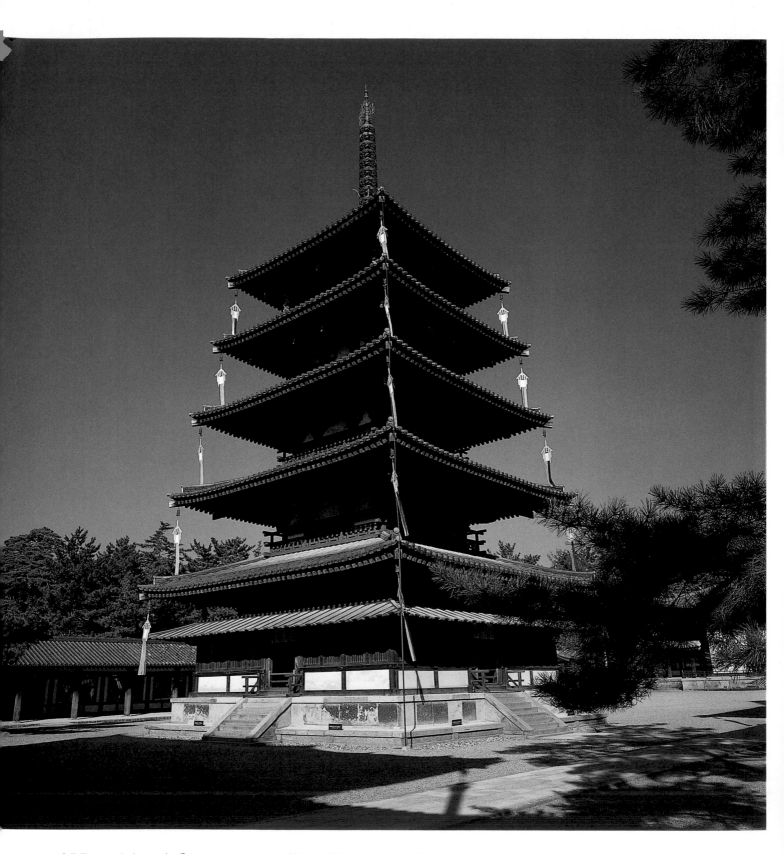

6.5 Five-storied pagoda, *Goju-no-to*, monastery of Horyu-ji, Nara, Japan, late 7th century.

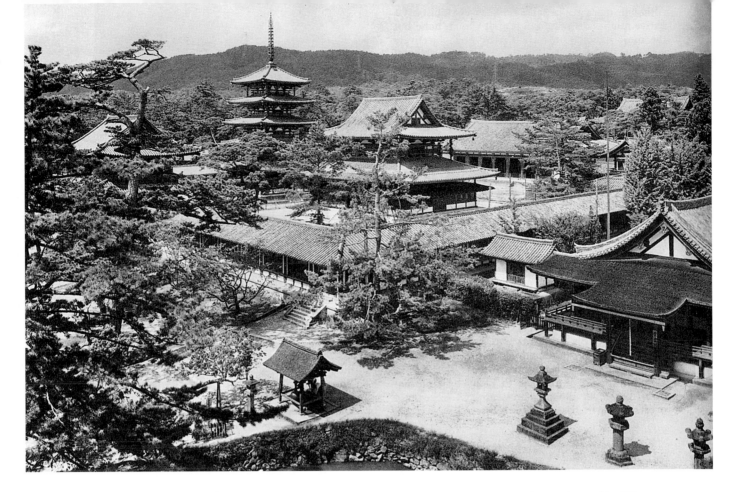

6.6 View of the monastery of Horyu-ji, Nara, Japan, late 7th century. Prince Shotoku's original temple complex was burned in 670 and rebuilt nearby as the monastery of Horyu-ji.

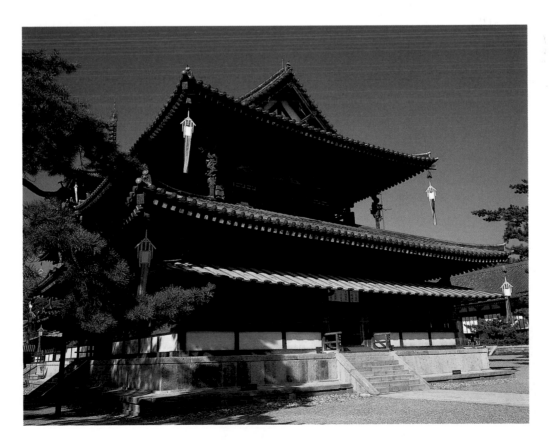

6.7 *Kondo* (Golden Hall), Horyu-ji, Nara, Japan, late 7th century.

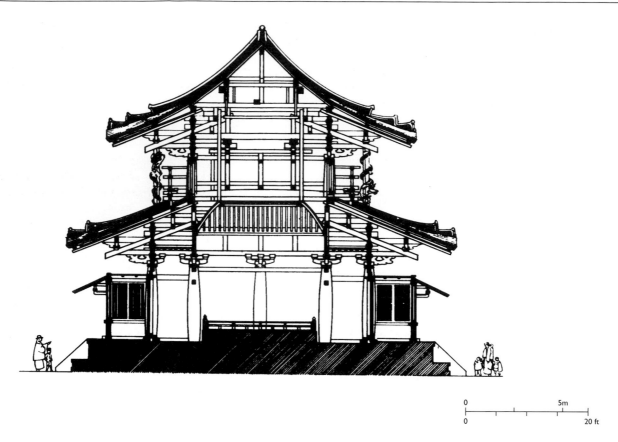

0 5m
0 20 ft

6.8 Diagram section of the Horyu-ji *kondo.*

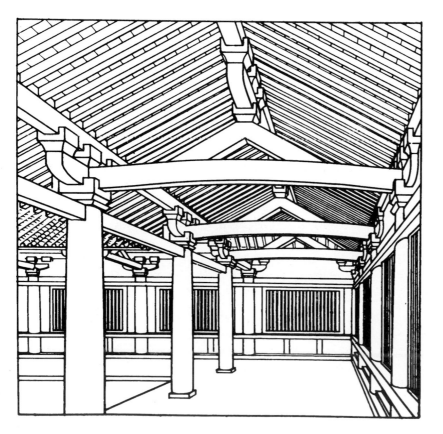

The *kondo* (fig. 6.7), also derived from a Chinese building type, is supported by a stone plinth oriented to the cardinal points of the compass. Stairs at the center of each side lead to double doors. The basic elevation is post-and-lintel, with the lintel inserted into the upper part of the post (figs. **6.8** and **6.9**). The points where post and lintel join are reinforced by brackets decorated with carvings. Such brackets channeled the thrust of the tile roof through the wooden posts and into the main foundation supports, and remained a strong design element in later Japanese architecture. By making the inner posts taller than those at the ends, it was possible to create a curved roof supported by the extended (**cantilevered**) lintels.

6.9 Drawing of part of the Horyu-ji *kondo;* gallery, showing post-and-lintel construction.

The Hindu Temple

The roots of Hinduism (see box) predated Buddhism in South Asia by some 1,500 years, and the newer faith borrowed many ideas and artistic motifs from the older one. Hinduism also spread to other regions, particularly to Southeast Asia, although to a lesser degree than Buddhism.

The earliest sacred structures on the Indian subcontinent may have been *vedikas* (railings) that surrounded trees and stones to mark places of spiritual significance. As Vedic religion developed, Brahmin priests constructed temporary open-air fire altars according to a strict geometric system. Hindu temple architecture evolved from these two traditions. (While fire altars are rarely built

Hinduism

Hinduism is the only major religion without a founder, being based on an accumulation of sacred and devotional texts, myths, rituals, and practices. Its origins lie somewhere in the second millennium B.C., following the Aryan invasion of the Indian subcontinent. Hindus conceive of the universe as cyclical, destroyed by fire, and dissolving into the ocean at the end of each cosmic age, to be reborn again and again. This universe is conceived of as an egg, separated into three regions where gods, humans, and demons—the forces of order on the one hand and of chaos on the other—battle for control. Hinduism recognizes this cosmic struggle as a necessary, even desirable, search for balance between opposing forces.

The Hindu gods appear in many manifestations, and in art the varied iconography of a single deity represents its different aspects. Often, like Vishnu (see fig. 6.12), the gods are represented with multiple limbs and heads as a sign of their superhuman powers. Each deity is believed to embody a truth that transcends its physical guise, and images are a conduit for bringing the divine world into contact with the human. By making sculptures of the gods beautiful—following certain canons of proportion and form, clothing and anointing the figures, and so forth—deities can be induced to inhabit their representations. Priests chant in Sanskrit, the sacred language of Hinduism, pray, and make offerings to attract the gods.

The Hindu pantheon is vast and includes deities assimilated from indigenous nature cults (such as *Yakshas* and *Yakshis*), as well as from early Aryan religion. The abode of the gods is Mount Meru, the central World Mountain whose axis links earth to heaven. A trio of male gods is responsible for the great cycles of cosmic time: Brahma (the Creator), Vishnu (the Preserver), and Shiva (the Destroyer). Each has a powerful female energy, his *shakti*. While Hindus identify themselves as either Vaishnavite or Shaivite (devotees of Vishnu or Shiva, respectively), they honor multiple deities.

Embodying the multiplicity characteristic of Hinduism, Shiva is both destructive and creative. He is associated with male sexual energy and procreation (worshiped in the form of a *lingam*, or phallus, or in anthropomorphic guise astride his bull, Nandi), as well as with asceticism and sacred texts (in the form of a meditating yogi with matted hair, clad in an animal skin). He is the three-eyed lord of the beasts and of the battlefield (symbolized by his trident), and patron god of the arts. His consort is Uma, daughter of the Himalaya Mountains. Their elephant-headed, pot-bellied son Ganesh is popularly worshiped as the remover of obstacles.

Vishnu keeps the universe in equilibrium. According to the creation myth illustrated in figure 6.12, he dreams the plan of the universe at the beginning of each cycle of existence—hence, we are living Vishnu's dream, and what we perceive as reality is actually illusion. Vishnu has ten *avatars,* or manifestations, among them a fish, tortoise, boar, man-lion, a dwarf who encompasses the universe in three strides, and Rama, the hero of the *Ramayana* epic. (Hanuman, a monkey-general who helps Rama, is a popular god.) Vishnu's best-loved *avatar* is Krishna, the blue-skinned, flute-playing erotic trickster god. In each of these forms, Vishnu saves the world from destruction by demons. To upstage Buddhism, its younger rival, Hinduism, incorporated the Buddha as another *avatar* of Vishnu.

Among Hinduism's many important female deities are Sarasvati (goddess of learning) and Lakshmi (goddess of fortune). The holy rivers Ganga (Ganges) and Yamuna (Jumna) are worshiped as fertility goddesses. Collectively, Hindu goddesses may be thought of as embodying aspects of Devi, the Great Mother. Like Shiva, Devi is both creative and destructive: she is a voluptuous, maternal nurturer, and she is also Kali, the skeletal, bloodthirsty hag who eats children; she is both a subservient consort of a male god and Durga, the superwarrior whose strength combines that of the male gods to defeat an otherwise invincible Buffalo Demon. Devi is also worshiped in the ancient form of the Sapta Matrikas, the Seven Mothers. She is closely associated with nature and fertility, and is sometimes represented as a *yoni* (female sex organ) encircling a *lingam*, thus symbolizing the conjunction of female and male energies. Outside mainstream Hinduism, goddess worship is a powerful force in esoteric Tantric sects (Buddhist as well as Hindu), whose practices may include ritual sexual intercourse and offering sacrificial animal blood to the goddess.

One of the central Hindu beliefs is reincarnation leading to *nirvana,* the ultimate release from the cycle of rebirth, when the soul unites with the cosmos. Each incarnation is a stage in the long journey toward liberation from this illusory world, and progress toward *nirvana* depends on *karma,* the quality of behavior in a current or previous life. While in the world, everyone is ruled by *Dharma,* the Law, in addition to which each hereditary social class (*varnas,* or caste) has its own code of conduct. Society is divided into an elite, ritually pure Brahmin caste, whose men are traditionally priests; a warrior and ruler Kshatriya caste; an artisan and merchant Vaishya caste; and a peasant Shudra caste. Those beneath caste, considered ritually polluted, were known as Untouchables until they were renamed Harijans (Children of God) by Mahatma Gandhi (1869–1948) in an attempt to improve their social status. While hereditary caste is no longer all-important in the lives of Hindus, one must still be born Hindu in order to be Hindu.

today, the ancient practice of worshiping at very simple outdoor shrines continues.)

The highly sophisticated mathematics of Hindu temples was codified in texts called *Shilpa shastras,* in which temples were conceptualized as both anthropomorphic forms and as mandalas (cosmic diagrams connecting the human world with the celestial). The temples are believed to concentrate divine energy and anchor sacred space along a world axis.

Basically, Hindu temples are houses for deities. Images abound, and worship takes place throughout temple precincts. A temple's main cult image is contained within its inner sanctuary, or **garbha griha** (literally "womb chamber"), which is a small, windowless, cube-shaped *cella.* This dark, intimate space is typically perfumed by incense and lit by the glow of oil lamps. Priests and worshipers perform *puja,* or devotions. The protective, womblike function of the Hindu temple is reflected by the thickness of the ceiling and the *cella* walls.

Hindu worship is not congregational in the Western sense. Instead, priests perform elaborate sacred rites on behalf of their communities. *Puja* at a temple begins with the sunrise, when a priest opens the chamber of the "womb" and salutes the door guardians. In a ritual involving all the senses, he sounds a bell and claps to expel negative spirits, arouse the deity or deities, and announce his presence. He then chants hymns and *mantras* (ritual sacred formulae), accompanied by *mudras* (symbolic hand gestures). Vessels are readied for the cleansing and dressing of images, which are anointed, draped with garlands, and offered specially prepared food. When the priest has completed his ceremonial duties, he circumambulates the statue clockwise, bows, and leaves the sanctuary.

For Hindus, the temple was one stop on a long metaphorical journey in the quest for spiritual perfection. In the course of this journey, worshipers progress from a large to a small space, from natural light to a dark interior, and from the illusory complexities of the material world to spiritual simplicity.

These beliefs are reflected in the concepts underlying temple construction. First, a sacred site is chosen—a grove for its links to early tree cults, a river for its life-giving water, or a mountain by association with Mount Meru. Several years are then dedicated to purifying the ground and ridding it of evil and impure spirits. Sacred cows graze on the site in order to enhance its fertility. The ground plan is thought of as a mandala, which maps divine space. This is a geometric "picture" of the pantheon and a miniature manifestation of the cosmos in which the temple represents Mount Meru. After its plan has been laid out, a temple's proportions are arranged according to a unit of measurement deemed to be in alignment with cosmic harmony. Finally, foundation stones are placed in the ground, and construction begins (see box).

The materials of which Hindu temples are built, like the Hindu social structure, were conceived of hierarchically in the early *Shilpa shastras.* Some recommended stone and wood for the higher classes of society, while others related materials to gender. Generally, however, most Hindu temples were of stone, and the color of the stone was associated with a particular caste—white being reserved for Brahmins. Either stone was quarried and bricks baked near a building site, or the materials were floated to the site on barges or brought on wood rollers by elephants. Stone blocks were shaped by masons and hauled onto the structure by a pulley system. They were then held in place with iron clamps. In what remained basically a post-and-lintel elevation system, Hindu temples had projecting lintels made possible by the strength of the clamps. The main supporting elements were stone columns, and doors were

The Hindu Artist

For Hindus, art is an expression that transcends the individual artist. The creation of religious art is both a hereditary vocation and an act of devotion, an offering to the gods. Hindu artistic activity centers around temples, much as the cathedral towns of medieval Europe were a focus of Christian artistic production. Some Hindu artists were organized into guilds, which tended to be composed of family groups and within which skills were passed from one generation to the next. The guilds set ethical and artistic standards as well as rules regulating the lives of their members. They set prices and arranged contracts. Duties were strictly divided by rank, including those of the chief architect (*sutradhara*), the general overseer, the head stonemason, and head image maker (sculptor). Each supervised a particular group of workers. Brahmins, who were expert in art theory and iconography, were in charge of quality and content. The Vaishyas under them were regarded as skilled laborers.

Artists and their families who lived and worked at temple sites were so numerous that thriving communities grew up around them. Since temples were the intellectual as well as spiritual centers of their communities, schools were established, and festivals were held in their vicinity.

The financing of Hindu temple construction was primarily in the hands of royal patrons. It was supported by donations of money, cattle (sacred to Hindus), objects of value, land grants, and services from others. Contributions to temples were partly motivated by the donor's hope of accumulating good *karma* and of receiving divine assistance. Since Hindu temples amassed considerable wealth, which included land, they became major employers and landlords. In southern India, there are vast temple complexes that were once cities within cities, employing hundreds of specialized artists.

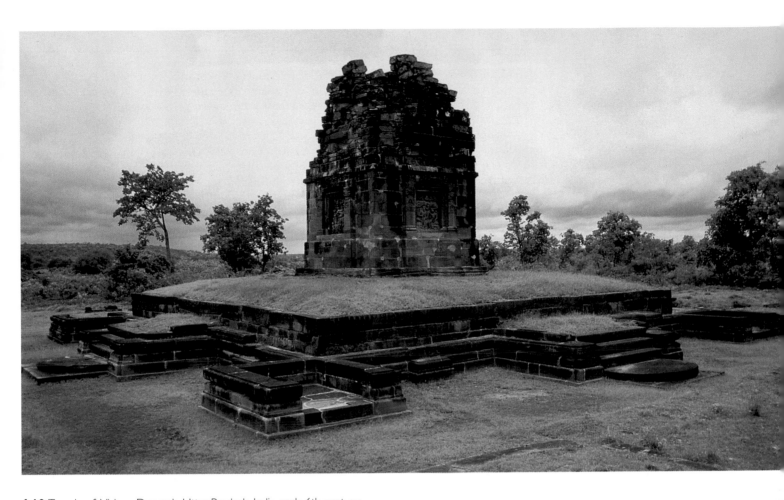

6.10 Temple of Vishnu, Deogarh, Uttar Pradesh, India, early 6th century.

of wood. Window bars were stone copies of wooden prototypes. Hindu temple architecture is characterized by a wealth of regional variations on two general temple types—the northern and southern—differing primarily in the forms of their towers.

The Vishnu Temple (6th Century)

The early sixth-century Temple of Vishnu at Deogarh, in Uttar Pradesh (figs. **6.10** and **6.11**), exemplifies early northern-style Hindu temples. This relatively simple, one-chambered structure was crowned by a **shikhara** (northern-style tower), most of which is now in ruins. Its cubic *garbha griha* (sanctuary) stood on a raised plinth and was accessible by a stairway on each side. The dark corner rectangles on the plan mark lesser shrines dedicated to different gods. The temple's relief sculpture, with its rounded, rhythmically swaying forms, embodies the classic Gupta style. In the view shown here, one of the framed panels containing reliefs is visible.

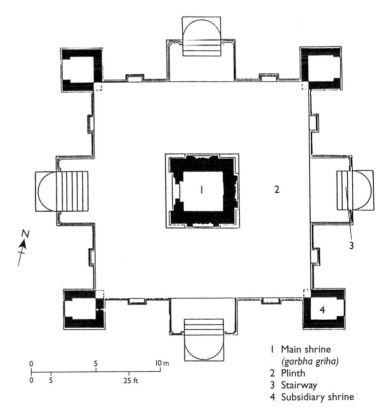

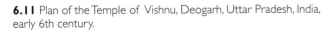

1 Main shrine
 (garbha griha)
2 Plinth
3 Stairway
4 Subsidiary shrine

6.11 Plan of the Temple of Vishnu, Deogarh, Uttar Pradesh, India, early 6th century.

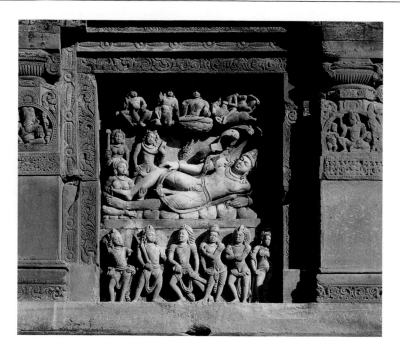

6.12 *Vishnu Sleeping on Ananta,* relief panel, south side, Temple of Vishnu, Deogarh, Uttar Pradesh, India, early 6th century.

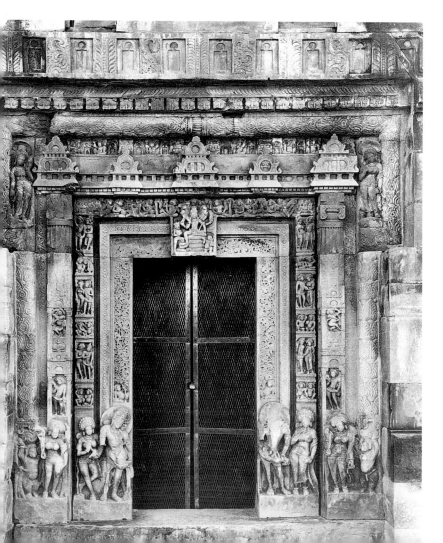

The relief panel of *Vishnu Sleeping on Ananta* (fig. **6.12**), on the south side, depicts the origin of the universe and the forces of evil within it. The large reclining figure of Vishnu, whose four arms reflect his powers, dominates the image. Crowned and jeweled, he dreams the universe into existence as he sleeps on Ananta, the Endless Serpent encircling the world. Ananta's cobra hood frames the god's head. Holding Vishnu's foot is his wife, Lakshmi, the goddess of fortune. As his *shakti,* she represents his female nature, which energizes his male self to conceive of, and give birth to, the universe. Time is set in motion when a lotus flower emerges from Vishnu's navel. Among the gods at the top of the relief, the first deity, the four-headed Brahma, sits on the lotus. Holding the tools of a builder, he will construct the world. The four figures below Vishnu to the right represent the god's weapons and prepare to do battle against two demons, Madhu and Kaitabha, at the left. The demons were born from Vishnu's ear and tried to destroy Brahma, but Vishnu killed them instead.

The doorway at the west of the temple that leads to the *garbha griha* (fig. **6.13**) is framed by a series of elements. The lintels and door jambs are decorated with foliate reliefs and various theological guardians.

6.13 West doorway, Temple of Vishnu, Deogarh, Uttar Pradesh, India, early 6th century.

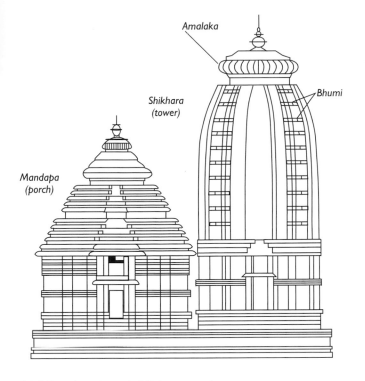

Amalaka

Shikhara
(tower)

Bhumi

Mandapa
(porch)

6.14 Elevation of a typical Orissan temple.

Within the upper corners, the river goddesses Ganga and Yamuna bless the sanctuary by pouring their waters over the threshold. Set in a square panel over the doorway is Vishnu enthroned on Ananta's coils. Here, as in the large relief on the south, Lakshmi strokes Vishnu's foot to stimulate his cosmic dream.

The Orissan Temple

(8th–13th Centuries)

By the eighth century, Hindu temples had become extremely complex structures. They varied according to period, region, patronage, and cult affiliation. From the eighth to the thirteenth centuries, Orissa, in eastern India, was a center of architectural development with a relatively consistent evolution of style. Figure **6.14** is a diagram of the elevation of a typical Orissan temple, which shows the extent to which architectural style had become elaborated.

The mid-tenth-century Mukteshvar Temple of Shiva at Bhubaneshvar (figs. **6.15** and **6.16**) illustrates the Orissan version of northern-style temple architecture. This is the

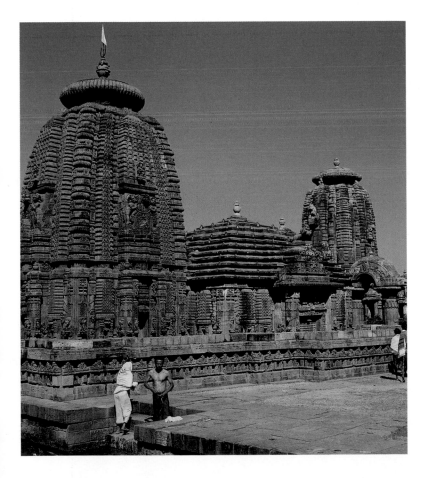

6.15 Mukteshvar Temple of Shiva, Bhubaneshvar, Orissa, India, c. 950. Sandstone. The temple compound is entered through a *torana* (gateway) on the right. Inside the *garbha griha* at the heart of the temple, the focus of worship is a Shiva *lingam* inside a *yoni* (see box, page 67). At the far left is a sacred water tank used for ritual bathing.

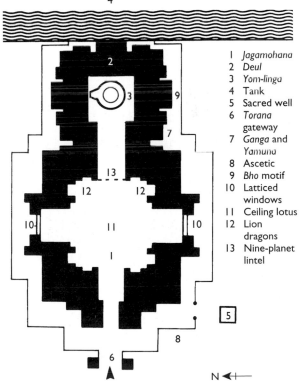

1 *Jagamohana*
2 *Deul*
3 *Yom-linga*
4 Tank
5 Sacred well
6 *Torana*
 gateway
7 *Ganga* and
 Yamuna
8 Ascetic
9 *Bho* motif
10 Latticed
 windows
11 Ceiling lotus
12 Lion
 dragons
13 Nine-planet
 lintel

6.16 Plan of Mukteshvar Temple of Shiva, Bhubaneshvar, Orissa, India, c. 950.

only one of India's famed "temple-cities" to survive. It originally had some seven thousand temples, of which about five hundred still exist, as do some of the *Shilpa shastras* on which they were based (see page 68). This view of the exterior shows the towering superstructure that rises over the *garbha griha*. The tower consists of a lobed *shikhara*, surmounted by an **amalaka** (the cushion shape below the finial). A porch (**mandapa**) has also been added. The projecting veranda was used for meditation and reading as well as for dancing and ceremonies. The slightly convex outline of the exterior, which has been referred to as "expanding form," is an architectural expression of *prana*. This small temple's vertical and horizontal planes are unified by the carved detail covering its surface. The repetition of stacked ridges (**bhumi**) on the superstructure is complemented by a rich variety of organic and abstract forms designed to welcome Shiva.

The meaning of these forms is associated with the Hindu concept of the temple as a manifestation of Mount Meru; the very term for the towers, *shikhara*, means "mountain peak." The term *bhumi*, meaning "earth" (in the sense of "soil"), has similar symbolic connections with landscape. The *amalaka* symbolizes the spiritual heights achieved when one transcends the reincarnation cycle. As an elaboration of the ancient Indian axis pillar, the finial was placed above the *garbha griha* so that the most sacred and highest points of the temple were in alignment.

Synthesis of Buddhism and Hinduism at Angkor

Both Hinduism and Buddhism spread from India to Southeast Asia and were assimilated into the local belief systems. Under the Khmer Empire (sixth to thirteenth century) in Cambodia, the main local contribution to the imported religions was the cult of the Devaraja (god-king), in which Hinduism and Buddhism merged. The royal Khmer capital city of Angkor was founded by the late ninth-century king, Indravarman. His rule was notable for the development of an irrigation system that made rice the economic backbone of Cambodia during the Khmer period. Under the patronage of Indravarman, characteristic Khmer architectural features were first established. These included royal temple complexes consisting of several buildings united in an axial plan. Relatively modest at first, these complexes grew in size and splendor as each Devaraja sought to outdo his predecessor.

Angkor Wat (12th Century)

In the twelfth century, Khmer architecture culminated in the massive complex of interconnected waterways, roadways, terraces, monastic buildings, and shrines called Angkor Wat (*wat* meaning "temple"). These were built in gray-black sandstone, under the patronage of Suryavarman II (ruled c. 1113–50), and dedicated to Vishnu. The temple's central icon depicted Suryavarman in the guise of Vishnu. The plan of the central complex (fig. 6.17) shows the characteristic rectangle arranged in an east–west orientation and concentric colonnaded galleries. An inner rectangle (fig. 6.18), three stories high, has five towered

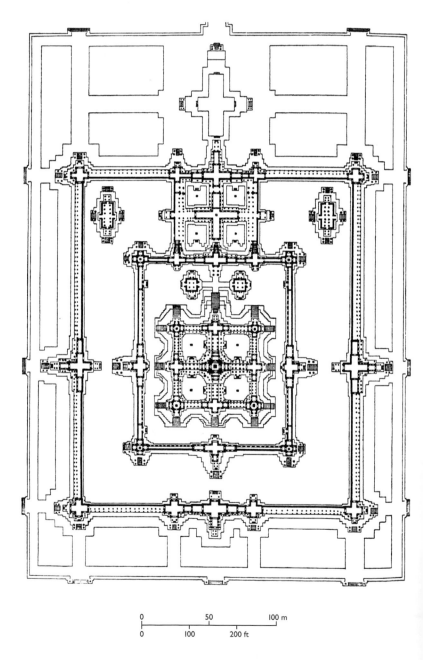

6.17 Plan of the central complex at Angkor Wat, Cambodia, c. 1113–1150.

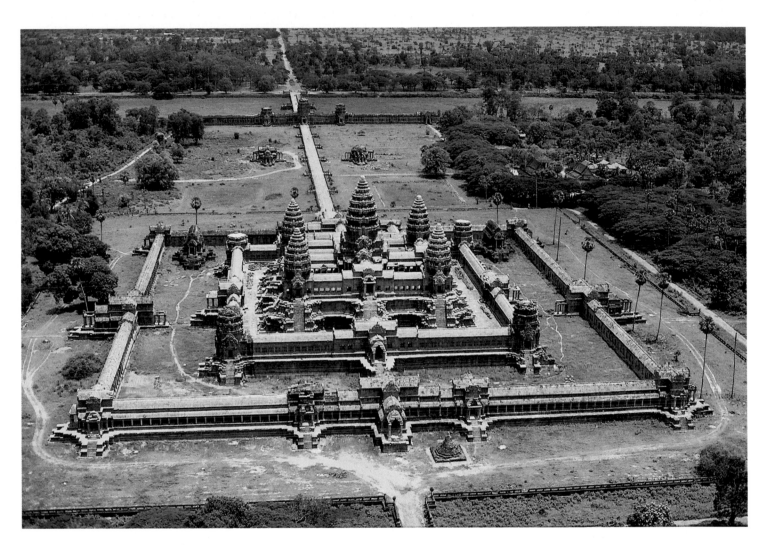

6.18 Aerial view of Angkor Wat, Cambodia.

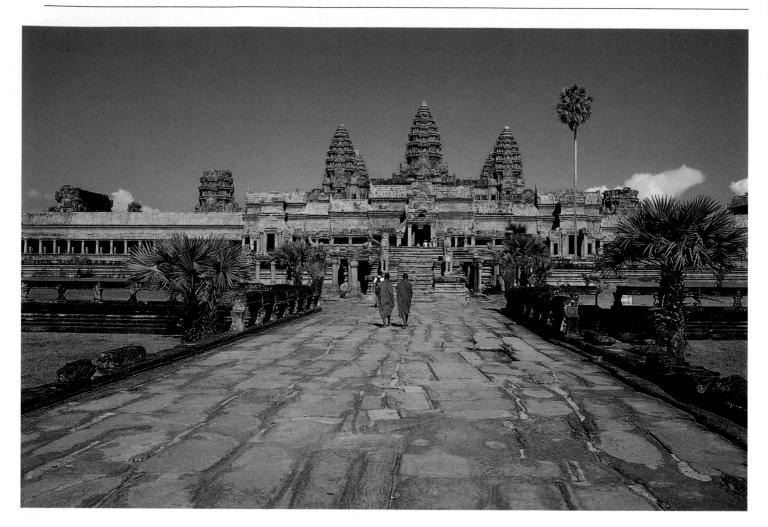

6.19 Roadway approaching Angkor Wat, Cambodia.

shrines and connecting colonnades accessible by stairways. At the focal point of this complex is the central temple, which stands for Mount Meru. Thus the entire conception is a two- and three-dimensional mandala of the cosmos. At the same time, the temple had a mortuary significance and was designed as a memorial to its patron. This is reflected in the frequent representations of the death god Yama in the relief sculptures covering the walls. In addition, the temple's unconventional orientation toward the west reinforces its association with death.

The main roadway leading to Angkor Wat (fig. **6.19**) is flanked by balustrades in the shape of giant water serpents, which are cosmic fertility symbols. There is elaborate surface decoration on the tall towers, with their flame-like motifs, and the supporting stone columns. As in Hindu temples, the towers at Angkor are tiered, overlaying a basic vertical plane with repeated horizontal bands. This repetition is broken only at the peaks, which, as in India, stand for the highest spiritual state of being.

Angkor Wat is covered with nearly 13,000 square feet (1,200 m²) of intricate relief sculpture. As on the towers, the low relief depicting an *Army on the March* (fig. **6.20**) is characterized by repetitive detail, which can be hypnotic in effect. The elephant-drawn chariot creates a formal counterpoint, its curves and diagonals combined with expansive forms.

An isocephalic frieze of celestral *Apsaras* (fig. **6.21**)— courtesans and dancers, probably water nymphs—adorns the exterior wall of a gallery. The figures provide a visual transition from the carved moldings to the plain wall and thus are integrated with the architecture. The *Apsaras* are portrayed dancing on short, horizontal platforms that repeat the projections of the molding. Each figure faces outward and appears to sway with the music. They seem to greet visitors with seductive grace, while also referring to the spiritual heights symbolized by the peaks of the towers. This synthesis of the spiritual with the erotic is characteristic of much Hindu sculpture, particularly at transition

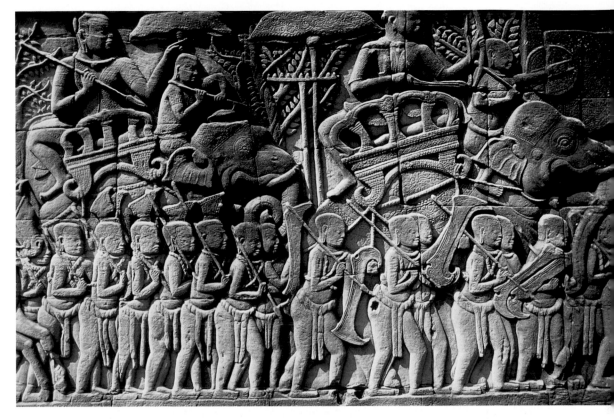

6.20 *Army on the March,* Angkor Wat, Cambodia, first half of 12th century. Sandstone.

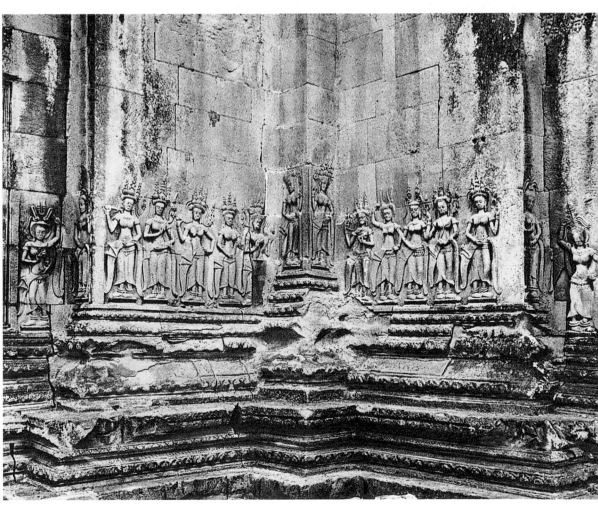

6.21 *Apsaras,* exterior wall of a gallery, Angkor Wat, Cambodia.

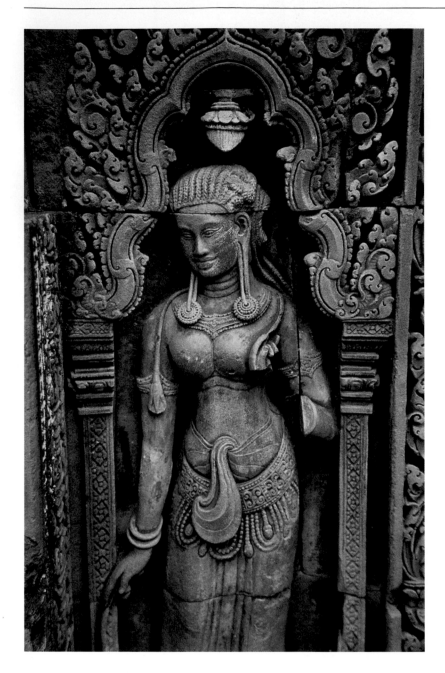

6.22 *"Water Nymph,"* detail of a frieze, Angkor Wat, Cambodia. Photo: © Daniel Entwistle.

points. The detail of the frieze (fig. **6.22**) shows one of the dancers, whose jewelry is carved in low-relief patterns that contrast with her voluptuous breasts and ample proportions. Echoing her S-shape pose are the framing arch and her belt.

Angkor Thom (13th Century)

Angkor was abandoned after being sacked by a neighboring ruler. By the beginning of the thirteenth century, the Buddhist Khmer king, Jayavarman VII (ruled 1181–1218), had planned a new capital and sacred precinct at the nearby Angkor Thom, meaning "Great Angkor" (fig. **6.23**). There, the city walls have huge gateways with towers on which monumental images of the Devaraja's face are

carved (fig. **6.24**). The most important temple at Angkor Thom, the Bayon, was Buddhist but also incorporated local ancestor cults. As at Angkor Wat, the Angkor Thom temple was intended to replicate the cosmic center and to identify it as the king's power base. The height of the large central tower (see fig. 6.23) is equal to its depth below ground, uniting the subterranean realm with earth and sky. Similarly, the wide moat around the complex was identified with the cosmic ocean. Jayavarman VII's huge face over the entrance proclaims his union with the mountain and his symbolic role as "king of the Mountain"—specifically, the king of Mount Meru.

The Buddhist era at Angkor was short-lived. With the death of Jayavarman VII and the subsequent decline of Angkor's importance, Hinduism was revived in Cambodia.

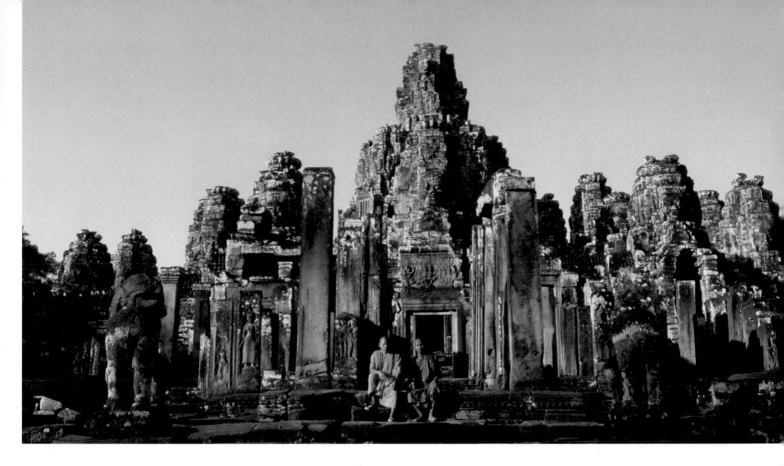

6.23 Bayon temple, Angkor Thom, Cambodia, c. 1200.

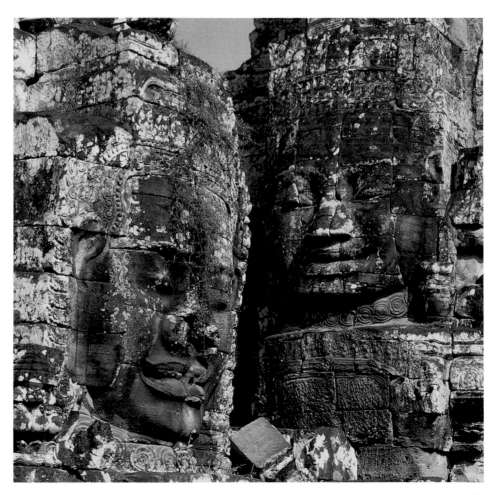

6.24 Towers with monumental faces of the Devaraja, Bayon, Angkor Thom, Cambodia.

7

Mesoamerica and the Andes (1500 B.C.–A.D. 1500)

The Americas were isolated from the rest of the world by vast oceans, and to date there is scant archaeological evidence of contact. However, there are intriguing formal and conceptual similarities, as well as significant differences, between the cultures of the Americas and other civilizations contemporary with them.

The origins of the Native Americans have been traced to the arrival of Paleolithic peoples from Siberia to Alaska over a landmass (now the Bering Strait) that connected them during the last Ice Age. During the Paleolithic era, migrations to the south from the far north (Alaska and Canada) led to settlements in North and South America. By around 9000 B.C. or earlier, human culture had spread to the southernmost tip of South America. It was not until the fifteenth century that explorers, including Columbus, traveled to the Americas. With their subsequent conquest by Spain in the sixteenth century, many American civilizations were destroyed. The European invaders (particularly the Spanish) affected some of these cultures to such an extent that scholars now divide their history into pre-Columbian and post-conquest periods.

Mesoamerica

The arts of three major civilizations from Mesoamerica—the landmass connecting North and South America—are outlined here. These are Olmec, Teotihuacán, and Maya. Mesoamerica stretches from northern Mexico to Panama and includes the province in Mexico of the Yucatán, Belize, Guatemala, Honduras, and El Salvador (see maps). The archaeology of the region is in a state of flux, although advances have been made in deciphering Mesoamerican writing systems since the 1960s. Nevertheless, the complex nature of these civilizations remains little understood.

The history of the region has been divided into three major phases: the Preclassic (or Formative), c. 2000 B.C. to A.D. 250/300; the Classic, c. 300 to 900; and the Postclassic, 900 to 1521. As elsewhere, a period of hunting and gathering (c. 11,000–7500 B.C.) preceded the development of agriculture, monumental stone architecture, and the organization of villages into social and political hierarchies. Examples of pottery as well as of figurines that probably served a fertility function survive from around 1800 B.C. By Late Preclassic, there is evidence of urbanization; temples were constructed on pyramidal platforms, and stone monuments containing portraits and inscriptions were carved.

Although Mesoamerica produced culturally distinctive civilizations and correspondingly distinct styles of art and architecture, certain important similarities appear in several of them. These include the development of (base 20) mathematics, an understanding of astronomy, hieroglyphic writing, books made of fig-bark paper or deerskin, and a complex calendar. The religions were polytheistic, requiring offerings to the gods, bloodletting rituals, and human sacrifice. One of the most intriguing Mesoamerican practices was a ritual ball game, which was played on a large rectangular court. As in modern soccer, players were not supposed to touch the ball with their hands. The movements of the ball were symbolic, apparently conceived of in relation to the sun and moon. Often, captives were forced to play, and losers, according to some scholars, could be sacrificed to the gods.

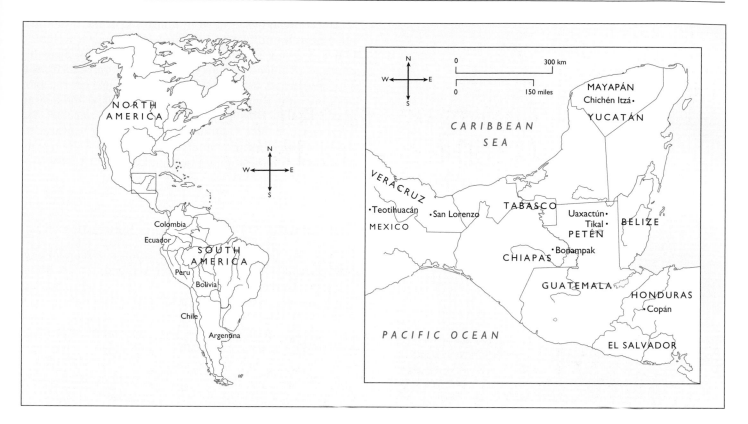

Map of Mesoamerica in relation to North and South America.

Map of Mesoamerica.

Olmec (Flourished c. 1200–900 B.C.)

The Olmec civilization, located in present-day Mexico, dates from Early to Middle Preclassic and had a lasting influence on the entire region. As in other areas of Mesoamerica, by around 900 B.C. Olmec society was stratified into a class of commoners and a ruling elite. The elite maintained a flourishing trade in exotic goods that were symbols of authority and status, especially jade, obsidian, and iron pyrites (used for mirrors). Most of the population were farmers who supported the priests and rulers with labor and goods.

Monumental stone sculptures of basalt such as the *Seated Jaguar* (fig. **7.1**) were produced at San Lorenzo in Veracruz, the oldest known Olmec site. The solid, blocklike forms remain characteristic of Mesoamerican art well into the Late Classic period. Merging with the features of a jaguar—an animal indigenous to Mesoamerica and important in its mythology—is the physiognomy of a human child. The hands and feet are pawlike, but the pose and upright posture are human. Such combinations of human with animal elements are first seen in Olmec sculpture and continue in later Mesoamerican art.

7.1 *Seated Jaguar*, San Lorenzo, Veracruz, Mexico, Olmec, Early Preclassic, 1200–900 B.C. Basalt; 35½ in. (90 cm) high. Because this figure seems to be shedding tears, it is believed to be an aspect of a rain god or a water deity. Elsewhere in Mesoamerica, the jaguar is the god of the underworld. This figure was found by an underground canal, which suggests its connection to a water cult.

7.2 Colossal head, from San Lorenzo, Veracruz, Mexico, Olmec, c. 1000 B.C. Basalt; 70⅞ in. (180 cm) high. Museo Regional de Veracruz, Jalapa, Mexico.

The colossal basalt head in figure **7.2** is one of ten that have been found at San Lorenzo. These heads, weighing between 5 and 20 tons, representing males, are probably portraits of individual rulers. The fleshy, organic faces usually have broad, flat noses and thick lips; also characteristic is the tight, domed headdress with earflaps and a strap under the chin. Most of these colossal heads were defaced and buried. Similar sculptures are found at La Venta, a site that flourished from around 900 to 400 B.C., along with monumental public architecture and elaborate tombs containing jade offerings.

Teotihuacán (Flourished c. 350–650)

By A.D. 200, Teotihuacán had become a commercial city-state specializing in the manufacture of stone tools (especially of obsidian) and pottery. Between c. 350 and 650, Teotihuacán was the biggest and most influential city anywhere in the Americas. It spread over an area of 8 square miles (20.7 sq. km) and supported a population of as many as 200,000. The later Aztec culture dominated the region at the time of the Spanish conquest and attached mythical importance to the great ruins of Teotihuacán (an Aztec name, as are the names of many of the gods).

The most significant architecture at Teotihuacán was the ceremonial complex (figs. **7.3** and **7.4**). aligned with the Avenue of the Dead, which was 3 miles (4.8 km) long. The largest structure, called the Pyramid of the Sun by the

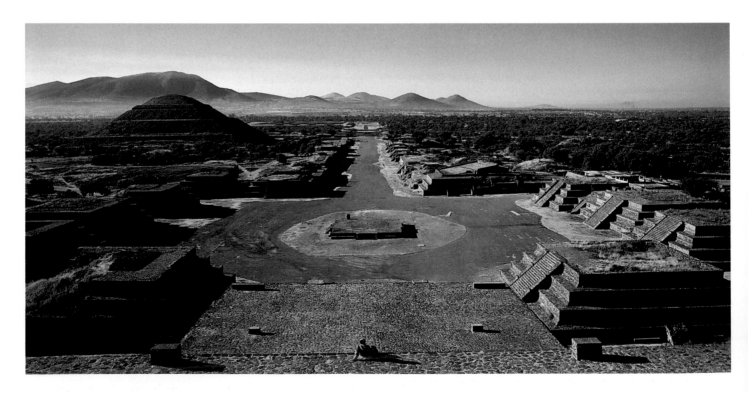

7.3 View of Teotihuacán, c. 350–650. The Pyramid of the Sun as seen from the Pyramid of the Moon, Teotihuacán c. 350–650. Square base over 700 ft. (213 m) per side; over 210 ft. (64 m) high; 1,700,400 cubic yards (1.3 million m³) volume. The Moon Pyramid is somewhat smaller with a height of 130 ft. (39.60 m) and a base of 400 × 500 ft. (122 × 152 m).

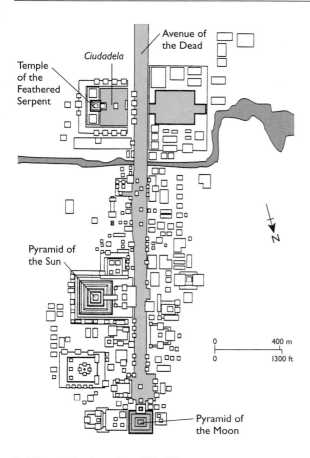

7.4 Plan of Teotihuacán, c. 350–650.

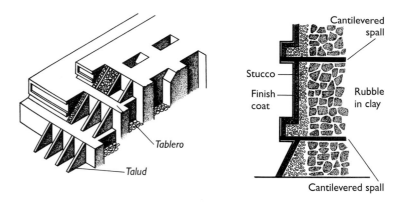

7.5 Diagrams of a *talud-tablero* platform.

Aztecs, was to the east of the avenue, near its center (see fig. 7.3). A stairway on the west side led to a platform at the top. This supported a two-room temple that has since disappeared. The slightly smaller Pyramid of the Moon was located at the north end of the avenue. Toward the southern end was the *Ciudadela*, or citadel, a square large enough for crowds of 60,000 that functioned as the religious and political center of Teotihuacán.

Surrounding the *Ciudadela* were temple platforms constructed in **talud-tablero** style (fig. **7.5**). This style is typical of Teotihuacán architecture: the *tablero* is the framed vertical element built above a sloping base, or *talud*. The platform façades were faced with painted stucco. The cores of the platforms were reinforced with stone piers and filled with rubble embedded in clay.

Excavations at the *Ciudadela* have revealed dramatic monumental painted reliefs on the façade of a temple platform dedicated to the Feathered Serpent (called Quetzalcoatl by the Aztecs). The detail in figure **7.6** shows massive, blocklike serpent heads with bared fangs, surrounded by a circle of feathers. They alternate with heads of Tlaloc, the rain god. Both are carved frontally, and their fixed gazes are reinforced by their wide, round eyes. The stylized geometry of these figures is characteristic of figural imagery at Teotihuacán, but the exact meaning of their iconography is not known.

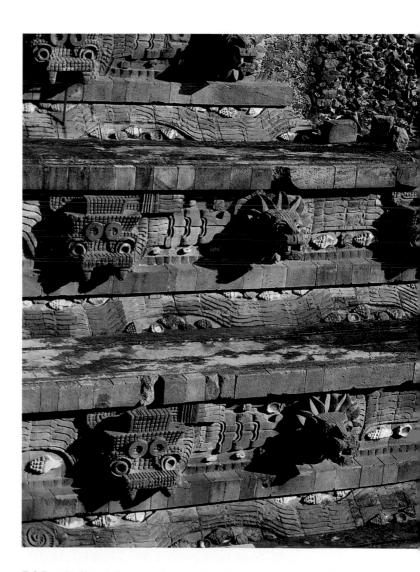

7.6 Detail of heads from the façade of the Temple of Quetzalcoatl, Teotihuacán, before 300. Painted relief. Skeletons of eighty men dressed as soldiers were found beneath this temple, possibly further evidence of human sacrifice in Mesoamerica.

That Tlaloc may have served an apotropaic function is suggested by his role—like that of the Western Gorgoneion—as a shield device. As such, he appears on a stele found at the Classic Maya site of Tikal, carved with the representation of a warrior in Teotihuacán costume (fig. **7.7**), which may indicate the widespread influence of Teotihuacán. Dressed in full regalia with an elaborate feathered helmet and a shell necklace, he carries a shield decorated with the face of Tlaloc. The warrior is depicted with his head in profile and his torso slightly turned. But his shield is frontal, like the gods on the temple of Quetzalcoatl in the *Ciudadela,* and the image of Tlaloc therefore confronts viewers with a direct, and symbolically protective, gaze.

Around 650 to 750, the architectural complex along the Avenue of the Dead was burned, possibly by invaders, and the thriving city of Teotihuacán fell into decline. Its culture was kept alive, however, particularly through Aztec legends, and continued to influence the art and architecture of Mesoamerica for centuries.

Maya (c. 1100 B.C.–A.D. 1500)

Maya civilization originated in the southern part of Mesoamerica and lasted until its destruction in the sixteenth century. It occupied eastern Mexico (particularly the Yucatán, Tabasco, and Chiapas), Belize, Guatemala, and the west of Honduras and El Salvador.

Maya culture developed not only the most complex writing system in Mesoamerica, but also a sophisticated knowledge of mathematics and methods of observing celestial phenomena, recorded in books made from strips of bark paper (see box). The Maya created many important political and religious centers, each populated by an elite class of rulers, priests, and nobles, supported by a far more numerous class of farmers and artisans.

Hereditary rulers were theocratic—that is, their claim to power rested on establishing a connection with the gods (see box, page 83, below right). A wood carving from Tabasco of a *Maya Lord* (fig. **7.9**), wearing a skirt and an elaborate necklace, kneels in a ritual pose. The Maya shared the pervasive Mesoamerican belief that the gods had given people their own blood when they created them. The gods thus had to be repaid in kind with human blood, and elaborate rites were performed in which rulers let their own blood—but only slightly—as a sign of their identification with the gods. The fate of their captives, however, was not as benign. Typically, four men would each hold a limb of the captive, while a fifth cut out the heart.

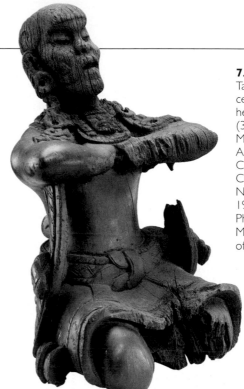

7.9 *Maya Lord,* from Tabasco, Mexico, 6th century. Wood with hematite pigment; 14 in. (35.5 cm) high. Metropolitan Museum of Art, New York. Michael C. Rockefeller Memorial Collection. Bequest of Nelson A. Rockefeller, 1979 (1979.206.1063). Photograph © 1980 Metropolitan Museum of Art.

The Maya Calendar

Several calendrical systems were developed by the Maya, all of them intimately related to seasonal change and astronomical phenomena. They were used in the service of religious rituals, ceremonies, and festivals. One of the most intriguing creations is the calendar round of fifty-two years, which developed in the Late Preclassic period (300 B.C.–A.D. 250).

Two time cycles within the calendar round have been identified. The 260-day count, which is still used by some contemporary Maya, is based on a sequence of thirteen periods, each of twenty days. Each day has specific omens that prophesy future events. The other cycle is the 365-day year, consisting of eighteen months, also twenty days long. Five unlucky days are added at the end to round out the total.

The so-called "long count," which dates time from August 13, 3114 B.C., was developed after the calendar round, although precisely when is not known. It was used by the Olmecs and the Maya. The long count differed from the calendar round in being based on a 360-day year. Time, according to recent scholarship, was recorded in units of 400 years, 20 years, 20 days, and individual days.

The jade plaque known as the Leiden Plate (fig. **7.8**) shows, on the front, an Early Classic Maya ruler from Tikal as he steps on the back of a defeated enemy, a typical iconographic motif in Maya stelae. The reverse shows glyphs indicating a long-count date corresponding to a day in the year 320, probably the day on which this particular ruler assumed power.

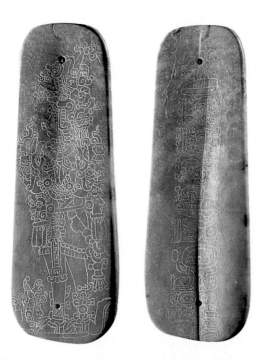

7.8 The Leiden Plate. Jade; 8½ in. (21.6 cm) high. Rijksmuseum voor Volkenkunde, Leiden.

Maya Religion

The Maya believed in cycles of creation and destruction, ages of development, and an apocalyptic end of the world. They conceived of the universe as having three tiers: sky, earth, and underworld. The earth was a square or rectangle resting on the back of a crocodile. The four corners of the world were oriented to the cardinal directions and associated with specific colors. East was red like the sunrise, and west, where the sun sets, was black. North was white, and south was yellow. Supporting the Maya sky—conceived of as a two-headed serpent—was the great Tree of Life at the center of the world. When Maya died, they went to the underworld, or "place of night" (*Xibalba*), which had nine levels.

The *Popol Vuh,* a Late Postclassic epic history of the Quiche Maya (an important nation that flourished just before the Spanish conquest), relates the story of Hero Twins who defeat the Xibalbans in a ball game. The heroes ascend to heaven and become the sun and the planet Venus. In so doing, they are a model for Maya rulers who likewise hope to escape eternal night. The epic is known from a manuscript discovered in the nineteenth century.

Maya religion was polytheistic, and each god was made more complex by having multiple aspects. Hunabku was the omnipotent god who controlled the universe. The chief god Itzamna ("Lizard House") was depicted as an old man who invented writing; he was the god of science and knowledge. His wife, Ix Chel ("Lady Rainbow"), was the goddess of weaving, medicine, childbirth, and the moon. Together, Itzamna and Ix Chel gave birth to all the other gods in the Maya pantheon.

Classic Maya

Copán (Early 5th Century–c. 820) One of the best-preserved Classic Maya sites is Copán, in western Honduras. The reconstruction drawing (fig. **7.10**) is based on the Late Classic period. It shows the temple pyramids with their stairways on the acropolis at the right and the plaza with monumental carved stelae at the left. Copán artists used durable green volcanic tufa for architectural monuments and their sculptural decorations, which included elaborate portraits of Maya kings. The ball court at Copán (fig. **7.11**) is one of the finest surviving examples of Classic architecture. It was dedicated in A.D. 738 by a king known

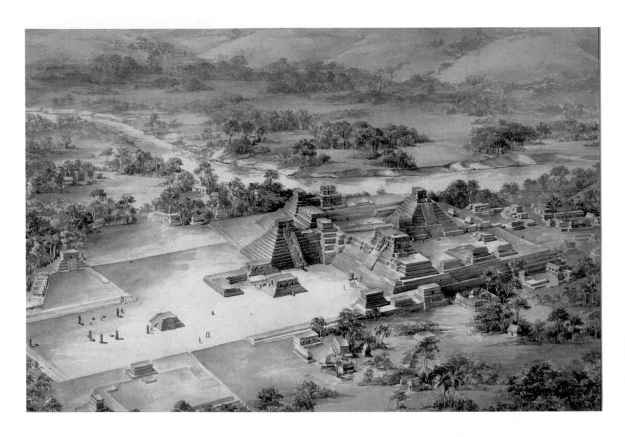

7.10 Tatiana Proskouriakoff, reconstruction drawing of the site of Copán, Honduras, Maya, Late Classic.

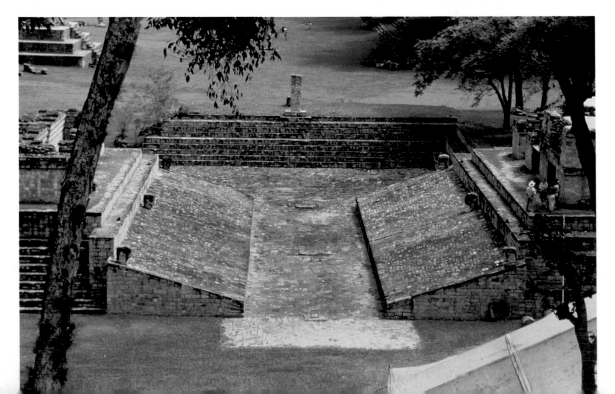

7.11 Ball court, Copán, Honduras, Maya, Late Classic, c. 800.

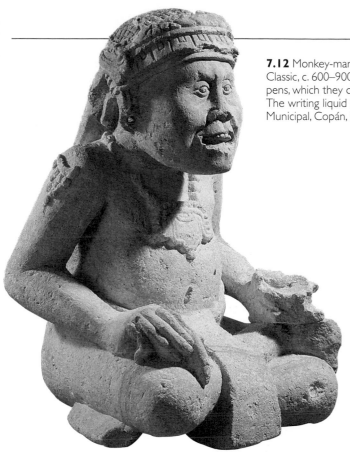

7.12 Monkey-man scribal god, from Copán, Honduras, Maya, Late Classic, c. 600–900. Maya scribes wrote with brush or feather pens, which they dipped into small pots made from conch shells. The writing liquid itself was either black or red pigment. Museo Municipal, Copán, Honduras.

as Eighteen Rabbit, who presided over the construction of a large palace.

Also at Copán, archaeologists have discovered a scribal palace of the Classic period decorated with sculptures of the monkey-man god represented as a scribe (fig. **7.12**). Scribes were members of the elite. The example illustrated here shows a scribe sitting cross-legged and listening attentively. His necklace is similar to that worn by the *Maya Lord* (fig. 5.9), while his combination of human and animal features is reminiscent of the Olmec jaguar deity (fig. 7.1).

Tikal: Temple I At Tikal, in the Peten region of modern-day Guatemala, Temple I (the Temple of the Jaguar) is one of six structures that reflect the increasing height of Maya temple pyramids (fig. **7.13**). In its heyday, Tikal was one of the largest Classic Maya city-states. It had an elevated ceremonial complex consisting of rulers' tombs surmounted

7.13 Temple I, Tikal, Guatemala, Maya, before 800. Approx. 157 ft. (48 m) high.

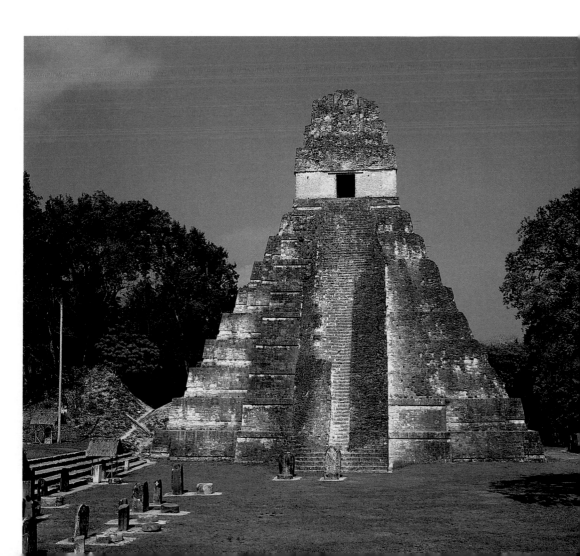

by temples, open squares, and ball courts. Temple I has nine layers supporting a temple, accessible by a staircase on the long side, and faces Temple II on the other side of an open square. The temple has two rooms with corbeled vaults and is crowned by a **roof comb** (the crestlike feature, originally decorated with painted sculpture). Beneath Temple I, archaeologists found the tomb of a ruler nicknamed "Au Cacao," "Lord Chocolate" (ruled c. 682–727); he was buried with jewelry, food and drink, and bone tubes incised with representations of gods.

Bonampak: Mural Painting In 1946, at the Classic Maya site of Bonampak (in Chiapas, Mexico), a remarkable group of murals dating to the late eighth century was discovered. These depict narratives of battles, victory celebrations, and the torture and sacrifice of prisoners. The recopied mural in figure **7.14** illustrates the Maya treatment of captured prisoners. The scene takes place on a stepped pyramid with King Chaan-muan at the center of the top step. He wears a jaguar-skin jacket and is flanked by masked, costumed members of the nobility. Standing at the right is

his principal wife wearing a white robe and holding a fan. Between the top step and the attendants at the bottom are nearly nude captives awaiting death. Some stare in shock at their hands, which drip blood. A dead captive lies below the ruler's staff, while a severed trophy head is beside his right foot.

Postclassic Maya: Chichén Itzá

(Flourished 9th–13th Centuries)

A Postclassic Maya people, the Itzá, flourished in northern Mexico. In their central city of Chichén Itzá (fig. **7.15**), a more cosmopolitan Maya style assimilated forms from the Toltecs of central Mexico, as did Maya social and religious institutions. The many frescoes at Chichén Itzá—on the walls of the ball court and in the Temples of the Jaguars and the Warriors—are unfortunately in very poor condition. But architecture here clearly reflects the continuing development of new forms. The view in figure **7.16** shows the *Caracol,* a circular temple, in the foreground, and in the

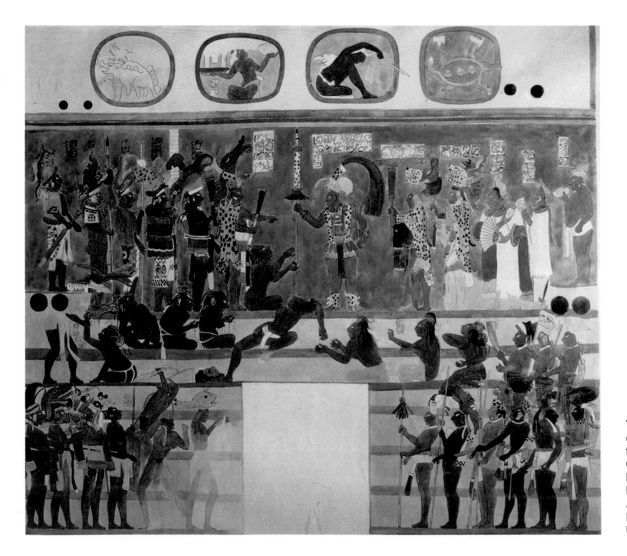

7.14 Reconstruction of a mural painting from Bonampak, Chiapas, Mexico, Maya, Classic, c. 790. Peabody Museum of Archaeology and Ethnology, Harvard University.

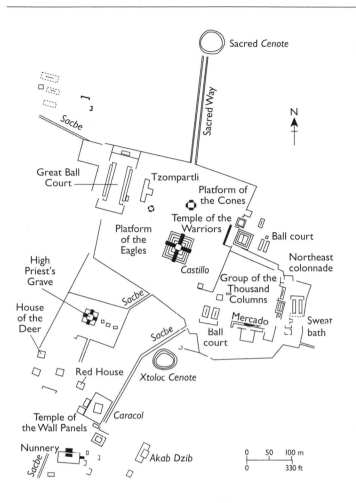

Sacred *Cenote*

Sacred Way

Sacbe

Great Ball Court

Tzompartli

Platform of the Cones

Temple of the Warriors

Platform of the Eagles

High Priest's Grave

Castillo

Ball court

Northeast colonnade

Group of the Thousand Columns

House of the Deer

Sacbe

Mercado

Sweat bath

Sacbe

Ball court

Red House

Xtoloc Cenote

Temple of the Wall Panels

Caracol

Nunnery

Sacbe

Akab Dzib

0 50 100 m
0 330 ft

N

distance the Temple of Kukulcan (called the *Castillo*) at the left and the Temple of the Warriors farther away at the right. Kukulcan—literally the Feathered (*kukul*) Serpent (*can*)—is mentioned in Maya records as the founder of Chichén Itzá's capital. The Temple of Kukulcan has corbeled vaulting, as at Temple I at Tikal, but unlike most Classic Maya temples it has multiple doorways and larger rooms. An earlier stage of the temple is encased by the terraced platform. Inside this buried temple, there is a room containing a red throne in the shape of a jaguar, with jade eyes and shell fangs.

The so-called *Chacmool,* meaning "Jaguar King," or "Red Jaguar" (fig. **7.17**), reclines at the top of the steps leading to the Temple of the Warriors. It turns its head abruptly, as if to stare toward the main open square. The *Chacmool* is a representation of a fallen warrior holding a plate believed to have been for sacrificial offerings.

Chichén Itzá declined in the thirteenth century, and the center of Maya civilization in the north shifted to a new capital at Mayapán. Today, despite the Spanish conquest in the sixteenth century, aspects of traditional Maya culture survive in Mesoamerica.

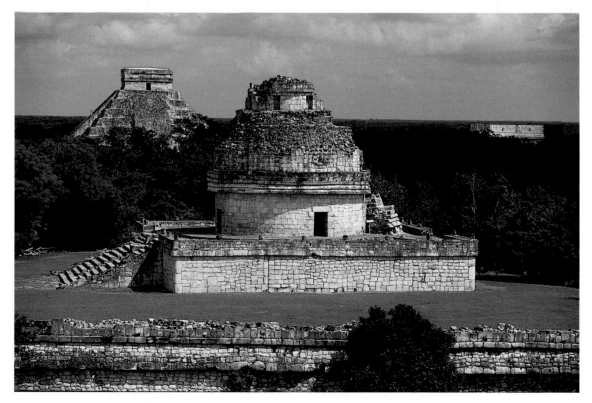

7.16 View of Chichén Itzá showing the *Caracol* with the Temple of the Warriors (left) and *Castillo* (right) in the distance, c. 800–1000.

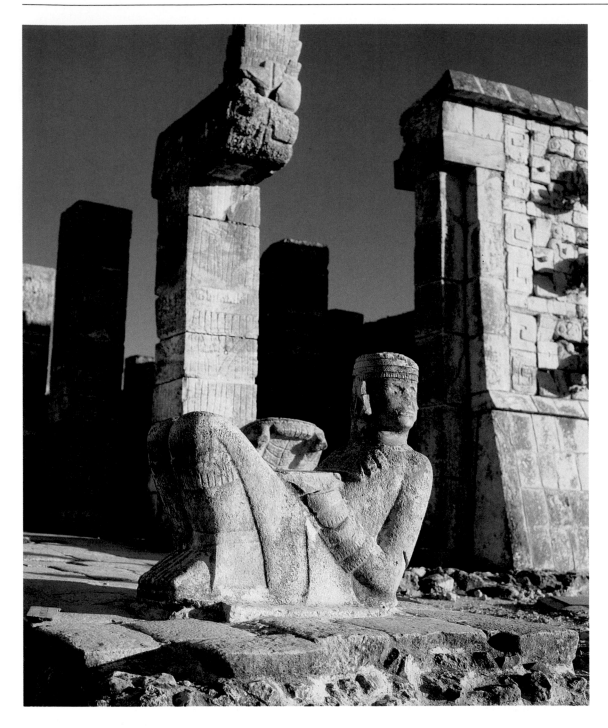

7.17 *Chacmool,*
Chichén Itzá, Mexico.
3 ft. 6 in. (1.10 m)
high.

The Aztec Empire (c. 1300–1525)

From around 1300, the Aztecs rose to dominance in the Valley of Mexico. They called themselves the Mexica, from which the name Mexico is derived, but their own name is from the legendary Lake Aztlan. Aztec tradition identifies the lake as the original site where they first settled into a recognizable cultural group. In the thirteenth century,

according to Aztec tradition, their patron god (Huitzilopochtli), son of Mother Earth and god of the sun and of war, instructed them to leave the region of the lake. After a period of nomadic wandering, the Aztecs arrived at Lake Texcoco, also in the Valley of Mexico. They named the spot Tenochtitlán, and they eventually became the most powerful culture in the area. By the fifteenth century, the Aztec Empire was vast, its wealth was legendary, and its works of art of remarkable quality.

7.18 *Coyolxauhqui, Goddess of the Moon*, from the Templo Mayor, Tenochtitlán, Mexico, 15th century. This relief was discovered in 1978 by workmen digging up the cellar of a bookstore in Mexico City. Volcanic stone; 88⅜ × 79½ × 14⅜ in. (225 × 202 × 37 cm). CNCA–INAH–MEX, Museo del Templo Mayor, Mexico City.

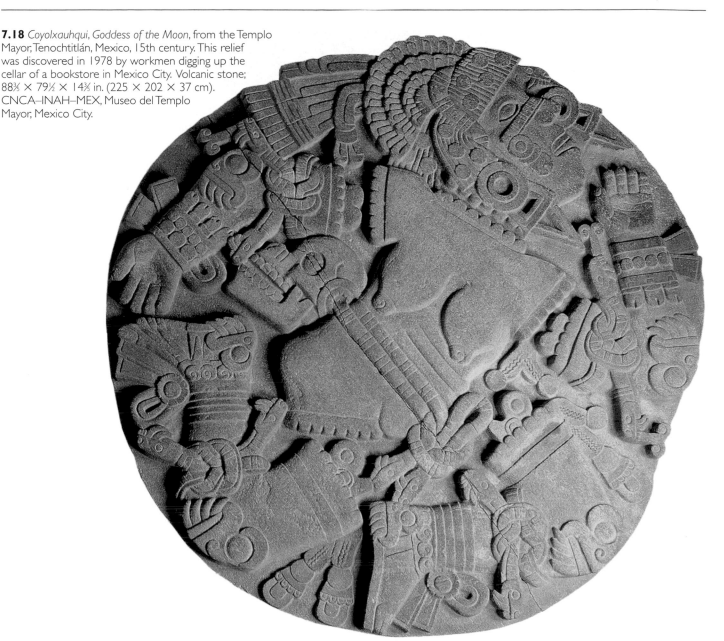

When Hernán Cortés, the Spanish conqueror, arrived in 1519 in what is today Mexico City, he found the dazzling capital of the Aztec Empire. It was built on a series of islands in the valley. The stone walls, towers, and temples of Tenochtitlán impressed the invaders, who joined forces with the enemies of the Aztecs and conquered them. Cortés destroyed the city and sent enormous quantities of plundered objects, most of gold and silver, to the queen of Spain. Although the spoils were subsequently melted down for the intrinsic value of their materials, caches of Aztec objects continue to be unearthed by archaeologists.

Aztec society was a warrior culture comprised of farmers and workers, merchants, and a ruling elite. Teotihuacán (see page 80), which had flourished centuries earlier, became a religious center—the site of the creation of the sun and moon—for the Aztecs. They assimilated the earlier gods into their own belief system, continuing the practice of bloodletting rituals and human sacrifice.

The fifteenth-century relief sculpture in figure **7.18** shows the dismembered moon goddess, Coyolxauhqui, sister of Huitzilopochtli. It was found at the base of the Templo Mayor in the capital city of Tenochtitlán with the head facing the stairway. Coyolxauhqui's head, at a right angle to her neck, is feathered, and her face is decorated with bells. Her belt consists of a two-headed snake with a knot at one end and a human skull at the other. Her arms and legs, adorned with jewelry, are severed from her body, and fanged masks decorate her elbows, knees, and heels. The raised, flat carving is characteristic of Aztec relief sculpture.

Reflecting the warrior culture of the Aztecs is the terra-cotta *Eagle Warrior* (fig. **7.19**) found in the Precinct of the Eagles at the Templo Mayor. A nobleman and member of the elite corps of Eagle Warriors, the figure wears the typical costume of eagles' wings and claws. Surrounding the head is the open beak of an eagle that functions as a kind of protective helmet. In battle, the aim of such warriors, in addition to territorial expansion, was to take the enemy alive for sacrifice to the Aztec gods.

After the Spanish conquest, the capital of Mexico City was built on the destroyed site of Tenochtitlán and a cathedral erected on the location of the sacred precinct.

7.19 *Eagle Warrior*, from the Templo Mayor, Tenochtitlán, Mexico, 15th century. Terra-cotta; 7 × 46½ × 21⅜ in. (170 × 118 × 55 cm). CNCA–INAH–MEX, Museo del Templo Mayor, Mexico City.

Art of the Andes

The Andes refers to the world's longest mountain range, which includes parts of modern Colombia, Ecuador, Peru, Bolivia, Argentina, and Chile; it also identifies one of the handful of world cultures that evolved as a pristine civilization (see map). Andean culture is often equated with that of the Inkas, who ruled only for a brief time before the arrival of the Spanish in the sixteenth century. Predating the Inkas, however, was a long and rich cultural tradition with defined artistic periods beginning about 2500 B.C., roughly 12,000 years after people are thought to have crossed the Bering Strait.

Andean art and architecture are remarkably complex, especially when one considered that the wheel, iron, and a clearly defined writing system were little used. The complexity is dependent on a system of duality pervading many abstract ideological concepts as well as many of the visible physical attributes of the society. Fabrication of fine textiles embodying hierarchical and cultural messages is found in each phase of Andean artistic development. Tex-

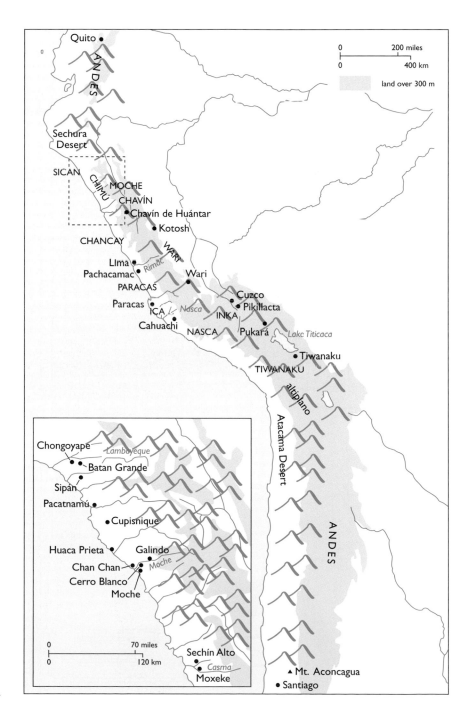

Map of the central Andes.

tiles attained the highest level of technology, encompassed the longest-known continuous tradition of fiber art, and were among the most revered objects of Andean culture.

The dramatic and often inhospitable landscape of the Andes influenced its art and contributed to a worldview based on the concept of duality. The dry coastal areas of Peru, which include some deserts where only one inch of rain falls annually, are rich in seafood and its nutrients. Highlands and mountains paralleling the coast, on the other hand, provide a contrasting environment where potatoes are often the only crop and conditions are optimal for llamas, alpacas, and other camelidae, which are important sources of fiber and fuel. Trade and reciprocity between these two regions, dating to the preceramic era (3000–1800 B.C.), have been documented. But the lowlands, or tropical jungle, a third geographic area, has not been fully documented because the climate does not permit preservation of cultural remains. Some evidence of interaction, however, particularly in terms of imagery, does exist.

Chavín: The Beginning

The earliest widespread style began in 900 B.C., the Late Initial period at Chavín, a ceremonial site located at what appears to have been a strategic position halfway between coast and jungle, in the center of two mountain ranges, and near the confluence of the Huachecsa and Mosna rivers. Chavín was well positioned for trading with the lowlands to the east, the surrounding highlands, and the coast. The main architectural complex at Chavín de Huántar is made up of two principal temples: the Old, dating from the Late Initial period (c. 900–500 B.C.), and the New, dating from the Early Horizon (500–200 B.C.) (fig. **7.20**). It was at Chavín that U-shaped pyramids facing a large plaza in the tradition of the coast, sunken circular courts in the tradition of the highlands, and various portrayals of snakes, raptors, and the jaguar were unified cohesively. The complex was constructed with large slabs of stone, a highland tradition that culminated in the spectacular architectural

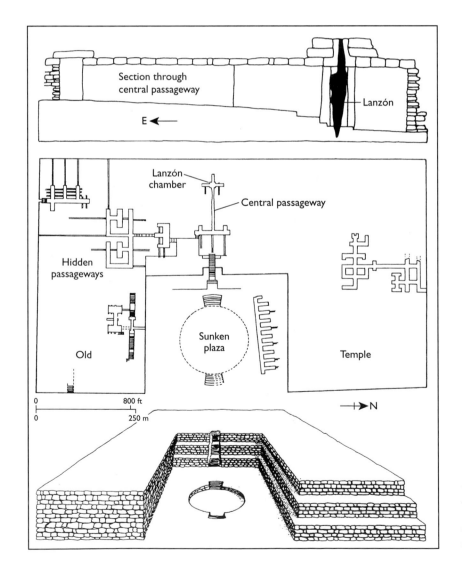

7.20 Chavín de Huántar: (*top*) cross section, showing the location of the Lanzón at the end of a gallery; (*center*) plan, showing some of the galleries hidden within the temple; (*below*) the Old Temple and its sunken circular courtyard, Late Initial Period, c. 900–500 B.C.

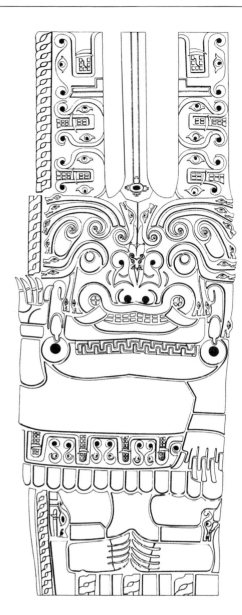

7.21 Roll-out drawing of the Lanzón, from the Old Temple at Chavín de Huántar, Late Initial Period, c. 900–500 B.C. The iconography of the Lanzón offers one of the oldest and most eloquent representations of Chavín de Huántar's supreme deity.

accomplishments of the Inkas over two thousand years later.

The Old Temple at Chavín, more than 300 feet (90 m) in length, faced the sunrise and was approached from the west. Embedded in the walls of the temple were a series of larger-than-life heads, which may have represented the shamanic transformation of a priest into a feline or other animal. Staircases lead to a circular plaza lined with a carved stone frieze showing idealized figures and felines. Beneath the temple, a series of narrow passageways lead to the *axis mundi* ("world axis") of the anthropomorphic Lanzón idol (fig. **7.21**), a carved shaftlike piece of granite

that extends above the chamber in which it is placed and represents the supreme deity, possibly an oracle. The iconography of the Lanzón embodies all the elements of the Chavín belief system, including a fanged mouth, a flat nose with flared nostrils, talons, and visual metaphors such as snakelike hair that are typical of Andean sculpture.

Evidence of portable Chavín objects such as carved stone bowls, gold repoussé crowns, and textiles have been found as far away as the south coast of Peru, a distance of some 300 miles (480 km), indicating the importance of this early cult oracle and its lasting influence on the art of the Andes.

Coastal Cultures and the Cult of Irrigation

Although Chavín was one of the defining influences on the Paracas (1000–200 B.C.) and Nasca (200 B.C.–A.D. 600) cultures from the south coast of Peru, they evolved a different type of imagery. The designs were based in part on the surroundings, a coastal desert where subsistence was dependent on irrigation that harnessed resources from the nearby mountains. In 1927, over 400 graves containing well-preserved mummy bundles wrapped in textiles were discovered at the Paracas site of the necropolis of Wari Kayan. The numerous finds notwithstanding, the iconography portrayed on the graphic textiles is still debated.

It is in textiles that the Paracas culture was preeminent. Finely woven examples were reserved for the elite, and gifts of textiles were made to the gods. Beginning with Paracas, textiles were constructed with two complementary elements. Cotton, a stronger material used as the supporting warp threads or as a background, was grown on the coast. Wool, which absorbs dye more readily than cotton and can be spun into extremely fine yarn, was supplied by highland camelidae. The use of these media is another example of reciprocity or duality in the Andes, for the very structure of weaving reflects duality in the intertwining created by the intersection of the warp and weft threads. Many Paracas textiles were executed using embroidery, a technique that permits greater expressive range than the strictly geometric structure of weaving.

Textiles were used as clothing as well as grave offerings, and family members invested thousands of hours in making the offerings, often entire sets of clothes from turban to mantle. If not completed at the time of death, textiles were placed in the tomb in their unfinished state. Other grave offerings found in the mummy bundles were food, gold, and precious objects including spondylus shells. These shells of the spiny oyster were traded with Ecuador throughout the pre-Columbian era and symbolized water.

Paracas textiles divide into two styles, Linear and Block, terms that describe the arrangement of the inherent design patterns. Both styles contain a multitude of images, the meaning of which is still debated by scholars. Warrior figures wielding knives and hatchets are often seen;

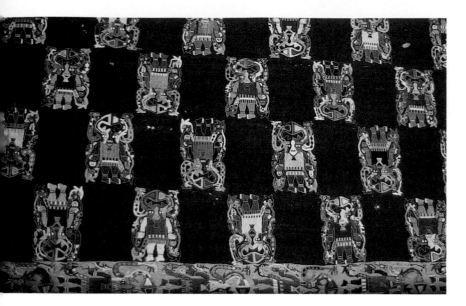

7.22 Textile with "impersonator" figures, Paracas, Peru, Early Intermediate, c. 100–200. Plain weave with stem-stitch embroidery.

the north coast. Of the three coastal cultures, the Moche was the most distinctive. Notable in its artistic output are ceramic vessels, metalwork, and monumental architecture, in which the Moche were innovators, developing new techniques that led to increased production. This artistic expansion may have been the result of the fact that the Moche kingdom was the first true centralized state in the Andes. In order for this state to function, corporate labor was required to produce enough objects to disseminate and maintain an ideological hold over a large area. Both the realistic and ritual scenes on Moche pottery indicate the necessity of warfare in extending the power and territory of the Moche.

Moche pottery is divided into various styles, including narrative scenes and portrait heads molded in the round, vessels on which fine line painting illustrates a ceremonial ritual, and sexually explicit subjects probably associated with fertility. For the first time in Andean culture, mold-making techniques were developed in order to increase production.

Moche portrait heads are unparalleled in Andean art. Researchers have identified portraits of approximately fifty subjects depicted at various stages of life. In its sense of humor and emphasis on personal themes, Moche pottery is

"impersonator" figures appear to be wearing face masks and nose ornaments (fig. **7.22**). Using the imagery found on the textiles as well as the archaeological record, it is possible to conclude that the Paracas state was more concerned with the immediate world than the earlier highland culture of Chavín had been. Realism and a sense of urgency are apparent in the design. Although the supernatural is still a factor, it is not the defining ideology that it had been during the Chavín era. The manner in which the designs are turned upon each other and the repetition of the colors reveal a high degree of sophistication. Earlier Linear designs tended to concentrate on the supernatural while the slightly later Block designs portray natural flora and fauna along with figures resplendent in ritual paraphernalia often anthropomorphized with simian feet. One scholar has proposed that these human impersonators are part of a conceptual structure of the universe and are wearing ritual symbolic costumes used in a ceremonial context related to celestial or agricultural phenomena.

Just south of Paracas, the Nasca culture (200 B.C.–A.D. 600) came to prominence along the coast. Most recognized for the monumental Nasca Lines carved in the desert, the art tends to be more naturalistic than earlier styles, with an emphasis on large-scale depictions not only in the earthworks still visible in the dark sands, but in ceramics and textiles as well. Nasca pottery is characterized by a slip-painted surface in which mineral pigments are mixed with clay to make a pliable medium for design. The pictorial elements are outlined in black, giving them an even stronger presence. Common themes are a heightened interest in crops through portrayal of fruits and vegetables, narrative scenes from everyday life, as well as ritual ceremonial figures. The vessel illustrated here (fig. **7.23**) shows the Andean taste for merging natural forms—of a fish, a feline, and a human—as well as for the lively animation of surfaces. This is a moment in Andean art when secular and religious imagery coexist.

While the Nasca flourished on the south coast of Peru, the Moche state (A.D. 100–700) was establishing itself on

7.23 Vessel depicting composite fish, feline, and human figure, Nasca, Peru, 50–200. Ceramic. The Art Institute of Chicago.

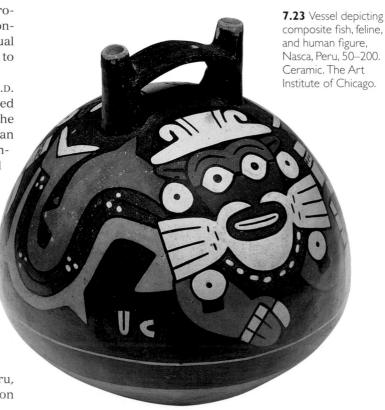

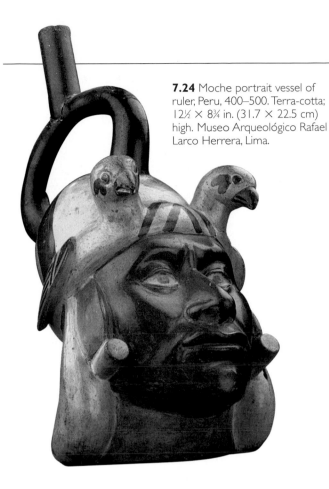

7.24 Moche portrait vessel of ruler, Peru, 400–500. Terra-cotta; 12½ × 8¾ in. (31.7 × 22.5 cm) high. Museo Arqueológico Rafael Larco Herrera, Lima.

distinctive. The portrait vessel of a ruler (fig. **7.24**) reflects the organic naturalism characteristic of Moche heads.

The largest adobe structure in the Americas was built by the Moche at their capital, Cerro Blanco. The Huaca del Sol (Pyramid of the Sun), the main temple (originally over 165 feet tall), faces the somewhat smaller palace, the Huaca del Luna (Pyramid of the Moon), across an open plaza. It is estimated that over 100 million bricks were used in the layered construction of the larger pyramid. Most bricks were inscribed with their maker's mark. The stepped pyramids, decorated with murals and containing elite burials, would have been impressive monuments of a grandiloquent civilization. The massive canal system constructed by the Moche permitted a food supply adequate for a ceremonial center of this size.

Contemporaneous metalwork is best known from the spectacular finds at Sipán in the late 1980s. Gilding, alloying, and soldering techniques were used by the Moche. Much of the ceremonial ornamentation was made of *tumbaga,* an alloy of gold, silver, and copper. The gold and turquoise earspool (fig. **7.25**) from the Tomb of the Warrior Priest at Sipán depicts an elaborately attired warrior carrying a shield and sword. Predominantly gold, he is contrasted with the figures flanking him, who are shown to be attendants by their smaller scale. The sense of unified artistic organization in this piece is created by the repeated formal rhythms and interlocking of the gold and turquoise.

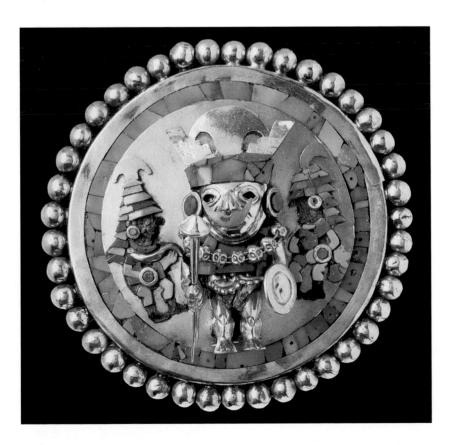

7.25 Earspool, from the Tomb of the Warrior Priest, Sipán, c. 300. Gold, turquoise, quartz, and shell; diameter 3½ in. (9.4 cm). Archeological Museum, Lambayeque, Peru.

The Highland Empires of Tiwanaku and Wari

The ceremonial center of Tiwanaku is situated in modern-day Bolivia near the southern border of Lake Titicaca, the highest inland lake in the world. It is located strategically between the lowlands to the east and the high plateau to the west. One of a few sites in the Andes with massive stone architecture, its buildings were aligned cosmically with the sunrise and sunset. An artificial moat surrounding the core temples signified the sacred nature of these structures and related the complex to an island in Lake Titicaca. Thus, it is thought that the site of Tiwanaku (600–1000) was conceived as the *axis mundi* in much the same fashion as the Lanzón at Chavín.

The iconography of the monuments, either colossal freestanding godlike figures or mythical carvings of human and animal composite deities, is emblematic of the power and cosmic symbolism of the city. The city of Tiwanaku, with a population of over 60,000, was the capital of an expansionist empire that ranged from the lowlands of Bolivia through Peru and Chile to northern Argentina.

Construction of ceremonial buildings consisted of blocks of ashlar (a carved, square stone), sandstone, and andesite finely worked and fitted much like later Inka structures. In the tradition of the architecture at Chavín, there is a sunken plaza, a wall with tenon heads, and a monumental entrance—the Sun Gate (fig. **7.26**). It is the most recogniza-

ble monument at Tiwanaku, with a carved frieze on the portal depicting a central figure holding a staff in each hand. The face is metamorphosed into the sun, and rays emanating from the heads are transformed into heads of mythical felines and other forms. This central deity is attended by composites of winged kneeling figures carrying spears. His frontality accentuates authority, and his image is repeated in every medium used by the Tiwanaku.

The placement of the figures on the portal is symbolic of the apparent taste for order, which was important to the Tiwanaku and Wari. Design patterns are regulated and based on a set standard of hierarchical figures, an aesthetic reflected in the strict grids of certain Wari cities.

The Wari Empire (500–750) did not produce a site with architecture as spectacular as that of Tiwanaku, but in the fiber arts the ideology of this culture unfolds its own permutations on the Sun Gate theme. The way in which textiles are woven, with intersecting warps and wefts, provides the grid from which Wari designs emanate (fig. **7.27**). Variations on both the ideological ideal and the changes in the way this message can be transmitted according to the arrangement of the threads are the supreme expression of these textiles. Although the imagery was limited and was directly influenced by the Tiwanaku canon, Wari weavers abstracted images through compression and expansion combined with alternation (in four directions—back and forth, up and down), making the encoded message harder to decipher. Perhaps the imagery was reduced to a short-

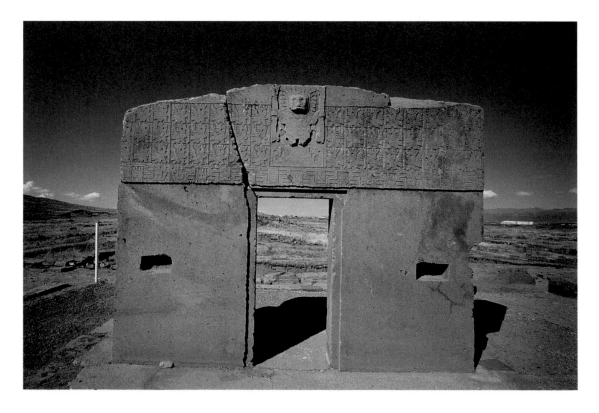

7.26 The Sun Gate, Tiwanaku, Bolivia, 500–700. Stone; 9 ft. 10 in. (3 m) high.

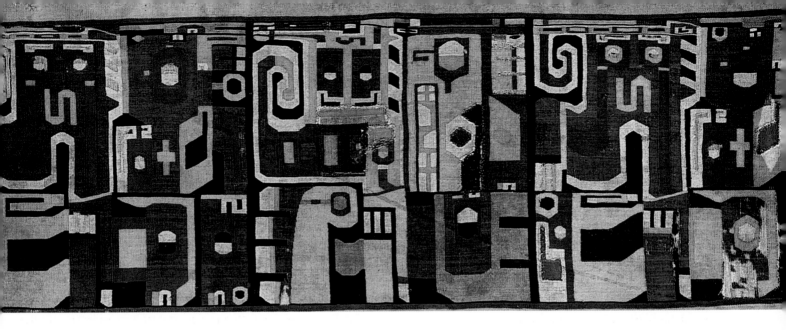

7.27 Detail of a Wari tunic, from Peru, 600–1000. Cotton and camelid wool tapestry; whole textile 40¾ × 20 in. (103.5 × 50.5 cm). Metropolitan Museum of Art, New York.

hand that was perfectly legible to those familiar with its meaning. Because few Wari textiles survived the humidity of the highlands, most have been found in the dry coastal outposts of the empire, most likely taken there to spread the supremacy of the encoded ideological message. Innovative terraced fields and widespread canalization gave this empire an advantage agriculturally; but because of its dependence on nature, the supernatural elements required constant appeasement through representation and veneration. The relationship between the Tiwanaku and Wari empires remains one of the most prominent unanswered questions among pre-Columbian scholars.

The Inka Empire: The End of an Era

(c. 1438–1532)

Nearly contemporary with the Aztecs and following the decline of the Tiwanaku and Wari cultures, another coastal kingdom, Chimor, rose to power in roughly the same area as the Moche. At the height of its influence in about 1400, the Chimú people of Chimor controlled two-thirds of the entire coast from the administrative center at Chan Chan. Shortly thereafter, another kingdom arose that would rival the Chimú. Its successors, the Inkas, are said to have come into power in 1438, at about the same time, and in much the same way, as the Aztecs in Mexico, having coalesced from a group of unexceptional tribes. The southern highland city of Cuzco, considered to be at the center of the world, was the Inka capital, and the Inka king was known as the Inka. For the Inkas, architecture was the highest expression of art and political power. The iconographic message was not supplication to the gods, as it had been in the past, but projected an image of the Inkas as the true kings.

A highly organized political entity, the Inka Empire, which assimilated various cultural groups, contained over 20,000 miles of roads called Tawantinsuyo, or the Four Quarters, connecting the far reaches of its domain, stretching nearly 3,500 miles from Ecuador to Chile. Local governors controlled each quarter, where they collected taxes in amounts determined by an accurate census and computed on a knotted string, or *quipu*. In less than a century, the Inkas were ruled by a succession of thirteen kings, the first three of whom are legendary.

The rapidity with which the Inkas consolidated power can be attributed in part to their shrewd management of the supernatural incorporated with myth and genealogy. Each king was venerated and, after his death, his mummy paraded on a litter. To sustain their relationship with the gods, the Inkas sacrificed llamas, which were associated with the sun, and burned cloth as an offering of the highest status. On occasion, they took young children to the top of a mountain, killing them and offering them in service to the gods.

In the Cuzco region, there are many architectural monuments made of monumental coursed ashlar blocks laid one on the other without mortar. The most famous Inka monument, Machu Picchu, is located at the northwest end of the Urubamba Valley, a short distance from Cuzco (fig. **7.28**). This majestic site, built on a mountaintop some 9,000 feet (2,743 m) above sea level, relates visually to the distant mountains, the Urubamba River raging below, and the surrounding jungle. A number of large stones echoes the shapes of the mountains, and windows frame spectacular views. At the beginning of the twentieth century, Machu Picchu was thought to have been the last stronghold of the Inkas and the site of a hidden treasure trove of gold, but now the site is considered to have been the royal estate of an Inka king.

Inka textiles and ceramics are standardized, typically decorated with nonfigurative geometric designs. More original was the metalwork, much of it in gold, which was melted down by the conquistadors and taken to Spain.

The Inka Empire came to an end shortly after the arrival of Francisco Pizarro in 1532.

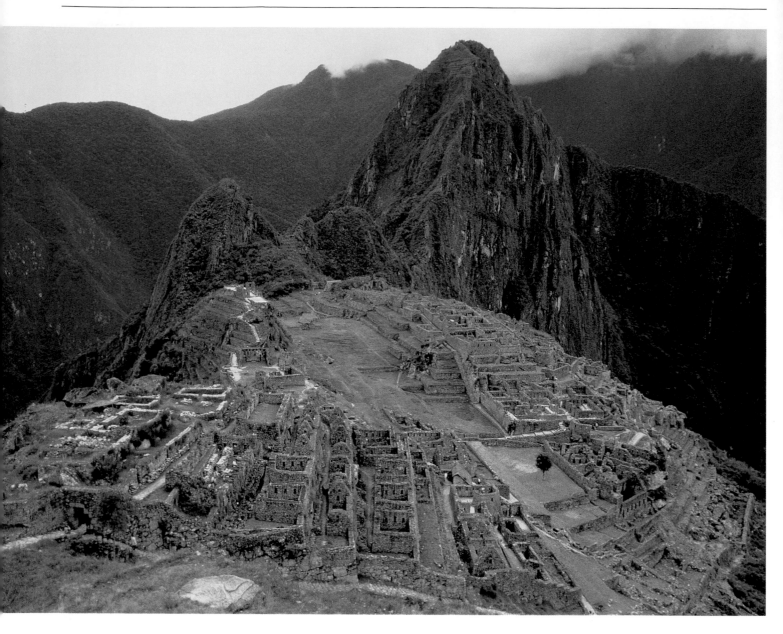

7.28 Machu Picchu, Inka culture, near Cuzco, Peru, 15th–16th centuries.

8
Aspects of Northwest Coast and Native North American Art

The ancestors of the people who inhabited the American Northwest Coast crossed the Bering Strait thousands of years ago. They were at first hunters and gatherers. Around 1100 B.C., new groups infiltrated the region, which led to the development of more permanent settlements (see maps, page 106).

Haida, Kwakiutl, Tlingit

Three of the early Northwest Coast cultures that produced rich traditions of wood carving are the Haida, on Queen Charlotte Island; the Tlingit, to the north in Alaska; and the Kwakiutl, on parts of the mainland and Vancouver Island (see map a, page 106). Occupying the Pacific coastal area beside vast cedar forests, these were largely fishing and hunting communities organized according to complex social systems. The societies were divided into a noble class, commoners, and a few slaves. They had no contact with Europeans prior to the eighteenth century.

The typical Northwest Coast village was laid out with wooden houses facing the beach and water. The most important member of the community—the chieftain—lived at the center of the village. As one's social status declined, so did the distance of the house from the center. Shamans, who were both sacred and taboo, lived apart from the community, in the direction of the forest.

Among the customs of the Northwest Coast were extravagant ceremonies, of which the potlatch feast is perhaps the best known. This was an elaborate ceremony that included feasting, dancing, singing, and other performances. The potlatch was usually held during the winter, after the food that had been gathered in the spring, summer, and fall was stored. Gifts of great value were lavished on the guests as a sign of the importance and wealth of the host.

Crest Poles

Many Northwest Coast cultures created three types of monumental wood carvings. These included house poles (attached to the front of the house and used as an entrance), mortuary poles (where the body, bones, or ashes of the deceased were placed), and freestanding memorial poles arranged in front of the houses (fig. **8.1**). They are carved with crest images signifying the clan totems (ancestors in animal form). The tall, slim poles conform to the original cedar trees from which they were carved in relief. The images themselves, which were painted, are monumental stylizations of animals, animal combinations, mythological creatures, and human faces. Some features, such as beaks and fins, were carved in the round and then attached to the poles. The crests, along with hunting and fishing rights to certain areas and rights to names, narratives, ceremonies, and costumes, are the property of individual clans.

Figure **8.2** shows a detail of a Tlingit crest pole with an animal body and a face with merged animal and human features. Each feature is accentuated by a stylized outline—red lips, a black mustache-shaped nose, blue shapes framing the stylized black edge of the eye, and wide, flattened eyebrows. The same colors are repeated on the paws. The frontality of the figure, its staring eyes, prominent teeth and claws, and the tension inherent in its pose create an impression of immanent power.

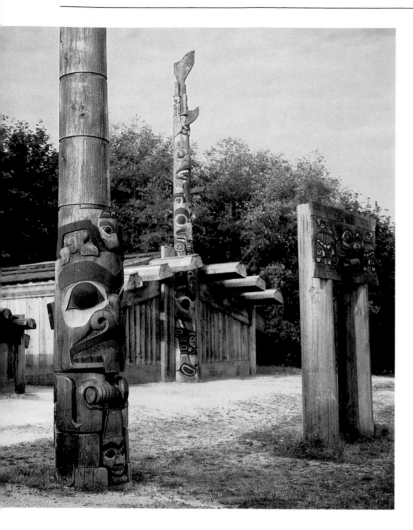

8.1 Bill Reid (Haida), assisted by Doug Kranmer (Kwakiutl), reconstructed 19th-century Haida village and frontal crest poles, Queen Charlotte Islands, completed in 1962. Museum of Anthropology, University of British Columbia, Vancouver.

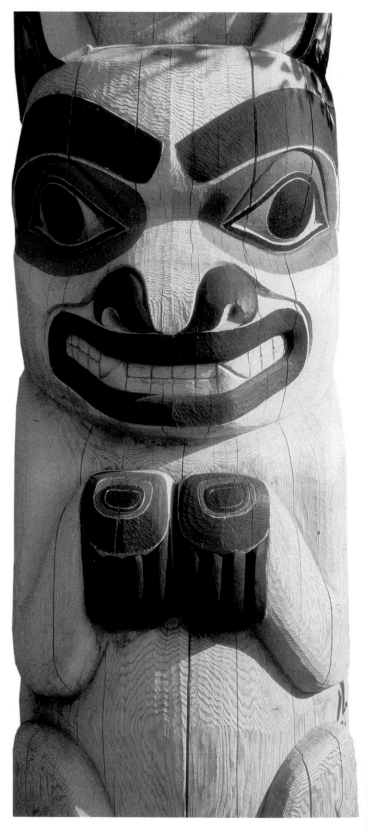

8.2 Tlingit crest detail, southeast Alaska. Wood. Photo: Explorer, Sylvain Cordier.

Screens and Blankets

The patterning in the detail of the crest pole is characteristic of Tlingit design in other works. This can be seen, for example, in the raven screen (fig. **8.3**), which, through the round hole at the center, led to a private apartment inside a Tlingit house. It is made of planks of cedar carved in low relief and is decorated with blues, reds, and blacks on a brown background. Raven heads and other raven motifs fill the space with lively shapes controlled by black edges, or form lines. In the screen, as in figure 8.2, there is an emphasis on frontality, especially in the eye motif. This creates a sense that the viewer is being watched and that the interior space is guarded by the power inherent in the images.

Similar patterns, designed by men and woven by women into fringed blankets, are found in the Tlingit village of Chilkat, in southeast Alaska (fig. **8.4**). These were among the most prized objects and were thus given away in the potlatches or worn as signs of high—usually chieftain—status. (In 1845, Canada made potlatches illegal.)

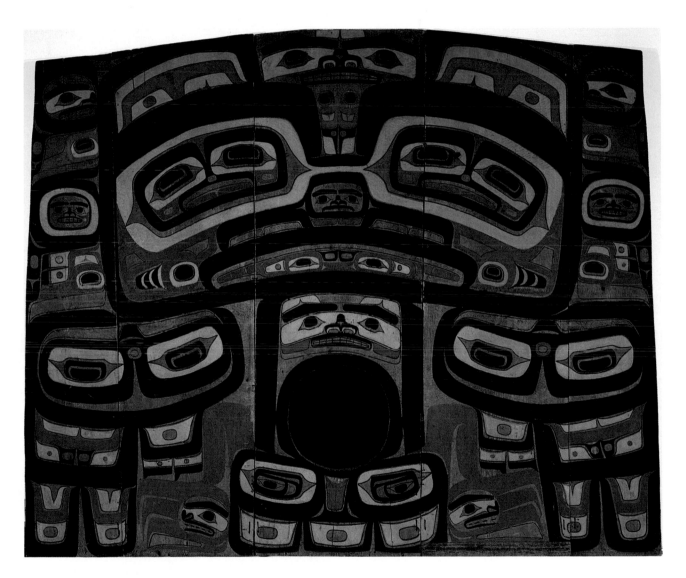

8.3 Raven screen, Tlingit (Native Alaskan), Klukwan Village, G̲aaha̲x teidi clan, c. 1810. Spruce, paint; 8 ft. 9½ in. × 10 ft. 8¾ in. (2.68 × 3.27 m). © Seattle Art Museum. Gift of John H. Hauberg.

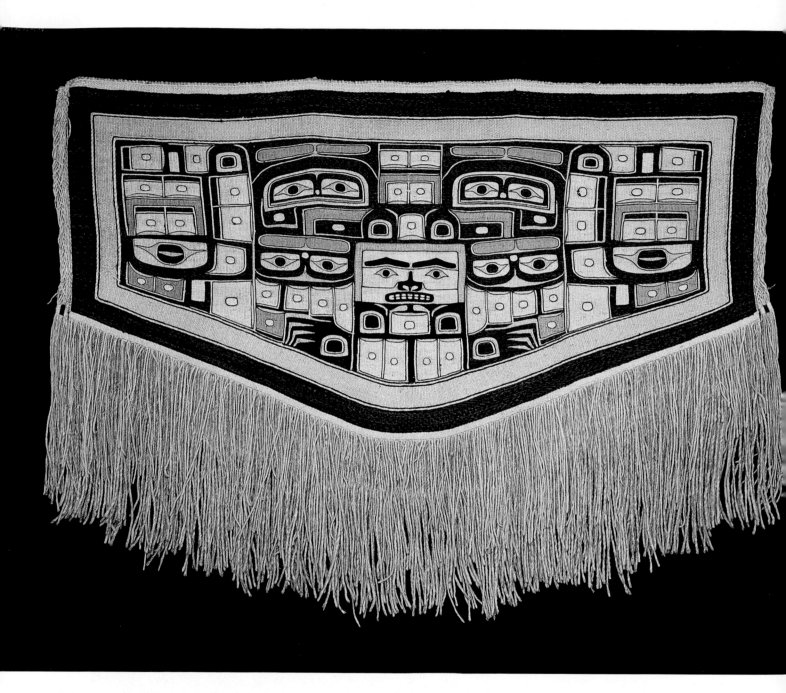

8.4 Woven robe (Chilkat style), Tlingit (Native Alaskan), c. 1880. Mountain goat wool, yellow cedar bark, natural dyes; 51½ × 66¹⁵⁄₁₆ in. (131.0 × 170.0 cm). © Seattle Art Museum. Gift of John H. Hauberg. Note that the robe is in the form of an upside-down house, imbuing the body of wearer with architectural symbolism related to status. When worn during festivals, especially dance performances, the movements of the fringe would have accentuated those of the dancer.

Masking

Another important aspect of Northwest Coast culture reflected in its art is masking. One type is the transformation mask, especially popular among the Kwakiutl, which changes according to the narrative requirements of a dramatic or shaman performance. The mask is controlled, like a puppet, by strings that are invisible to the audience. These allow the mask to be opened and the pieces rearranged to create new characters. Figure **8.5** illustrates the Kwakiutl eagle transformation mask, the features of which resemble designs on other Northwest Coast works. Reflecting shamanistic beliefs, the eagle head in figure 8.5a is transformed into a human head in figure 8.5b when the strings are pulled. The heads are painted the same colors, and their features combine stylization with lively organic movement.

From even this small sample of Northwest Coast objects, it is clear that they comprise a recognizable style. Shapes are consistently stylized from organic forms and often seem to shift viewpoint to create optical illusions. The images combine abstraction with naturalism, repetition with variety, and controlled form lines with flowing, dynamic patterning. There is no shading or sense of contour. An insistence on symmetry and regularity frames and orders the designs even as the artists create the impression of enormous variety and visual motion.

8.5a Kwakiutl eagle transformation mask (closed), Alert Bay, late 19th century. Wood, feathers, and rope; 1 ft. 10 in. × 11 in. (55.9 × 27.9 cm). American Museum of Natural History, New York.

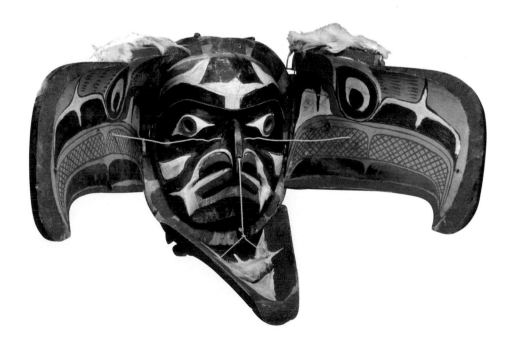

8.5b Kwakiutl eagle transformation mask (opened).

The United States Regions

As with other cultures of the Americas, those that inhabited what is now the United States are divided into periods before and after regular European contact—in this case, in the seventeenth century (see map b, page 106). Within the broad categories of pre- and post-European contact, a wide variety of cultural groups speaking different languages and practicing different customs is included in the term *Native American*. In this section, we consider a few types of objects created in three main regions of the country—the Southeast, the Plains, and the Southwest. In each of these regions, as elsewhere on the North American continent, individual societies, or clans, formed around a shared totemic ancestor.

The Southeast: Ritual Objects

The Hopewell culture of the Woodlands period, which originally occupied what is now Illinois and Ohio, expanded eastward. Between 200 B.C. and A.D. 400, their most permanent architecture consisted of rectangular or oval wooden structures divided into rooms for the dead and covered with earth mounds. The deceased, divided into high-ranking social groups, were either cremated or placed in tombs made of logs. After a ceremonial burning of the structure, earth was piled on top of it to form the mound.

Among the offerings found with the dead is the small but impressive *Bird Talon* from Ohio (fig. **8.6**). Made of mica sheets, the talon has a reflective surface and a crisp, graceful outline. Its smooth, curvilinear forms combine abstraction with organic quality. The work also has a transitional character in terms of content; it represents the claws of a bird, but the forms curving around the circular feature evoke the movement of the human hand.

The so-called *Falcon Man* gorget, a chest ornament made of shell, is from the Mississippian period (fig. **8.7**), which flourished to the southwest of the main Hopewell regions. The image, incised in low relief, depicts a kneeling male who could represent a warrior, a priest, or a warrior-priest. He overlaps a series of concentric rings that frame the inner circle, and his costume—especially the headdress, earspools, necklace, and tunic—identify him as a person of high rank. He holds a mace in one hand and displays a severed head in the other, an iconography that has been related to the presence of a warrior death cult. Both his own head and the one he holds are in profile, but the eyes are frontal, thus directly engaging the gaze of the viewer.

Another warrior figure from a Mississippian site burial in Oklahoma leans over a defeated enemy (fig. **8.8**). The warrior's action has been read as an execution, possibly a decapitation, although this is not certain. Like the figure on the gorget, the warrior wears an earspool and wide rings on his arms and legs.

The effigy pipe in figure **8.9** is from the same site and, as with the warrior in figure 8.8, exemplifies the characteristic monumental style of small Mississippian stone carvings: their spaces are closed, their massive forms are compact, and they impart a sense of controlled inner tension. The effigy pipe figure wears an elaborate headdress, a beaded necklace, and earspools, and was found in an elite burial. It is thus likely that he represents a chieftain. He sits cross-legged and leans forward, either meditating or focusing on the game of chunkey (see caption, fig. 8.9).

8.6 *Bird Talon* (falcon or eagle), Hopewell site, Ross County, Ohio, Woodland period, 200 B.C.–A.D. 400. Mica; 11 × 6¾ in. (27.9 × 17.1 cm). Ohio Historical Society, Columbus.

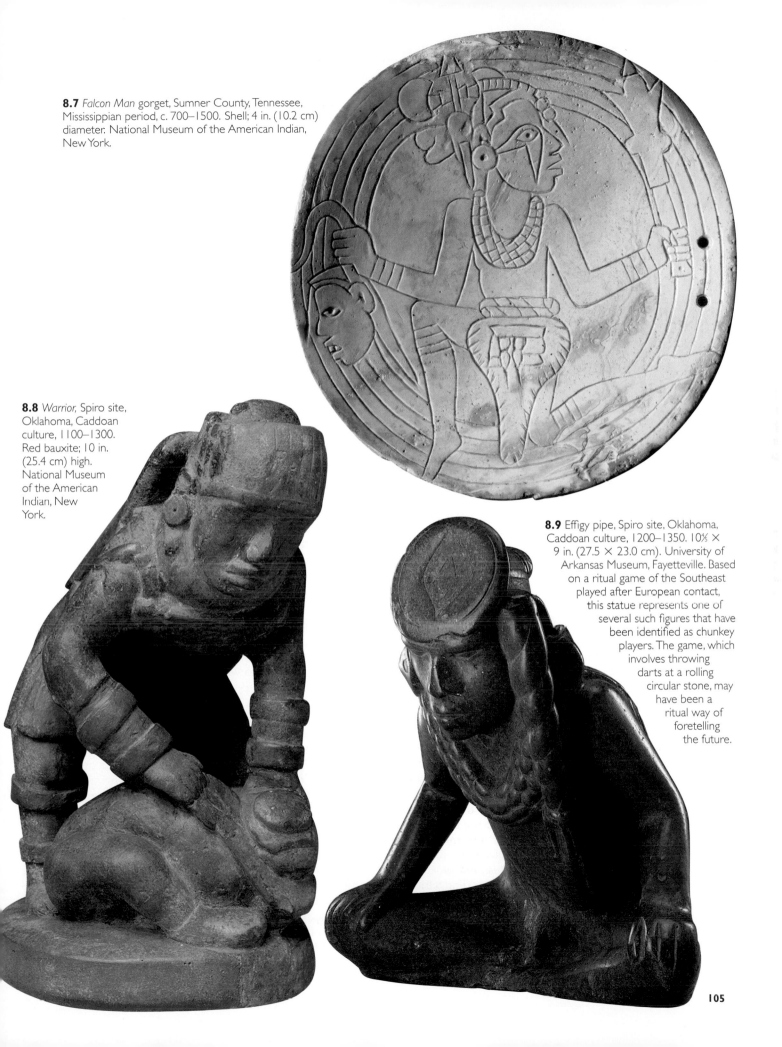

8.7 *Falcon Man* gorget, Sumner County, Tennessee, Mississippian period, c. 700–1500. Shell; 4 in. (10.2 cm) diameter. National Museum of the American Indian, New York.

8.8 *Warrior,* Spiro site, Oklahoma, Caddoan culture, 1100–1300. Red bauxite; 10 in. (25.4 cm) high. National Museum of the American Indian, New York.

8.9 Effigy pipe, Spiro site, Oklahoma, Caddoan culture, 1200–1350. 10⅞ × 9 in. (27.5 × 23.0 cm). University of Arkansas Museum, Fayetteville. Based on a ritual game of the Southeast played after European contact, this statue represents one of several such figures that have been identified as chunkey players. The game, which involves throwing darts at a rolling circular stone, may have been a ritual way of foretelling the future.

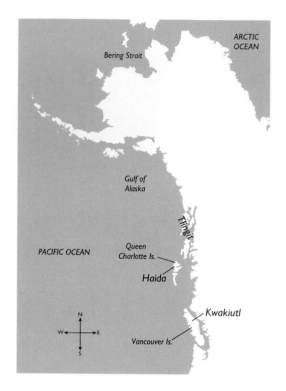

A. Map of Haida, Kwakiutl, and Tlingit areas.

B. Map of North America showing selected pre-European-contact cultures and post-contact tribal areas.

The Plains

The Great Plains cultures, from southern Canada to the Rocky Mountains and western Texas, were not only hunters and gatherers. They also cultivated food. Some, therefore, settled into stable village communities, while others led a more nomadic existence. We have seen from the Plains petroglyphs (see fig. 1.6) that hunting and hunting-related shamanism were important features of the culture and its iconography. Some Plains people lived in tipis, which were made every two or three years of buffalo skins and wooden poles. Generally, the women prepared the hides and sewed them together with threads made from buffalo sinews. They peeled the bark from tree trunks, pared them down to the desired size, and stood them upright. The hides were then stretched over the poles and attached to the ground with short stakes. An interior fire smoked the hides, which prevented them from drying out and cracking in the cold weather. Once the tipi was in place, it was decorated—usually by men—with symbolic motifs and, by the late nineteenth century, with narrative scenes depicting historic events.

Paintings One of the characteristic surfaces used for Plains paintings was the buffalo hide—not only on tipis, but also on robes. These were painted and worn by women as well as men. The women's designs tended to consist of symbolic geometric shapes, whereas the men typically painted figurative scenes of warfare. The detail of a Lakota robe from the Plains illustrates a series of combat scenes in pictographic form (fig. 8.10). Warriors wearing large feathered headdresses fight each other on galloping red or yellow horses, with a few of them fighting on foot. The artist has created a sense of rapid motion through repeated diagonals that convey both the energy of battle and the nomadic lifestyle of the Plains.

From the 1860s, Plains artists recorded warfare in paper notebooks. They drew with pen, pencil, and watercolors (fig. 8.11). Clearly influenced in detail, technique, and media by contact with Europeans, this image shows the Sioux fighting the army of General George Custer, who lost the famous Battle of Little Big Horn. The drawing is more specific and graphic than that on the Lakota robe—note the blood flowing from the wounds and the United States flags, guns, and army uniforms.

8.10 *Young Man Afraid of His Horse,* detail of a warrior's robe, Lakota, Plains region, 1880s. Buffalo hide; 88 × 69 in. (223.5 × 175.3 cm). National Museum of the American Indian, New York.

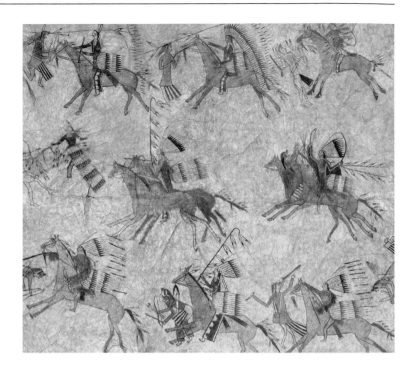

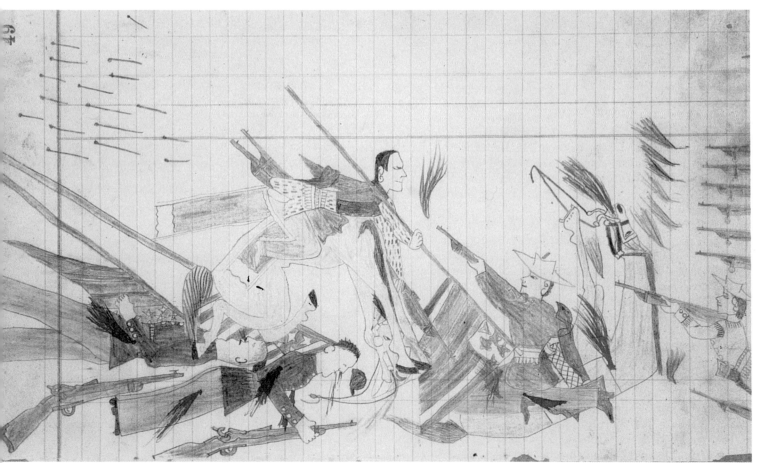

8.11 *Yellow Nose,* detail from *The Battle of Little Big Horn,* Cheyenne reservation, Oklahoma, c. 1885. Lined paper and colored pencil; 12¼ in. (31.0 cm) long. National Museum of Natural History, Washington, D.C.

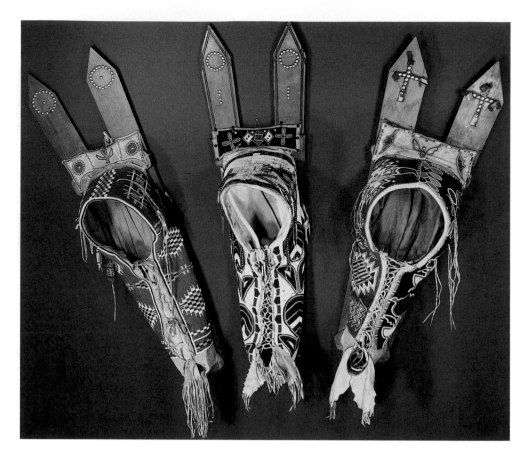

8.12 Beaded Kiowa cradles, Oklahoma, c. 1900. Artists, from left to right: Mrs. G. Qui-ah-tone, Hoy-Koy-Hoodle, Tah-o-te. Dimensions, left: 3 ft. 11¼ in. × 12⅜ in. (120.0 × 32.0 cm); center: 3 ft. 10⅞ in. × 1 ft. 1⅜ in. (119.0 × 34.0 cm); right: 3 ft. 5¾ in. × 1 ft. 1⅜ in. (106.0 × 34.5 cm). Haffenreffer Museum of Anthropology, Brown University, Bristol, Rhode Island (69.10683; 75.158; 61.339).

Beading

Beading The attention to personal adornment among the Plains people is evident in the headdresses depicted on the Lakota robe as well as in the robe itself (fig. 8.10). Many Plains items such as purses, belts, horse trappings, moccasins, and border areas of clothing are beaded. The bright color patterns possible in beading appealed to the Plains aesthetic, making beads a valuable trading commodity. They were either sewn directly onto hides and articles of clothing or woven onto separate pieces of cloth and attached later.

The three beaded cradles in figure **8.12** were made by women. All three cradles are decorated with geometric designs and laced in the center. Originally, the infant would have been placed inside the beaded pouch with his or her head protruding from the hole and protected by the slats of wood extending upward. The cradles could be hung from a saddle, from a tipi pole, or from the mother's back.

The Southwest

In the Southwest—including Arizona, New Mexico, and parts of Colorado and Utah—before contact with Europeans, Native Americans hunted, fished, and farmed. One such group, the Hohokam, shows evidence of Mesoamerican contacts, from which its members learned irrigation and imported the ritual ball court (see page 84).

Ceramics and Basketry Hohokam ceramics from the Santa Cruz period (c. 700–900) are decorated with animated, repetitive patterns that enliven their surfaces. The globular jar in figure **8.13** depicts geometric circle dancers

connected to each other by their extended arms. Their large, rectangular heads fall just above the widest part of the jar and tilt forward as if mesmerized by the energetic stomping motion of their feet. In this case, as in many Hohokam ceramics, the circular form of the jar corresponds to the movement of the dancers painted on it. The figures also reflect the typical formation of circle dancing in the Southwest.

The related and more ancient art of basketry has continued among Native American women to the present day. An example from the Washoe tribe of California and Nevada can be seen in figure **8.14**. These were made by Louisa Keyser (c. 1850–1925) of Nevada, the leading basketmaker of her generation. She coiled and sewed together willow rods to produce an original type of nearly spherical basket known as the *degikup*. The geometric decorations, made of dyed fern roots, are tightly knit, orderly, and extremely elegant.

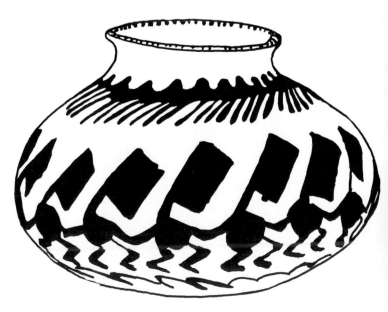

8.13 Painted ceramic jar, Hohokam, c. 700–900.

8.14 Louisa Keyser, baskets, Washoe, Nevada, c. 1900. Photo: E. S. Curtis, from E. S. Curtis, *The North American Indian* (Cambridge, 1909).

Architecture Among the most ancient and dramatic architectural achievements of the Southwest are the multiple dwellings placed beneath cliff faces or isolated as multistoried, self-contained, apartment-like complexes in low-lying river basins. At Mesa Verde, Colorado, the Anasazi built an elaborate arrangement of such stone block "apartment houses" below the broad overhang of a cliff (fig. **8.15**). These included living spaces, storage

8.15 Anasazi cliff dwellings, Mesa Verde, Colorado, c. 100.

8.16 Apartment block, Taos Pueblo, New Mexico.

rooms, and rectangular towers. They also contained underground ceremonial areas, or *kivas,* which were decorated with fresco paintings and sculptures. The presence of altars is evidence of the *kivas'* ritual purpose—in this case, functioning as symbolic passages from the spirit world to the world of the living.

A related architectural system is the adobe structure of the Hopi pueblo villages. The example in figure **8.16** consists of communal houses divided into individual units made of adobe (mud-brick). Figure **8.17** is a diagram of a typical pueblo unit. The thick walls keep the interior cool in summer and prevent freezing in winter.

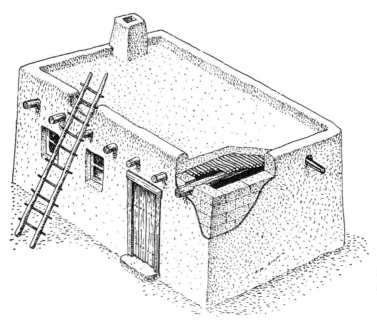

8.17 Diagram of a typical pueblo adobe unit, American Southwest.

Hopi Kachinas In Hopi villages, there is an open central space devoted to ceremonies, in which Kachinas play a major role. According to Hopi mythology, Kachinas are supernatural spirits who dwell in the mountains. They exist in three forms: as unseen spirits, as impersonations by masked men, and as carved wooden dolls. There are over 200 such Kachinas, some of which are deceased members of the Hopi tribe. Ceremonies involving Kachinas are performed from the winter solstice to mid-July in connection with agriculture, rites of spring, and weather conditions.

Each type of Kachina serves a particular function. There are runners, for example, who race with men in order to train boys in speed, and ogres whose function is to frighten children into obedience. Clowns provide comic relief during intermissions between rites, a practice similar to the satyr plays in ancient Greece. Children are given Kachinas as presents to serve an exemplary purpose and to train them to recognize the different classes of Kachina. Although there are female Kachinas, they are always impersonated by men.

The Hopi carve Kachinas by shaping the roots of dead cottonwood trees with a chisel and saw. The finer carving is done with a penknife, and the surface is then smoothed with a rasp and sanded. Facial features are attached with glue or pins. Kachinas are painted, and the colors symbolize geographic directions or spatial orientation—blue and green represent the West or Southwest, red the South or Southeast, white the East or Northeast, black the depths, and all the colors together represent the top. Facial markings are also symbolic. For example, parallel lines under the eye denote a warrior's footprint, an inverted V over the mouth denotes an official, and phallic symbols indicate fertility.

The two Kachinas illustrated here represent Black Ogre (fig. **8.18**) and Butterfly Maiden (fig. **8.19**). Black Ogre wears a mask with movable jaws and prominent teeth. He has a blue crow's foot on his forehead, wears a white shirt and trousers, red leggings and moccasins, and holds a hammer and a bow. He is believed to take food from children, whom he swallows whole. Butterfly Maiden is a more benign Kachina. She wears a white mask decorated with triangles, a white robe with geometric designs, and her bare feet are yellow. Her feathered headdress is particularly elaborate. In contrast to Black Ogre, whose crow's foot between his eyes make him seem to be frowning angrily, her expression is impassive.

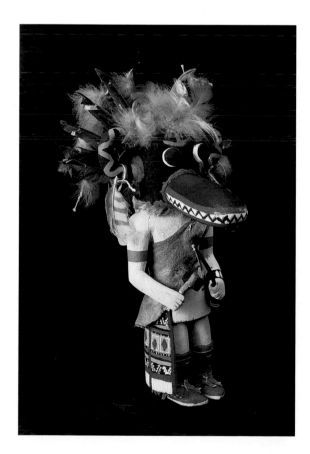

8.18 *Black Ogre*, Hopi Kachina. Carved cottonwood.

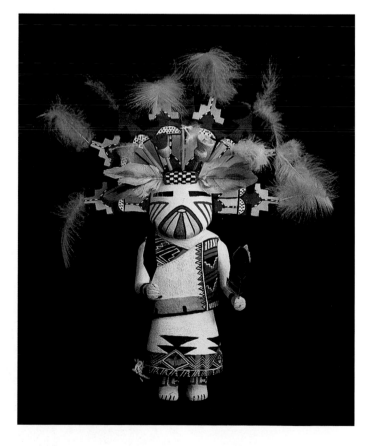

8.19 *Butterfly Maiden*, Hopi Kachina. Carved cottonwood.

Not all non-Western cultures were as isolated from European contact as those of the Americas were. Traders had traveled the Silk Road from China to the West since antiquity. Along with commercial goods, artistic motifs migrated from East to West and vice versa as a result of warfare and conquest as well as of trade. Alexander the Great brought Greek Classical influence to the art of Gandhara, and the Romans traded with black Africa. But it was not until the latter part of the nineteenth century that Western artists consciously began to assimilate aspects of non-Western styles and the cultural myths that inspired them (see box). And although Westerners often did not completely understand non-Western arts or cultures, the nineteenth- and early twentieth-century avant-garde developed a taste for what they had not previously focused on. Individuals as

well as museums began collecting and exhibiting such works, exposing them more and more to the general public.

The next three chapters consider three areas of non-Western influence—in addition to the examples of Native American art already discussed—on the Western art world: Japanese woodblock prints of the Edo period, which influenced the Impressionists and Post-Impressionists; the arts of Oceania, which influenced Gauguin and others; and the African art of Benin, which had had contact with the Portuguese from the fifteenth century, the Dutch from the seventeenth century, and the British from the late nineteenth century. That non-Western works have been referred to as exotic, or "primitive," is a mark of both the fascination they exerted over Westerners and Western misunderstanding of them.

Cross-Cultural Influences: Max Ernst

Beginning in the late nineteenth century and continuing well into the twentieth, avant-garde artists in the West looked to non-Western art for inspiration. Attempting to free themselves from Western formal conventions, especially the Classical tradition, these artists were also interested in the myths and rituals associated with non-Western imagery.

From 1946 to 1953, the German Surrealist Max Ernst (1891–1976) lived in Arizona and collected Hopi Kachinas (fig. **8.20**). He thought of himself as a shaman, identifying with Hopi mythology and describing his own mystical visions. He believed that shamans, like artists, have highly charged sensory experiences that offer new ways of seeing and representing everyday phenomena.

8.20 Max Ernst with his Kachina doll collection, 1942. Photograph by James Thrall Soby. Collection of Elaine Lustig Cohen.

9
Japanese Woodblock Prints

From 1853 to 1854, the United States naval officer Commodore Matthew Perry led an expedition that forced Japan (see map) to end its policy of isolation. This opened up trade with the Far East and set the stage for cultural exchange with the West. In the Paris Universal Exposition of 1867, many Japanese woodblock prints were on view. As a result, *japonisme*, the French term for the Japanese aesthetic, became popular in fashionable Parisian circles. Japanese prints exerted considerable influence on Impressionist painters in France, the United States, and elsewhere.

Woodblock printing had begun in China in the fourth century A.D. In the sixth century, Buddhist missionaries brought the technique to Japan. At first, it was used for printing words, but in the sixteenth century artists began to make woodblock images illustrating texts. Originally the images were black and white, but in the seventeenth century color was introduced. In order to create a woodblock print in color, the artist makes a separate block for each color and prints each block separately. The raised portions differ in each block and correspond to a different color in the final print. It is important, therefore, that the outlines of each block correspond exactly, so that there is no unplanned overlapping or empty space between forms.

The prints that most influenced the Impressionist painters were made during the Edo period (1615–1868). Founded in 1590 as a castle city, Edo (the former Tokyo) became the capital of Japan. In the seventeenth century, Edo was an urban center of feudalism and was the primary residence of the Shogun, or military ruler, whose power was nearly

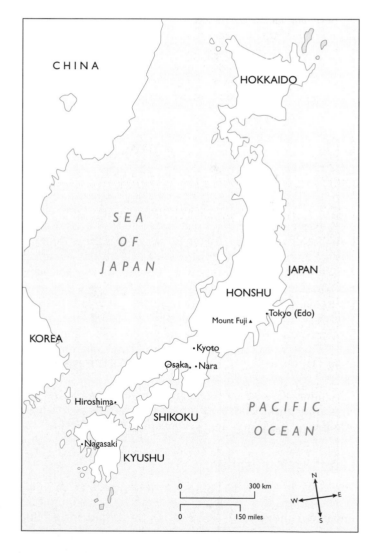

Map of 19th-century Japan.

absolute. Nevertheless, a merchant class developed that produced the main patrons of literature and the visual arts. Woodblock prints provided multiple images, which could be sold to a wide audience. As a result, publishers commissioned artists to prepare preliminary designs and then supervised the engraving, printing, and sale of the final works.

Japanese art students were apprenticed to master artists for a lengthy period of training. The signatures on the prints reflect this system, for the artist had a chosen name (or *go*) as well as an apprentice name. The former was framed by a cartouche while the latter was usually unframed and placed at the bottom of the page. A publisher's mark might also be stamped on the print. At the top of the page are the titles of the individual texts, or series of texts, that are illustrated. If the subject is an actor, his name or role is sometimes added.

From 1790 to 1874, the Japanese government made several unsuccessful attempts to censor certain types of imagery—especially erotica—so occasionally there is an official seal and a date printed on the page. The standard dimensions (*oban*) of a woodblock print were 15 by 10½ inches (38 × 26 cm). Smaller works were reduced proportionally, and subjects demanding larger sizes or several episodes were printed in sections and then attached to each other.

Ukiyo-e

The Golden Age of Japanese woodblock was the Ukiyo-e school of painting, which was founded around the middle of the seventeenth century. It lasted until the end of the Edo period in 1868. The term *ukiyo-e* means "floating world" and refers to the transience of material existence. The most popular subjects were theater, dance, and various kinds of female services ranging from outright erotica to the highclass courtesan. Respectable, middle-class women performing daily tasks were also depicted, but mythological and historical scenes were less popular, and landscape was used only as background until the nineteenth century. Both the stylistic techniques of woodblock prints and their subject matter—leisure genre scenes, entertainment (such as theater), courtesans, landscape and cityscape, aerial and close-up views, and so forth—have affinities with French Impressionism.

Utagawa Kunisada

The actor in figure **9.1** by Utagawa Kunisada (1786–1865) is shown from a close-up viewpoint. The monumental impact of the print is created by the broad forms that extend beyond the frame. The actor's stylized facial expression—its exaggerated, masklike quality—conforms to the stylization of the Kabuki theater. (Kabuki is a type of Japanese theater derived from sixteenth-century songs

9.1 Utagawa Kunisada, *The Actor Seki Sanjuro in the Role of Kiogoku Takumi*, 1860. Woodblock print with *gauffrage* (blind printing) and burnishing. Collection Hotei, the Netherlands.

and dances that were originally performed by women and later exclusively by men. The typical Kabuki play lasts many hours and has many parts. There is a great deal of action in the plot, actors change costume on stage, and props are numerous. Costumes are elaborate, poses and gestures are stylized, and the actors' voices are trained according to strictly defined systems of modulation. Music and sound effects are created by a banjo, drums, bells, and clappers.) The triptych (fig. **9.2**) of around 1835 shows an episode from a Kabuki play. Here stylization characterizes the interaction among the players: figures assume contorted, *contrapposto* poses that constrict and monumentalize the space. At the same time, the elaborate patterning of the costumes carries the observer's gaze across the picture plane and accentuates the flatness of the surface.

9.2 Utagawa Kunisada, *Scene from Sukeroku,* c. 1835. Woodblock print; 8½ × 22½ in. (21.6 × 57.2 cm). Victoria and Albert Museum, London.

Utagawa Toyokuni

Utagawa Toyokuni's (1769–1825) actor portrait (fig. **9.3**) shows Onoe Matsusuke as a villain. Its lively color and expressive character were qualities that contributed to Toyokuni's reputation as the best artist of his generation. In this work, the figure's full body is represented, but the face, despite its small size, is the focus of attention. The picture plane is dominated by the geometry of the costume, from which the villain's face emerges. The downward curve of his mouth and long, pointed nose accentuate his villainous intent. This, in turn, is reinforced by the upward sweep of his sword's sheath, which repeats the curved eyebrows and headdress. Both this actor's portrait and the one in figure 9.1 convey an intensity of stylized pose, gesture, and facial grimacing that is typical of Kabuki.

9.3 Utagawa Toyokuni, *Portrait of the Actor Onoe Matsusuke as the Villain Kudo Suketsune,* 1800. Woodblock print; 14⅝ × 9⅝ in. (37.2 × 24.6 cm). Victoria and Albert Museum, London.

Kitagawa Utamaro

The Ukiyo-e images of beautiful women (*bijin*) reflect a new expressiveness of mood and personality. The late eighteenth-century example by Kitagawa Utamaro (1753–1806) illustrated here (fig. **9.4**) is from a series entitled *Ten Facial Types of Women*. It reveals some of the differences between Western and Japanese portraiture. At first glance, the stylization of the *Young Woman with Blackened Teeth Examining Her Features in a Mirror* appears to eliminate the specificity of Western portraits. The depiction of the features recurs in many of Utamaro's female portraits: the brushed eyebrows form two raised curves, the eyes contain a black pupil, the nose is purely linear, and the small lips are slightly parted. A sense of three-dimensional space is created by contours almost entirely without shading. As in Kunisada's *Actor,* it is by the foreshortening of the forms and the arrangement of curved outlines—especially of the drapery folds—that Utamaro conveys the illusion of depth. The flat background was originally coated with powdered mica, most of which has since worn away. But its shine made the figure stand out, enhancing its three-dimensional quality and creating a reflective, mirrorlike surface.

Two aspects of this print can be related to the later prevailing concerns of Western Impressionism. The intimate, close-up view, in which one sees the woman in a private moment of self-absorption, became an Impressionist theme. She is unaware of being observed, for she is locked in the gaze of her own reflection. The flat blackness of the mirror repeats the other blacks—hair, pupils, teeth, and the official stamps and signatures in the upper right. Silhouettes of this kind would appeal to the Impressionist taste for the effects of black-and-white photography. Furthermore, the back of the mirror—its form as well as its black tone—makes us aware of our exclusion from the intimate interchange between the woman and her reflection. This, too, became characteristic of certain Impressionist works.

9.4 Kitagawa Utamaro, *Young Woman with Blackened Teeth Examining Her Features in a Mirror,* from the series *Ten Facial Types of Women,* c. 1792–1793. Woodblock print; 14⅖ × 9⅖ in. (36.5 × 24.6 cm). British Museum, London.

Keisei Eisen

The print of *The Prostitute Hanaoka Holding a Poem* (fig. **9.5**) by Utamaro's pupil Keisei Eisen (1790–1848) illustrates a different type of *bijin*. This is one of the Edo period's high-ranking courtesans decked out in full regalia. Her lofty position is reflected by the massive proportions of her robe and the attention to its design. Utamaro's influ-ence is evident in the depiction of the unmodeled face but not in the abundance of patterning.

The setting for this scene was the Yoshiwara district of Edo, which was reserved for female services accorded to men. Access to such services was highly sought after, requiring money, contacts, and persistent courtship. The poem in Eisen's print was presumably the offering of an admirer hoping for Hanaoka's favors.

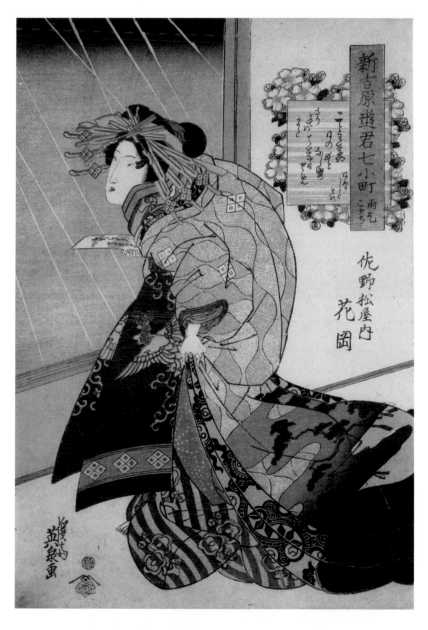

9.5 Keisei Eisen, *The Prostitute Hanaoka Holding a Poem,* from the series *Prostitutes from the New Yoshiwara Compared to the Nine Episodes in the Life of Onono Komachi.* Collection Hotei, the Netherlands.

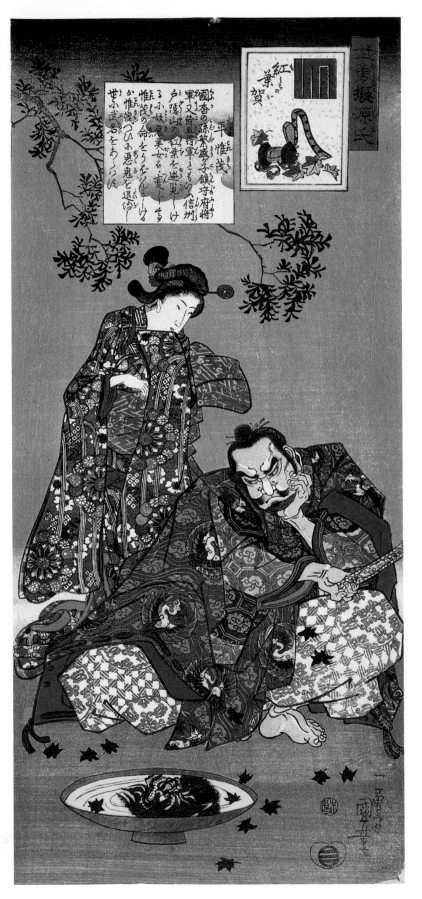

Utagawa Kuniyoshi

Tairano Koremochi Waking Up from a Drunken Sleep (fig. **9.6**) by Utagawa Kuniyoshi (1797–1861) illustrates a scene from the *Tale of Genji,* an epic Japanese romance of the eleventh century attributed to the aristocratic Lady Murasaki Shikibu. It chronicles the life of its hero, Genji, and continues into the generation of his grandchildren. In this episode, a man sees a woman reflected in a large *sake* cup as a demon. In contrast to the portraits, this print has a sense of place. Scattered leaves and the *sake* cup appear to be on the ground, and the tree branch identifies an outdoor setting. The attention to detail in the layers of patterned drapery corresponds to the elaborate descriptions of sartorial minutiae that characterize the *Tale of Genji.*

Katsushika Hokusai

The two greatest Japanese woodblock artists who accorded a prominent role to landscape were Katsushika Hokusai (1760–1849) and Utagawa Hiroshige (1797–1858). Hokusai's *Great Wave of Kanagawa* (fig. **9.7**) is from the series entitled *Thirty-Six Views of Mount Fuji.* Such series of scenes, in particular different views of the same place or similar views of the same place at different times of day and in different seasons, were taken up by the Impressionists. In addition, the use of Prussian blue, which was imported from Europe, as well as linear perspective and foreshortening, reflects the fact that the Far East was also influenced by the West. The blue enhances the wave's naturalism, and the dramatic rise of the wave and its nearness to the picture plane create its impressive effect. This is a convincing portrayal of the rhythmic power of a swelling wave, even though the wave's flat, patternistic quality seems to arrest its movement. In the distance, the sacred Mount Fuji is small and insignificant by comparison. When the Impressionists first saw this print in the late nineteenth century, they were astounded by it. According to the French composer Achille-Claude Debussy (1862–1918), this

9.6 Utagawa Kuniyoshi, *Tairano Koremochi Waking Up from a Drunken Sleep,* 1843. Woodblock print. Collection J. Asselbergs, the Netherlands.

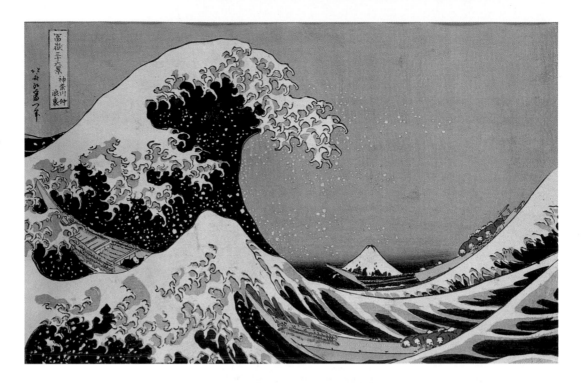

9.7 Katsushika Hokusai, *Great Wave of Kanagawa*, from the series *Thirty-Six Views of Mount Fuji*, 1831. Woodblock print; 9⅞ × 14⅝ in. (25.0 × 37.1 cm). Victoria and Albert Museum, London.

image inspired the music of his famous atmospheric composition *La Mer* (*The Sea*).

Hokusai's *Horsetail Gatherer* (fig. **9.8**) of about 1840 uses landscape to create an atmosphere of stillness. As in the *Great Wave,* the artist depicts the scene from a bird's-eye view. It is from a Noh play, another type of Japanese theater. In contrast to Kabuki, Noh plays are austere, usually consisting of one main actor conveying a specific emotion. Hokusai's print shows an old man searching the woods and mountains for his lost child. In the print, the moon moves from behind the distant trees as if to light the man's way. But although it is nighttime, the landscape is brightly illuminated. Its stillness is broken only by the flowing water under the bridge. The curves of the stream form a sharp contrast to the smooth, glasslike water on which two ducks have settled. Their peacefulness highlights the man's anxious search, which, in turn, is echoed in the rushing stream beneath him.

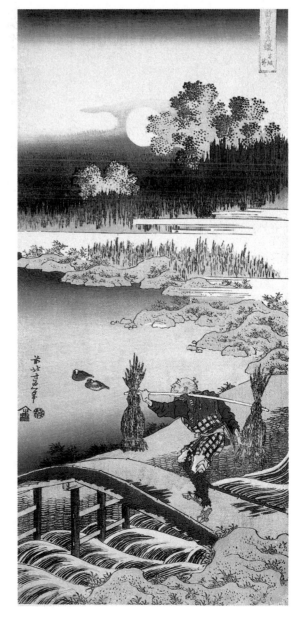

9.8 Katsushika Hokusai, *The Horsetail Gatherer,* c. 1840. Woodblock print; 19⅟₁₆ × 8⅔ in. (50 × 22 cm). Musée des Arts Asiatiques-Guimet, Paris.

Utagawa Hiroshige

Travel, which became a popular subject in nineteenth-century France, is also depicted in Japanese woodblock prints. Hiroshige produced several travel series, which established his reputation. *Travelers in the Snow at Oi* (fig. **9.9**) is from the *Sixty-Nine Stations of the Kisokaida* of the late 1830s. Hiroshige, like the Impressionists, conveys a sense of the season. The abundance of white, the heads bowed and arms folded to ward off the falling snow, express the coldness of winter. This impression is enhanced by the minimal color, the stark geometric quality of the round hats, and the predominance of flattened forms.

Hiroshige's last series was entitled *One Hundred Famous Views of Edo*. The *Kasumigaseki* (the pre-World War II Foreign Ministry at the right and also the name of the sloping street) illustrates festivities associated with the New Year celebration (fig. **9.10**). A procession of outdoor lion dancers and jugglers climbs the slope. The central figure carries a pole, whose inscription would have alluded to the sun goddess worshiped by the performers. Her presence is implied in the rich red of the horizon, which is echoed in the high-flying red kite. To the left of the procession, two performers of chants and dances watch intently, and to the right a mother and daughter begin to descend the slope. Approaching the foreground from the opposite

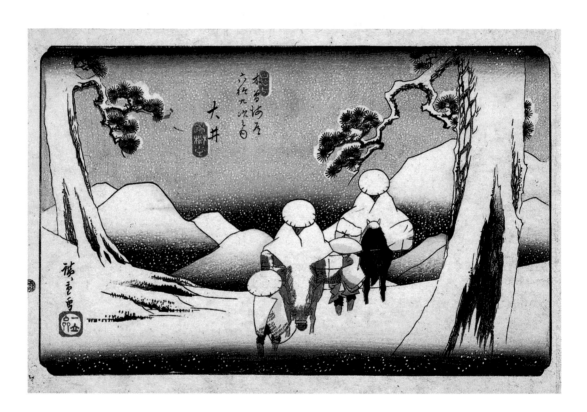

9.9 Utagawa Hiroshige, *Travelers in the Snow at Oi*, late 1830s. Woodblock print; 10¼ × 14½ in. (26 × 36.8 cm). British Museum, London. Hiroshige was born in Edo and belonged to the samurai (warrior) class. His father was a supervisor of firefighters responsible for keeping the castle and the houses of its retainers safe. Hiroshige joined their ranks and worked with them during his training as an artist.

direction is a procession of samurai warriors. At the far left and right, respectively, one man is delivering boxes of sushi and the other is collecting boxes of fans to resell.

Hiroshige shows the scene in linear perspective as the buildings and figures going toward the background diminish in size. But he also uses aerial perspective in making the distant rooftops less distinct than the nearer buildings. The abrupt shift in perspective in the sharp descent of the street increases the dramatic character of the scene. In addition, the attention to the changing colors of the sky at dawn is consistent with the later Impressionist renderings of transitional times of day.

9.10 Utagawa Hiroshige, *Kasumigaseki,* 1857. 9¼ × 14½ in. (23.5 × 36.8 cm). Brooklyn Museum, New York.

Cross-Cultural Influences: Vincent van Gogh

The Dutch Post-Impressionist Vincent van Gogh not only studied and collected Japanese woodblock prints, but also copied scenes from Hiroshige's *One Hundred Famous Views of Edo*. His *Japonaiserie: Bridge in the Rain (after Hiroshige)*, for example, is a copy of Hiroshige's *Sudden Shower at Ohashi Bridge at Ataka* (figs. **9.11** and **9.12**). Both works share certain formal and iconographic interests with the French Impressionists. The picture planes are divided by strong diagonals—the bridge and the shoreline—into asymmetrical trapezoids. The resulting tilt is stabilized by the silhouetted verticals of the piers supporting the bridge. Hiroshige's portrayal of rain is echoed in the Impressionist studies of weather conditions, a subject that also had personal meaning for van Gogh. The darkened sky and the huddled figures, which are small and anonymous, echo van Gogh's depressive personality. And, as in many of van Gogh's paintings, the people in Hiroshige's print are arranged in pairs that contrast with single figures. A lone boatman, working against the current, drives his boat up the river. Such juxtaposition of pairs and solitary figures was a continuous theme in van Gogh's work. It reflected his personal struggle with isolation and his unsuccessful attempts to form a lasting relationship with a woman. It also evoked his close—"paired" —relationship with his brother Theo.

9.11 Vincent van Gogh, *Japonaiserie: Bridge in the Rain (after Hiroshige)*, 1887. Oil on canvas; 28¾ × 21¼ in. (73 × 54 cm). Vincent van Gogh Foundation. Rijksmuseum Vincent van Gogh, Amsterdam.

9.12 Utagawa Hiroshige, *Sudden Shower at Ohashi Bridge at Ataka*, from the series *One Hundred Famous Views of Edo*, 1857. Woodblock print; 14⅛ × 9¾ in. (35.9 × 24.8 cm). Whitworth Art Gallery, University of Manchester.

10
Aspects of Oceanic Art

Oceania (see map, page 125), in the Pacific Ocean, is a large region consisting of many island groups north and east of Australia. It includes Polynesia (many islands), Melanesia (black islands), and Micronesia (small islands). Oceania attracted European explorers such as Captain James Cook, who sailed to Oceania on three separate occasions in the eighteenth century. His accounts of what he saw inspired the Romantic notion of an island paradise. In the late nineteenth century, Oceania, especially Tahiti, fascinated the Post-Impressionist painter Paul Gauguin, who spent several years living and working there. In 1882, the Paris Museum of Ethnography (the Musée de l'Homme) was opened to the public. The museum remains in existence today, and its installations are designed to exhibit Oceanic works in their cultural settings.

Polynesia

Easter Island

In 1872, the great French actress Sarah Bernhardt was given a drawing of the monumental statues on Easter Island. These imposing stone figures have huge heads and block-like features. They date from the seventh to the late seventeenth century A.D. and are among the most monumental of Oceanic sculptures (fig. **10.1**). Their frontal poses and impassive gazes endow them with a fascinating, timeless quality. Some mark burials, but their primary purpose was to embody the divine power of a deceased ancestral ruler.

Easter Island, on the southeastern tip of Polynesia, was colonized by the Marquesans (inhabitants of the Marquesas Islands) from A.D. 300. Captain Cook described the impressive artistry of the Easter Island carvers who produced the figures from volcanic tufa. Known as *moai,* these statues consist of an upright torso and head standing on a stone wall and gazing out to sea. Some had eyes inlaid with coral or stone as well as stone crowns, or hairpieces, resembling topknots.

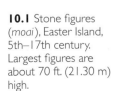

10.1 Stone figures (*moai*), Easter Island, 5th–17th century. Largest figures are about 70 ft. (21.30 m) high.

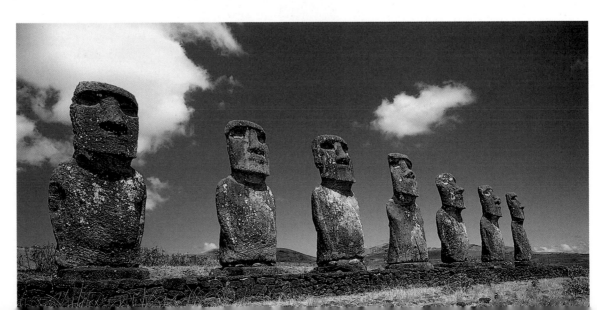

Hawaii: *Kukailimoku*

Around A.D. 300, Marquesans also inhabited Hawaii, which is at the northern end of Polynesia. By the late eighteenth century, European explorers reported having seen temples surrounded by moats and guarded by monumental sculptures representing boundary gods. These differ from the Easter Island figures in that they are made of basketry or carved from wood and are depicted with specific facial features and expressions.

A good example of such figures is the wood sculpture of the Hawaiian war god, Kukailimoku (fig. **10.2**). The sturdy, blocklike limbs and short torso are surmounted by a huge head, believed to be the site of the god's power. Kukailimoku's face is nearly all mouth; his toothy grimace is framed by repeated curves. He is shown bellowing out a war cry, his nostrils flaring, his jaw jutting, and his hands and feet coiled as if ready to spring forward. The sharp, angled facets of the crested headdress echo the forms of the teeth and enhance the sense of aggressive fury.

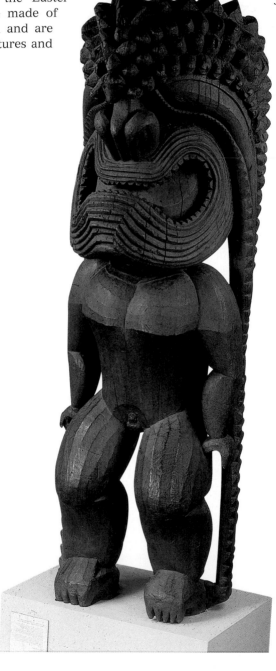

10.2 *Kukailimoku*, late 18th–early 19th century. Wood; 7 ft. 7 in. (2.36 m) high. British Museum, London.

The Marquesas: Tattooing

The Marquesas Islanders were masters of the Oceanic art of tattooing. Tattoos, from the Tahitian word *tatau,* were believed capable of protecting the wearer in daily life and in battle. Figure **10.3** shows a nineteenth-century European engraving of a warrior carrying a weapon and a water gourd. His elaborate tattoos, which are a mark of his status, are arranged in relatively symmetrical patterns, echoing the near (but not absolute) symmetry of nature. The predominance of curves reflects the organic forms of the body, with individual shapes accentuating anatomy— for example, the ovals at the calves and along the arm muscles, and the triangles pointing toward the toes.

The top of the war club is decorated with a stylized face, having two large "eyes" and pupils in the form of little faces. A third face appears just below the mustachioed curves under the "eyes." Such repetition of frontal eye and face configurations may have served an apotropaic (protective) function.

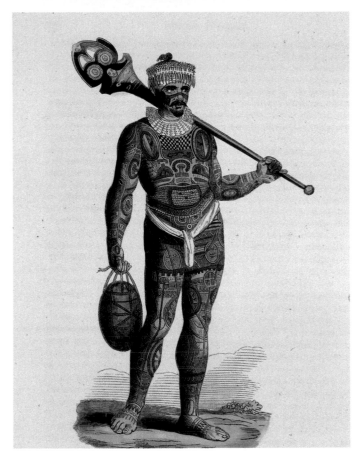

10.3 *Marquesan Warrior Decorated with Tattoos.* Engraving from N. Dally, *Customs and Costumes of Peoples of the World* (Turin, 1845).

Map of Oceania.

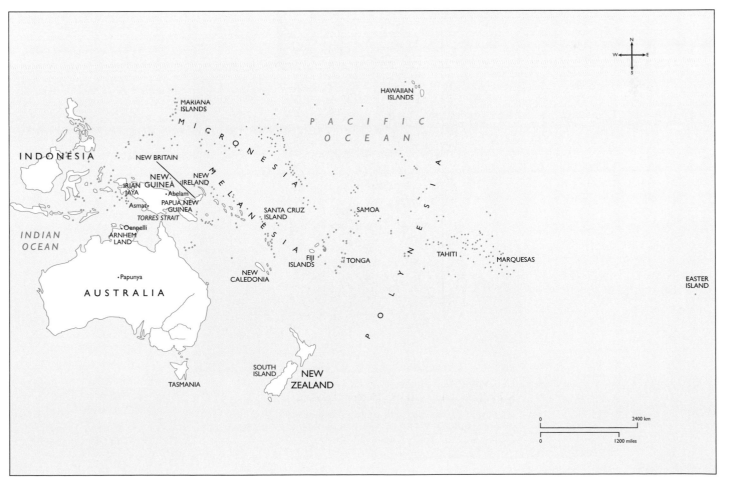

Melanesia: New Guinea

The large island of New Guinea in Melanesia has been inhabited since at least 40,000 B.C. and some of the islands in the Bismarck Archipelago (such as New Ireland and New Britain) by at least 30,000 B.C. Most of the remaining Melanesian Islands and coastal regions of New Guinea were populated more recently from around 4,000 B.C. by seafaring peoples who spoke Austronesian languages related to Malayo-Polynesian languages. The largest of the Melanesian islands, 1,200-mile-long New Guinea, is home to a wide variety of cultures. Their art, which includes ritual masks, ancestral poles, initiation houses, weapons, canoes, drums, and other objects, is generally related to ceremonial practices.

New Ireland: Malanggan Mask

The mask for lifting taboos from New Ireland, in northeastern Papua New Guinea, is of a type known as Malanggan, used in burial rites designed to summon the tribal ancestors (fig. **10.4**). This colorful mask is decorated with complex images of snakes, birds, and fish, all of which are endowed with totemic significance. Its designs are somewhat symmetrical, although the many small shapes and linear variety create a sense of rapid movement and some visual confusion. The mask's overall structure, on the other hand, is ordered symmetrically—a central, aggressive face with bared teeth is framed by two long ears extending below the chin. Two verticals, painted with feather and eye motifs, rise from the top of the head. Interlaced through the openings (including the nostrils) are serpentine shapes that tie the visual units together; their heads emerge and point upward at the top of the verticals.

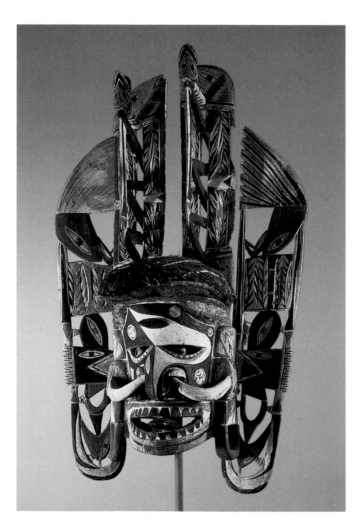

10.4 Malanggan mask for lifting taboos, northern New Ireland, Papua New Guinea, late 19th century. Painted wood, fiber, and feathers; 2 ft. 1½ in. (64.8 cm) high. Museum der Kulturen, Basel, Switzerland.

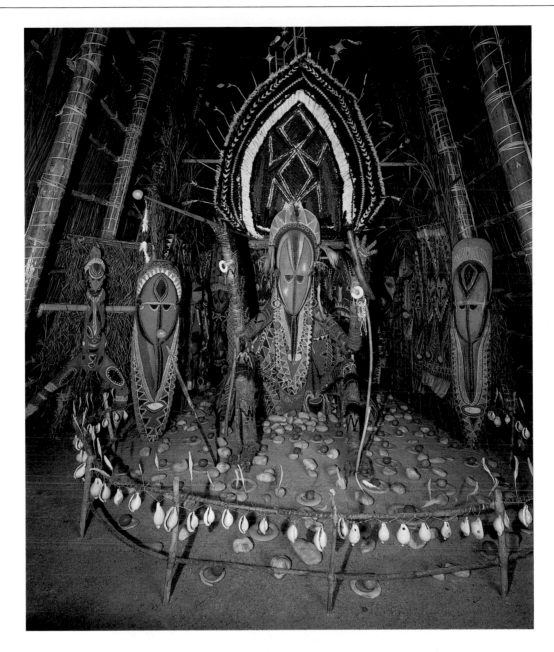

10.5 Abelam initiation-house interior from Bongiora, East Sepik Province, Papua New Guinea. Collected by G. F. N. Gerrits in 1972–73. Museum der Kulturen, Basel, Switzerland.

Abelam Initiation House

The art and culture of the Abelam people north of the Sepik River, Papua New Guinea, centered around agricultural fertility and initiation ceremonies. The Abelam constructed initiation houses, which are conceived of as female, with poles surmounted by spires, which are conceived of as male. Young Abelam men grow a type of particularly long yam, which is highly valued for both its phallic symbolism and its trade value.

Agricultural initiation rites mark the boys' transition to maturity as they are symbolically reborn when they enter the "womb" (interior) of the female house. Figure **10.5** shows a room inside the ceremonial house. It is elaborately decorated with a large costumed and masked ancestor manikin before a crest made of feathers. The walls are painted, and shells are suspended from a low wooden barrier in front of the manikin. The floor is strewn with ritual objects—stones, fruit, and leaves. All of these elements are believed to assist the young male farmers in their gendered function of growing large yams endowed with masculine fertilizing power.

Asmat: Ancestor Poles and War Shields

The art of the Asmat, who inhabit the southwest coast of New Guinea (modern Irian Jaya, in Indonesia), focuses on ancestral imagery and practices related to head-hunting and cannibalism. In Asmat culture, women raise the children, gather food, and participate in community affairs. Men engage in head-hunting and war. If one member of a village is killed, his angry spirit is thought to be a source of danger until appeased by a number of ritual acts, including the killing, eating, and beheading of the enemy. Cannibalism among the Asmat derives from the belief that

eating the flesh of an enemy and displaying an enemy's severed head transfer power from the vanquished to the victor. In some regions, the Asmat build canoes to contain the angry spirit, pending its appeasement.

The Asmat also construct tall ancestral poles, or *mbis*, for the same purpose. The three poles illustrated here (fig. **10.6**) are intricately carved with ancestor images designed to convey a number of symbolic ideas. The shafts contain figural images supported at the base by shapes representing the roots of the sacred banyan tree. At the top, the figures that are posed like the praying mantis (which bites off the head of its mate) allude to head-hunting. The diagonal projections represent phalluses, which are

10.6 Asmat ancestral poles (*mbis*), New Guinea, 1960. Painted wood and sago palm leaves; about 17 ft. (5.20 m) high. Metropolitan Museum of Art, New York.

imbued with the masculine power of Asmat ancestors. They also embody the ability of the Asmat warrior to take revenge by successfully head-hunting his enemy.

Similar intricate carving can be seen on the wooden shields of Asmat warriors (fig. **10.7**), which also contain phallic, head-hunting-related iconography. The top of the left shield resembles the head of both a phallus and a ray fish. Represented in relief below are five stylized flying foxes, which are flattened and frontal. The foxes, like the praying mantis, are signs of head-hunting. Decorative elements on the central shield include a human head at the top, curvilinear wing shapes over most of the surface, and a human figure at the bottom. Its absent head suggests that the figure might be a defeated enemy. The shield at the right has a large human figure taking up most of the field, an ancestor, a bird, and various curves and S shapes. In all three shields, the emphasis on predatory animals, the phallic fish, and the headless humans reflect the association of a successful headhunter with masculine power.

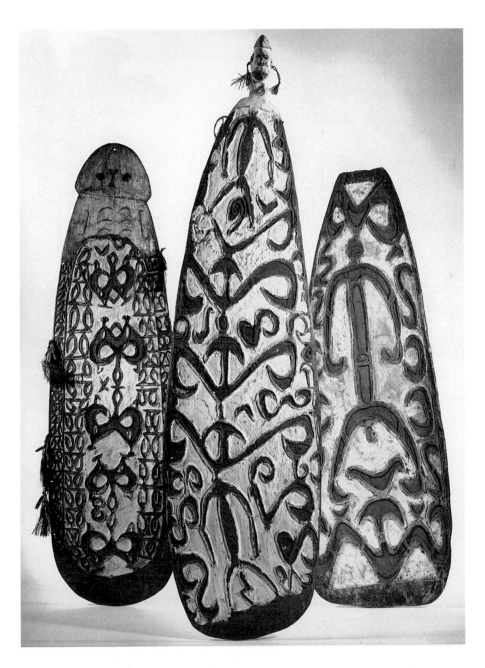

10.7 Asmat war shields, New Guinea, 20th century. Wood. Metropolitan Museum of Art, New York. The Michael C. Rockefeller Collection. Gift of Nelson A. Rockefeller. Museum photo.

Cross-Cultural Influences: Jean Dubuffet

To the Western eyes of the twentieth-century French painter Jean Dubuffet (1901–1985), Oceanic designs, particularly those of New Guinea, resonated with the post-Freudian fashion for "automatic writing." The interest in hidden meaning and hidden images that seemed to emerge spontaneously from the unconscious was a feature of several Western styles—including Cubism, Surrealism, Abstract Expressionism, and Figurative Abstraction. Dubuffet, who worked in the latter style, coined the term *art brut,* or "raw art," to convey what he thought of as a "primitive," childlike, and spontaneous sensibility. He collected Oceanic art of the type seen in the small spirit figure (fig. **10.8**) from Papua New Guinea, which somewhat resembles the lively forms and organic patterns of his own *L'Hourloupe* series, of which *The Reveler* is an example (see fig. **10.9**).

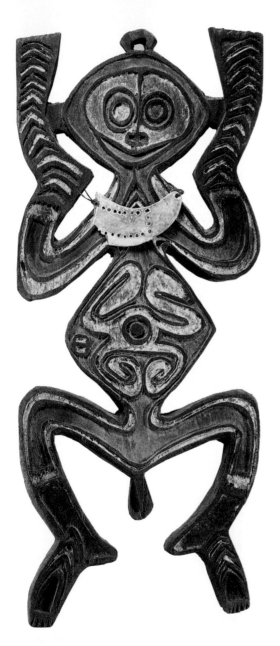

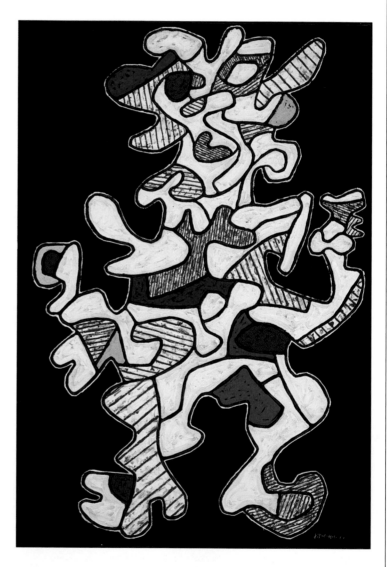

10.9 Jean Dubuffet, *The Reveler,* 1964. Oil on base of black acrylic; 6 ft. 4¼ in. × 4 ft. 3¾ in. (1.94 × 1.31 m). Dallas Museum of Art, Texas. Gift of Mr. and Mrs. James H. Clark.

10.8 Spirit figure from Wapo Creek, Papua New Guinea. Painted wood and shell; 25 in. (63.5 cm) high. Friede Collection, New York.

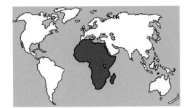

11
Africa
The Royal Art of Benin

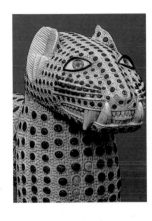

From about 1906, leading European artists began to notice African works in museums and shops, to discuss them with each other, and to collect them. Artists also traveled outside of Europe more than they had in the past. Despite this geographic and intellectual expansion, the early twentieth-century approach to the visual arts led to certain misconceptions about African art. First, Africa is a huge continent (see map), comprising many different cultures, each with its own artistic history. The time span of African art is as vast as that of Europe, ranging from the Stone Age to the present. Second, the understanding of African art is complicated by certain essential differences between it and other non-Western styles. Unlike Far Eastern art, there is virtually no narrative in African art. African artists did not conceive of their objects as set in a time and space in the way that Western artists had. As a result, much African art has a timeless quality, which was one of the sources of its appeal to the West.

In this section, we focus on a few works of art from the kingdom of Benin. Around the turn of the century the art of Benin, a small kingdom in the southeastern part of modern Nigeria, attracted the art world's attention. Benin culture had been known since the fifteenth century, when the Portuguese infiltrated the area, sending missionaries, fighting as mercenaries in the Benin armies, and introducing guns to the local population. As traders, the Portuguese were interested in cloth, ivory, pepper, gold, and slaves. Their presence on Benin soil is known from contemporary accounts and from bronze Benin sculptures representing Portuguese soldiers. Two centuries later, the Dutch also began trading in Benin. In 1897, a group of

British officials went to Benin City during the annual festival honoring royal ancestors. The officials were killed, and Britain sent in a force known as the "Punitive Expedition," which burned the city. The metal and ivory objects that survived were taken to England. Some were sold to the British Museum, others to the Berlin Museum of Folk Art. Several ended up in private collections.

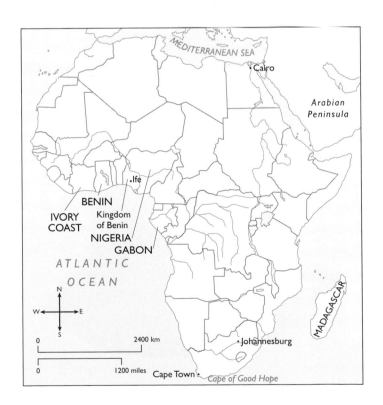

Map of Africa.

The Oba and the Queen Mother

The bronze head in figure **11.1** represents the oba, or divine king, of Benin. He controls the fate of his subjects through the spiritual power conferred on him by his divine ancestors. In Benin tradition, which is transmitted orally, the former celestial kings of Benin had failed their subjects, who sought a new ruler. They turned to the oni, who ruled the neighboring Ife culture in modern Nigeria, and he sent his son, Oranmiyan, to Benin. There he became the father of Eweka I by a local princess. The present oba is the direct descendant of Eweka I and the undisputed ruler of Benin. He combines the power of earth and sky, and is both feared and loved by his people.

According to Benin tradition, lost-wax bronze casting was a fourteenth-century import from Ife. Heads of kings

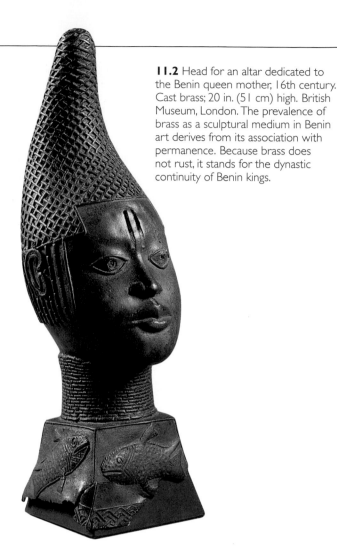

11.2 Head for an altar dedicated to the Benin queen mother, 16th century. Cast brass; 20 in. (51 cm) high. British Museum, London. The prevalence of brass as a sculptural medium in Benin art derives from its association with permanence. Because brass does not rust, it stands for the dynastic continuity of Benin kings.

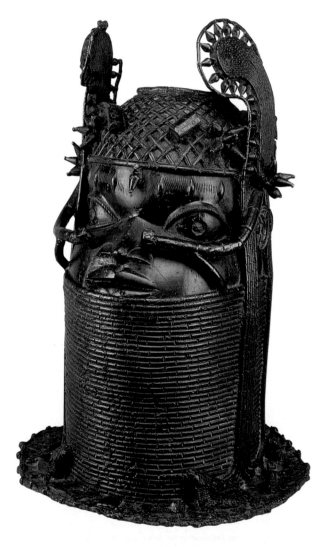

11.1 Bronze oba head, Benin, mid-19th century. 20⅛ in. (51.1 cm) high. British Museum, London. In 1927, Picasso acquired an oba head for his personal collection of African art.

cast in bronze or brass comprise a major iconographic category in Benin art. They reflect the importance of the oba as a patron and the fact that most Benin art is connected to the court. The example illustrated here is cast in bronze, a technique introduced in the late 1300s. Multiple strands of coral beads covering the neck and chin are indications of wealth and status. The crown is decorated on either side with curved features, which were introduced in the nineteenth century. Such works were placed on ancestral altars—in this instance as a stand for an ivory tusk.

In the sixteenth century, from the period of Oba Esigie's reign, the Benin queen mother (the *iyoba*) was accorded special status. Esigie's mother, Idia, was honored for her role in helping her son achieve victory in the Tgala war. According to oral tradition, Idia was a skillful military tactician who was able to communicate with the spirit world. Her position is reflected in the production of heads cast in brass for altars in the queen mother's home and in the palace (fig. **11.2**). The high polish of the brass, the beaded strands around the neck, and the beaded crown adorning the so-called chicken's beak hairstyle are signs of her importance.

The carved ivory mask in figure **11.3** is also thought to represent the queen mother from Oba Esigie's reign. Its style, conveying a sense of organic form, is characteristic of

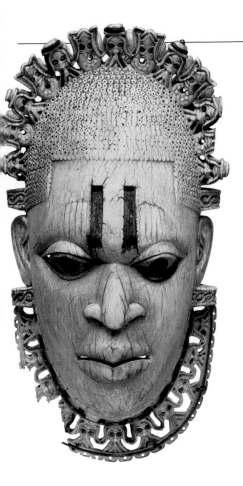

11.3 Pectoral ornament or waist pendant mask representing the queen mother, c. 1550. Ivory, iron, and copper; 9⅜ in. (23.4 cm) high. The Metropolitan Museum of Art, New York. The Michael C. Rockefeller Memorial Collection, gift of Nelson A. Rockefeller, 1972 (1978.412.323).

sixteenth-century Benin naturalism. Two motifs, Portuguese heads and mudfish heads, are repeated on the collar and the headdress; they frame and elongate the queen mother's head. These motifs were believed to transfer divine and earthly power to the queen mother's head—the Portuguese because they supplied Benin with guns, and the mudfish because it symbolized Olokun, the god of oceans and rivers.

Many examples of mudfish, cast in relief on plaques and merged with the oba, appear in Benin sculpture. In figure **11.4**, for example, the oba, facing front, has mudfish legs that also have frontal faces. This iconography has been related to the Benin belief that the paralyzed legs of Oba Ohe, or Ohen, were mudfish rather than human legs. In fact, it is likely that this claim was a countermeasure designed to keep the king in power, despite an obvious—and culturally unacceptable—disability. The oba on the plaque twirls a pair of leopards, which signified good luck and power.

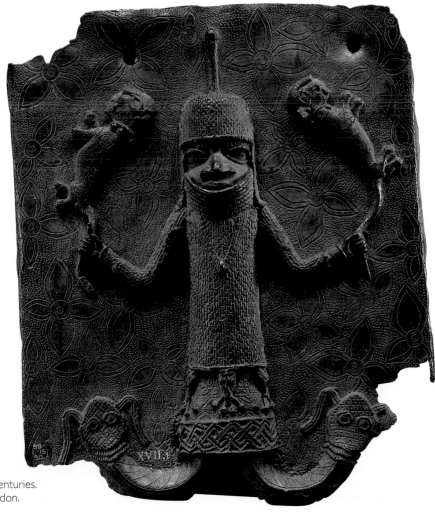

11.4 Plaque showing an oba with mudfish legs, 16th–17th centuries. Bronze; 16 × 12½ in. (40.6 × 31.7 cm). British Museum, London.

Portuguese Influence and Palace Architecture

The presence of Portuguese soldiers in the royal arts of sixteenth-century Benin is evidence of their acceptance by the culture. Since the arrival of their ships in the 1480s, the Portuguese brought goods such as shells and coral, cloth, brass, and weapons in exchange for spices, ivory, and slaves. They also provided mercenaries, which increased the power of the Benin kings.

The copper sculpture of a Portuguese soldier (fig. **11.5**), one of the objects looted during the Punitive Expedition, was probably meant for a royal altar. Despite the stylized eyes and mouth and the squat proportions, the figure is more naturalistic than the frontal, emblematic oba on the plaque (see fig. 11.4). The soldier turns freely in three-dimensional space, assuming a military stance as he prepares to take aim. The artist has paid careful attention to the interlace design on the base, pectoral, and helmet, which adds to the liveliness of the figure.

Evidence of both Portuguese influence and royal architecture can be seen in a sixteenth- or seventeenth-century plaque depicting a palace façade (fig. **11.6**). A warrior-priest with a shield and staff, or celt (an axlike tool), and a nude servant with a fan guard either side of an altar. Although all have similar stylized features, the warriors' higher status is shown by their larger size. Behind the altar, a flame pattern alludes to its divine spark infiltrating the air. Although the actual palace was destroyed by the British in 1897, it is known from surviving descriptions. It had a turret over the entrance, as this one does, and a figure of a bird, now missing from this example, at the top.

Pythons, as here, glided vertically along the turret; both the snake and the bird were royal protective devices. The python, in particular, was believed to unite various aspects of nature—comprising the earth from which it crawls and springs up, and the water in which it swims. The oba was thought capable of assuming bird and serpent shapes as a means of defeating evil, especially evil wrought at night. Vertical supports below the turret are decorated with small human figures, some of which are identified as Portuguese by their armor.

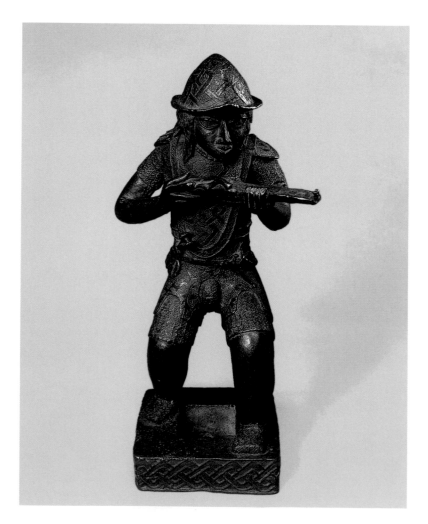

11.5 Portuguese soldier, 16th century. Copper alloy; 15 in. (38.0 cm) high. British Museum, London.

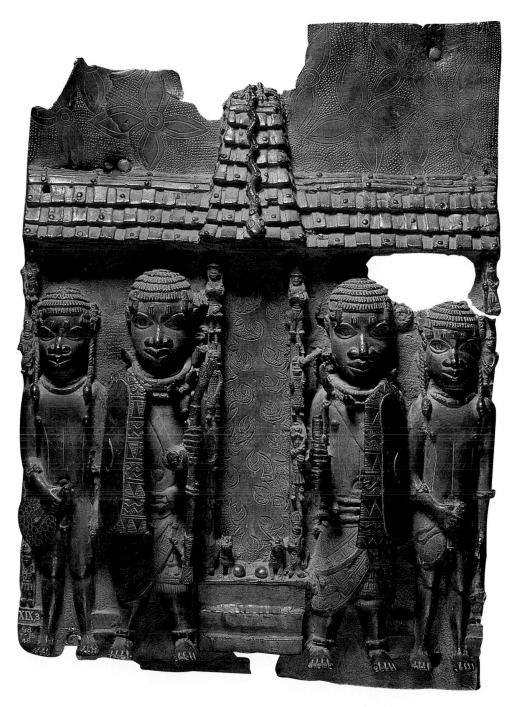

11.6 Plaque with an architectural façade and standing figures, 16th–17th centuries. Bronze; 21 × 14 in. (53.3 × 35.6 cm). British Museum, London.

Figure **11.7** shows a section of the Benin palace, which was the main architectural structure of the capital city. Cast by the lost-wax method, the box-palace includes the roof shingles, and patterned wall sections alternating with vertical supports. A bird, whose species has been debated by scholars, surmounts the turret and its descending python. Two other birds (one missing) guard the far ends of the roof, and two soldiers with European guns kneel between the birds. Here, as in the plaque, the guardian figures combine the power of European weapons with that of traditional mythological protective devices.

The brass stool in figure **11.8** was commissioned by the eighteenth-century oba Eresoyen, whose power was threatened by rebellion. There had been unrest in the Benin dynastic structure since the previous century, with different offshoots of the main dynasty vying for control. Eresoyen succeeded in restoring order, and his reign established peace and a flourishing of the arts. By this period, the Dutch had superseded the Portuguese as the main trading partner with Benin. The stool (fig. 11.8a), according to tradition, replicated a fifteenth-century Portuguese-made stool commissioned by Oba Esigie. Eresoyen's motive was to evoke the golden age of Benin and to reinforce the legitimacy of his own reign.

The base of the stool is decorated with reliefs of frogs and monkeys. At the center of the seat (fig. 11.8b) are reliefs of swords and blacksmith's tools. The crescent moon, cross, and sun are cosmic symbols, whereas the monkey head and elephant tusks merging into hands allude to the forest. Leaves held in the hands are magic protective devices. Framing the seat is an interlace with four additional monkey heads and two snakes on the outer rim.

The support is in the form of a coiled snake, symbolizing the oba's power and connecting two worlds, for the stool is reversible—it can be turned upside down. The other seat, which is not illustrated, contains additional animal motifs, including the crocodile and the mudfish.

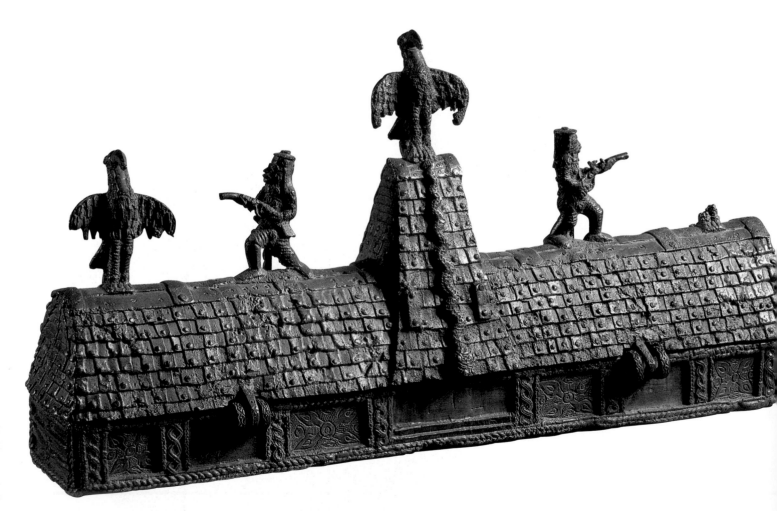

11.7 Box shaped like a palace, 17th–18th centuries. Brass, 12½ × 24 in. (32.0 × 61.0 cm). Museum für Völkerkunde, Staatliche Museen, Berlin.

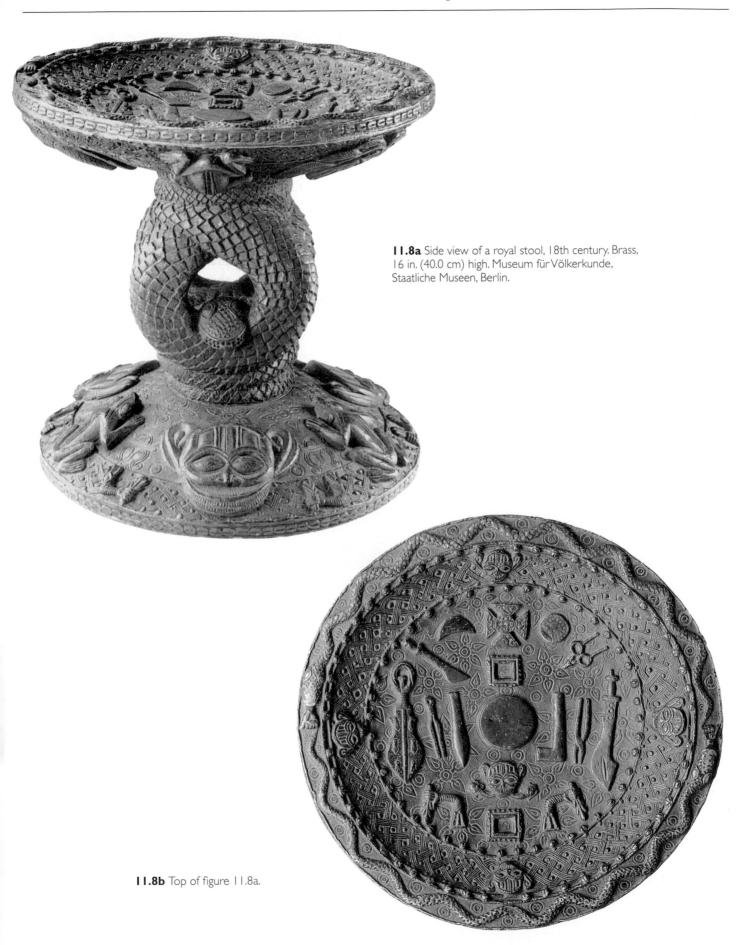

11.8a Side view of a royal stool, 18th century. Brass, 16 in. (40.0 cm) high. Museum für Völkerkunde, Staatliche Museen, Berlin.

11.8b Top of figure 11.8a.

Also protecting the divine Benin oba was the powerful leopard, statues of which traditionally flanked the king on state occasions. Live leopards were also kept in the palace. The nineteenth-century pair of leopards illustrated in figure **11.9** are made of brass and ivory, which were royal materials. They are impressive in their static but alert watchfulness. Their guardian function is enhanced by the tense pose, bared teeth, prominent fangs, and eyes made of mirrors. The spots are copper. A red coral ring encircles the haunches, symbolizing loyalty to the oba.

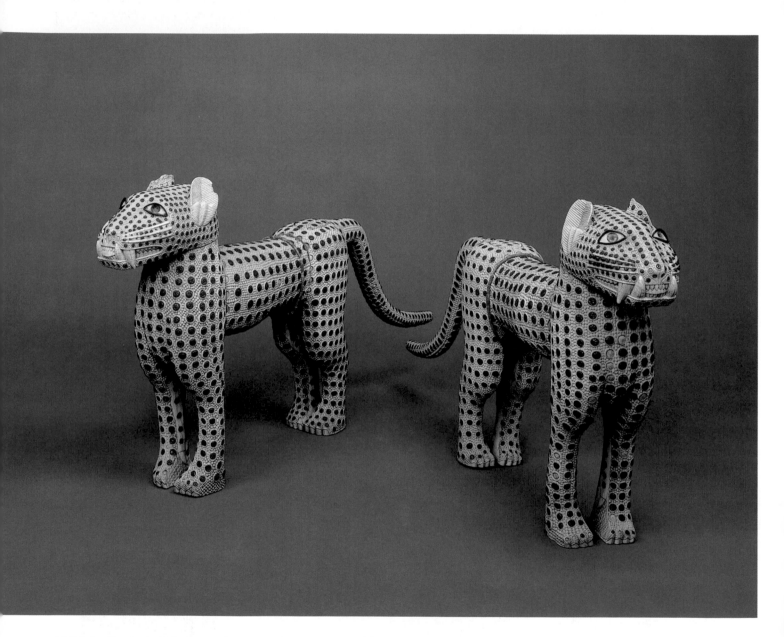

11.9 Pair of leopards, 19th century. Brass, ivory, glass, and copper; 32 in. (81.5 cm) high. Collection of Her Majesty Queen Elizabeth II, on loan to the British Museum, London.

Cross-Cultural Influences:
Kirchner, Nolde, and Matisse

For the Western avant-garde of the early twentieth century, the myths and symbols of non-Western cultures had meanings that were not necessarily those of their original cultures. In 1910, the German artist Ernst Ludwig Kirchner (1880–1938) described the Benin bronzes in the ethnology museum of Dresden as "a change and a delight."[1]

In 1912, Emil Nolde (1867–1956) asked: "Why is it that we artists love to see the unsophisticated artifacts of the primitives?" And he replied as follows: "It is a sign of our times that every piece of pottery or dress or jewelry, every tool for living has to start with a blueprint—Primitive people begin making things with their fingers, with material in their hands. Their work expresses the pleasure of making. What we enjoy, probably, is the intense and often grotesque expression of energy, of life."[2]

In an interview recorded in 1941, Henri Matisse (1869–1954) spoke about African sculptures in a shop on the rue de Rennes in Paris: "I was astonished to see how they were conceived from the point of view of sculptural language; how it was close to the Egyptians . . . compared to European sculpture, which always took its point of departure from musculature and started from the description of the object, these Negro statues were made in terms of their material, according to invented planes and proportions."[3]

Around 1916, Matisse's work began to reflect the influence of African sculpture, particularly its geometric stylizations. His bronze *Jeannette V* (fig. 11.10) of that year is imbued with a Cubist aesthetic and an appreciation of the African sculptor's difference from the Western Classical tradition in representing the human figure. The hair of his figure is divided into shifting forms, one of which merges into the long nose, and the neck and body are arranged in three zigzag planes. *Jeannette V* shares an aggressive, angular quality with the seated Bambara figure from Mali (fig. 11.11) that Matisse owned at the time. It is a type of image associated in Mali with a girl's initiation into adulthood and her procreative role in society. As with Cubist works, the structure of the figure is not organic. It has instead a geometric quality as if the features and limbs are attached to a vertical, rather than growing from it. In both works, there is an emphasis on pointed forms and a vigorous self-assertiveness.

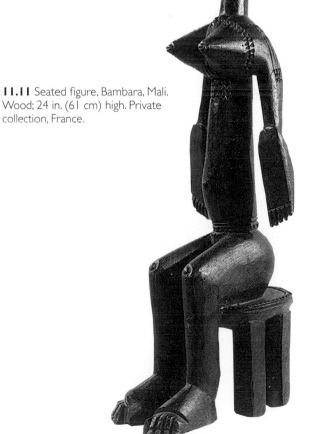

11.11 Seated figure, Bambara, Mali. Wood; 24 in. (61 cm) high. Private collection, France.

11.10 Henri Matisse, *Jeannette V*, 1916. Bronze; 23 × 7³⁄₄ × 11½ in. (58.4 × 19.7 × 29.3 cm). Art Gallery of Ontario, Toronto.

Glossary

Abhaya: see **Mudra**.

Amalaka: the cushion shape below the finial atop a northern-style Hindu temple's **shikhara**.

Anda: the dome of a Buddhist **stupa**, its egg shape symbolizing the arc of the heavens.

Aniconic: depicting a figure, usually a deity, symbolically instead of anthropomorphically.

Apsara (pl. **Apsaras**): celestial dancers seen in south and southeastern Asian religious art.

Axis: an imaginary straight line passing through the center of a figure, form, or structure and about which that figure, form, or structure is imagined to rotate.

Bhumi (literally, "earth"): the stacked ridges that horizontally segment a northern-style Hindu temple's **shikhara**.

Bhumisparsha: see **Mudra**.

Bodhisattva: one of many enlightened Buddhist deities who delay their own *nirvana* in order to help mortals attain enlightenment.

Calligraphy: handwriting designed to be beautiful; **calligraphic** writing or drawing can be expressive as well as beautiful.

Cantilever: a long, low architectural support that enables an element such as an eave or a cornice to project horizontally without vertical support at the far end.

Chaitya arch: a splayed, horseshoe-shaped curve derived from the profile of a barrel-vaulted **chaitya hall**; used to frame doors, windows, and gables, and as a decorative motif in early south Asian architecture.

Chaitya hall: a U-shaped Buddhist structural or rock-cut chamber for congregational worship centered on a **stupa**.

Chattra: a royal parasol crowning the dome **(anda)** of a Buddhist **stupa**, symbolically honoring the Buddha.

Chauri: a royal fly whisk symbolically honoring the Buddha.

Crypt: a chamber or vault wholly or partly below ground.

Dharmachakra: see **Mudra**.

Dhyana: see **Mudra**.

Finial: a small decorative element at the top of an architectural member such as a pinnacle or of a smaller object such as a vessel.

Garbha griha (literally, "womb chamber"): a small, cubical sanctuary that is the sacred core of a Hindu temple.

Gilding: a decorative coating made of gold leaf or simulated gold; objects to which gilding has been applied are **gilded** or **gilt**.

Harmika: a square platform surmounting the dome of a Buddhist **stupa**.

Ideograph: a written symbol standing for a concept, usually formed by combining **pictographs**.

Interlace: a form of decoration composed of strips or ribbons that are intertwined, usually symmetrically, about a longitudinal **axis**.

Jataka: a tale recounting an incident in the previous lives of the Buddha frequently depicted in Buddhist art.

Kondo: the main hall of a Japanese Buddhist temple, where religious images are kept.

Kufic: an early form of Arabic script in which letters are relatively uncursive; used later for headings and formal inscriptions.

Mandala: a cosmic diagram in Asian art.

Mandapa: a northern-style Hindu temple's porch.

Mandorla: an oval or almond-shaped aureola, or radiance, surrounding the body of a holy person.

Mihrab: a niche, often highly ornamented, in the center of a **qibla** wall, toward which prayer is directed in an Islamic **mosque**.

Minaret: a tall, slender tower attached to a **mosque**, from which the *muezzin* calls the Muslim faithful to prayer.

Minbar: a pulpit from which a Muslim (Islamic) *imam* addresses a congregation in a **jami mosque**.

Mithuna: a loving couple, symbolizing fecundity and riches in ancient South Asian art.

Mosque: an Islamic (Muslim) house of worship of two main types: the **masjid**, used for daily prayer by individuals or small groups; and the **jami**, used for large-scale congregational prayer on the Friday sabbath and holidays.

Mudra: a symbolic hand gesture, usually made by a deity, in Hindu or Buddhist art. Common Buddhist *mudras* include **abhaya mudra** (right hand raised, palm outward and vertical), meaning "fear not"; **dhyana mudra** (hands in lap, one resting on the other, palms up, thumb tips touching), signifying meditation; **dharmachakra mudra** (hands at chest level, palms out, thumb and forefinger of each forming a circle), representing the beginning of Buddhist teaching; and **bhumisparsha mudra** (left hand in lap, right hand reaching down, palm in and vertical, to ground level), symbolizing Shakyamuni Buddha's calling the earth to bear witness at the moment of his enlightenment.

Pagoda: a multistoried Buddhist reliquary tower, tapering toward the top and characterized by projecting eaves.

Petroglyphs: rock carvings.

Pictograph: a written symbol derived from a representational image.

Polychrome: consisting of several colors.

Prana: the fullness of life-giving breath that appears to animate some south and southeast Asian sculpture.

Qibla: a wall inside the prayer hall of a **mosque** that is oriented toward Mecca and is therefore the focus of worship.

Roof comb: an ornamental architectural crest on the top of a Maya temple.

Sahn: an enclosed courtyard in a **mosque** used for prayer when the interior is full.

Shikhara (literally, "mountain peak"): a northern-style Hindu temple tower surmounting a **garbha griha**, typically curved inward toward the top, with vertical lobes and horizontal segments **(bhumi)**, and crowned by an **amalaka** and finial.

Spacer: a small peg or ball used to separate metal, pottery, or glass objects during processes such as casting, firing, and mold blowing.

Stupa: in Buddhist architecture, a dome-shaped or rounded structure made of brick, earth, or stone, containing the relic of a Buddha or other honored individual.

Talud-tablero: an architectural style typical of Teotihuacán sacred structures in which paired elements—a sloping base (the **talud**) supporting a vertical **tablero** (often decorated with sculpture or painting)—are stacked, sometimes to great heights.

Torana: a ritual gateway in Buddhist architecture.

Tribhanga: in Buddhist art, the "three-bends posture," in which the head, chest, and lower portion of the body are angled instead of being aligned vertically.

Tugra: the Ottoman imperial monogram rendered in **calligraphic** style.

Urna: in Buddhist art, a whorl of hair or protuberance between the eyebrows of a Buddha or other honored individual.

Ushnisha: a conventional identifying topknot of hair on an image of Shakyamuni Buddha, symbolic of his wisdom.

Vedika: a railing that marks off sacred space in South Asian architecture, often found surrounding a Buddhist **stupa** or encircling the **axis** pillar atop its dome **(anda)**.

Veranda: a pillared porch preceding an interior chamber, common in Hindu temples and Buddhist **chaitya** halls.

Vihara: Buddhist monks' living quarters, either an individual cell or a space for communal activity.

Yaksha, yakshi: indigenous south Asian fertility deities, respectively male and female, later assimilated in Buddhist art.

Suggestions for Further Reading

Bahn, Paul, and John Flenley. *Easter Island: Earth Island*. London: Thames & Hudson, 1992.

Bauer, Brian S. *The Development of the Inca State*. Austin: University of Texas Press, 1992.

Ben-Amos, Paula Gershick. *The Art of Benin*, rev. ed. Washington, D.C.: Smithsonian Institution Press, 1995.

Berlo, Janet Catherine, and Ruth B. Phillips. *Native North American Art*. Oxford: Oxford University Press, 1998.

Berlo, Janet Catherine, and Lee A. Wilson. *Arts of Africa, Oceania, and the Americas: Selected Readings*. Englewood Cliffs, N.J.: Prentice-Hall, 1993.

Blier, Suzanne Preston. *The Royal Arts of Africa: The Majesty of Form*. New York: Abrams, 1998.

Chang, Léon Long-yien, and Peter Miller. *Four Thousand Years of Chinese Calligraphy*. Chicago: University of Chicago Press, 1990.

Chase, W. Thomas. *Ancient Chinese Bronze Art: Casting the Precious Sacral Vessel*. New York: China House Gallery / China Institute of America, 1991.

Clunas, Craig. *Art in China*. Oxford: Oxford University Press, 1997.

Coe, Michael D. *The Maya Scribe and His World*. New York: Grolier Club, 1973.

———. *The Maya*, 5th ed. New York: Thames & Hudson, 1993.

Coe, Michael D., and Richard A. Diehl. *In the Land of the Olmec*. 2 vols. Austin: University of Texas Press, 1980.

Corbin, George A. *Native Arts of North America, Africa, and the South Pacific*. New York: Harper & Row, 1988.

Craven, Roy C. *Indian Art: A Concise History*, rev. ed. New York: Thames & Hudson, 1997.

D'Alleva, Anne. *Arts of the Pacific Islands*. New York: Abrams, 1998.

Dehejia, Vidya. *Indian Art*. London: Phaidon, 1997.

Ettinghausen, Richard, and Oleg Grabar. *The Art and Architecture of Islam, 650–1250*. New York: Penguin, 1987.

Feest, Christian F. *Native Arts of North America*, updated ed. New York: Thames & Hudson, 1992.

Fisher, Robert E. *Buddhist Art and Architecture*. New York: Thames & Hudson, 1993.

Gillespie, Susan D. *The Aztec Kings: The Construction of Rulership in Mexican History*. Tuscon: University of Arizona Press, 1989.

Grabar, Oleg. *The Formation of Islamic Art*. New Haven: Yale University Press, 1973.

Guth, Christine. *Art of Edo Japan: The Artist and the City*. New York: Abrams, 1996.

Hanson, Allan, and Louise Hanson. *Art and Identity in Oceania*. Honolulu: University of Hawaii Press, 1990.

Holm, Bill. *Northwest Coast Indian Art: An Analysis of Form*. Seattle: University of Washington Press, 1965.

Huntington, Susan L. *The Art of Ancient India: Buddhist, Hindu, Jain*. New York: Weatherhill, 1985.

Irwin, Robert. *Islamic Art in Context: Art, Architecture, and the Literary World*. New York: Abrams, 1997.

Jessup, Helen Ibbitson, and Thierry Zéphir, eds. *Sculpture of Angkor and Ancient Cambodia: Millennium of Glory*. Washington, D.C.: National Gallery of Art, 1997.

Kenoyer, Jonathan Mark. *Ancient Cities of the Indus Valley Civilization*. Karachi: Oxford University Press, 1998.

Kubler, George. *The Art and Architecture of Ancient America: The Mexican, Maya, and Andean Peoples*, 3rd ed. Harmondsworth: Penguin, 1984.

Lee, Sherman E. *A History of Far Eastern Art*, 5th ed. New York: Abrams, 1994.

Lewis-Williams, J. David. *The Rock Art of Southern Africa*. Cambridge, Eng.: Cambridge University Press, 1983.

Loehr, Max. *The Great Painters of China*. New York: Harper & Row, 1981.

Mason, Penelope E. *History of Japanese Art*. Englewood Cliffs, N.J.: Prentice-Hall, 1993.

Miller, Mary Ellen. *The Art of Mesoamerica: From Olmec to Aztec*, rev. ed. New York: Thames & Hudson, 1995.

Mitchell, George. *The Hindu Temple: An Introduction to Its Meaning and Forms*. Chicago: University of Chicago Press, 1988.

Mitter, Partha. *Indian Art*. Oxford: Oxford University Press, 2001.

Morphy, Howard. *Aboriginal Art*. London: Phaidon, 1998.

O'Riley, Michael Kampen. *Art beyond the West*. Upper Saddle River, N.J.: Prentice-Hall, 2001.

Pasztory, Esther. *Aztec Art*. Norman: University of Oklahoma Press, 1998.

Paul, Anne. *Paracas Ritual Attire: Symbols of Authority in Ancient Peru*. Norman: University of Oklahoma Press, 1990.

Schevill, Margot Blum, Janet Catherine Berlo, and Edward B. Dwyer, eds. *Textile Traditions of Mesoamerica and the Andes: An Anthology*. New York: Garland, 1991.

Smidt, Dirk A. M. *Asmat Art: Woodcarvings of Southwest New Guinea*. New York: Braziller, 1993.

Stone-Miller, Rebecca. *Art of the Andes: From Chavín to Inca*. New York: Thames & Hudson, 1995.

Sullivan, Michael. *The Meeting of Eastern and Western Art from the Sixteenth Century to the Present Day*. Greenwich, Conn.: New York Graphic Society, 1973.

———. *The Arts of China*, 3rd ed. Berkeley: University of California Press, 1984.

Townsend, Richard F. *The Ancient Americas: Art from Sacred Landscapes*. Chicago: Art Institute of Chicago, 1992.

———. *The Aztecs*. London: Thames & Hudson, 1992.

Visonà, Monica Blackmun, et al. *A History of Art in Africa*. New York: Abrams, 2001.

Vogel, Susan Mullin. *African Aesthetics: The Carlo Monzino Collection*. New York: Center for African Art, 1986.

Whittington, E. Michael, ed. *The Sport of Life and Death: The Mesoamerican Ballgame*. New York: Thames & Hudson, 2001.

Notes

Chapter 1

1. Jennifer Isaacs, ed., *Australian Dreaming: 40,000 Years of Aboriginal History* (Sydney and New York, 1980), p. 69.

Chapter 2

1. *A Source Book in Chinese Philosophy,* trans. and comp. Wing-tsit Chan (Princeton, 1963), p. 30.
2. Cited by Bradley Smith and Wan-go Weng, in *China: A History in Art* (London, 1973), p. 44.
3. *Treasures from the Bronze Age of China* (New York: Metropolitan Museum of Art, 1980), p. 45.

Chapter 4

4. Florian Coulmas, *The Writing Systems of the World* (Oxford, 1989); Georges Jean, *Writing: The Story of Alphabets and Scripts* (London, 1992); Andrew Robinson, *The Story of Writing* (London, 1995).

Chapter 5

1. Robert Irwin, *Islamic Art in Context: Art, Architecture, and the Literary World,* Perspectives Series (New York, 1997), p. 254.
2. Franz Rosenthal, "Abu Haiyun al-Tawhidi on Penmanship," *Ars Islamica* 13–14 (1948): 18; cited in Anthony Welch, *Calligraphy in the Arts of the Muslim World* (Austin, Texas, 1979).

Chapter 11

1. Cited by Leopold Reidmeister, *Das Ursprüngtiche und die Moderne* (Berlin, 1964), no. 92. Also cited in *Primitivism in Twentieth-Century Art,* ed. William Rubin, 2 vols. (New York, 1984), II, p. 373.
2. Emil Nolde, *Jahre der Kampf,* cited by Donald E. Gordon, "German Expressionism," in Rubin, II, p. 383, as trans. in Herschel B. Chipp, *Theories of Modern Art* (Berkeley, 1968), pp. 150–151.
3. Cited by D. H. Kahnweiler, *Juan Gris et son oeuvre* (Paris, 1946), pp. 155–156. Also cited in Rubin, I, p. 216.

Picture Credits

1.1 George Chaloupka Collection, Darwin
1.2 © Ron Ryan / Coo-ee Picture Library Elwood Victoria
1.4 Powerstock / Zefa, London
1.5 James Wellard / Sonia Halliday Photographs
1.6 Image # 326529. Photo by: T. W. Daniels. American Museum of Natural History Library
2.2, 2.3, 2.7–2.11 The Metropolitan Museum of Art, New York. Department of Asian Art: Objects in "The Great Bronze Age of China," a Loan Exhibition from The People's Republic of China
2.4 © The Cleveland Museum of Art, 2002. Purchase from the J. H. Wade Fund, 1930.730
2.5 © Daniel Schwartz / Lookat, Zurich
2.6 © Joe Sohm / The Image Works CSOH6503
2.13 Museum Purchase, Gift of the Margaret Watson Parker Art Collection. University of Michigan Museum of Art, Ann Arbor. (1965 / 2.75)
2.14 Museum Purchase, Gift of the Margaret Watson Parker Art Collection. University of Michigan Museum of Art, Ann Arbor. (1970 / 2.7)
2.15 © The Cleveland Museum of Art, 2002. Gift of Mr. and Mrs. Severance A. Millikin, 1963.588
3.1, 3.3a, 3.10, 3.13 Scala / Art Resource, NY
3.2, 3.4a National Museum of India, New Delhi, India / The Bridgeman Art Library
3.3b, 3.9 Archaeological Survey of India, New Delhi
3.3c © Robert Harding Picture Library
3.4b © Angelo Hornak Library (London) courtesy of the National Museum of New Delhi, India
3.5a, 3.18 AKG London / Jean-Louis Nou
3.5b,c National Museum, New Delhi, India
3.6 Ashmolean Museum, Oxford
3.7, 3.14 Douglas Dickins, London
3.8 Archaeological Museum, Sarnath, Varanasi / The Bridgeman Art Library
3.15 © Staatliche Museen zu Berlin–Preussischer Kulturbesitz, Museum für Indische Kunst. Photo: Iris Papadopoulos. Photo source: Bildarchiv Preussischer Kulturbesitz, Berlin
3.16 © Trustees of the National Museums of Scotland 2004

3.17 Courtesy of American Institute of Indian Studies, Varanasi
4.1 Archaeological Survey of India, New Delhi
4.3 Scala / Art Resource, NY
4.4, 4.8, 4.9, 4.11, 4.18 AKG, London / Jean-Louis Nou
4.5 © Ann & Bury Peerless Picture Library
4.6 © Richard Ashworth / Robert Harding Picture Library
4.12 Douglas Dickins, London
4.13 © Robert E. Fisher
4.14–4.16 Werner Forman / Art Resource, NY
4.17 © I. Griffiths / Robert Harding Picture Library
4.19 © Robert & Linda Mitchell
4.20 Stedelijik Museum Amsterdam
5.1 Arthur M. Sackler Museum, Harvard University Art Museums, Francis H. Burr Memorial Fund (1967.23). © President and Fellows of Harvard College. Photo: Katya Kallsen
5.2 The Metropolitan Museum of Art, Rogers Fund, 1938 (38.149.1). Photograph © 1986 The Metropolitan Museum of Art
5.3 A. F. Kersting, London
5.4 Simmons Aerofilms Ltd
5.6 Jane Taylor / Sonia Halliday Photographs
5.8, 5.9 © Giamberto Vanni / Art Resource, NY
5.10 © Ann & Bury Peerless Picture Library
5.11 Scala / Art Resource, NY
5.12 Victoria and Albert Museum, London / Art Resource, NY
5.13 Courtesy of the Freer Gallery of Art, Smithsonian Institution, Washington, D.C.: Purchase, F1942.15a
5.14 AKG London / Jean-Louis Nou
6.1, 6.2 © The British Museum
6.3, 6.4 Prof. Sekino Masaru, Tokyo University
6.5, 6.7 © Christopher Rennie / Robert Harding Picture Library
6.6 Photo credit: Shogakukan, Tokyo
6.10 AKG London / Jean-Louis Nou
6.12 Borromeo / Art Resource, NY
6.13 Courtesy of American Institute of Indian Studies, Varanasi
6.15 Douglas Dickins, London
6.18 © Paul John Miller / Black Star, New York
6.19 © Ann & Bury Peerless Picture Library
6.20 © T. Hall / Robert Harding Picture Library
6.21 Eliot Elisofon / TimePix

6.22 © Daniel Entwistle
6.23 © Keren Su / CORBIS
6.24 AKG, London
7.1 Photo courtesy of Michael D. Coe, New Haven
7.2 Werner Forman / Art Resource, NY
7.3 © Adina Tovy / Robert Harding Picture Library
7.6, 7.13, 7.17, 7.22, 7.26, 7.28 © Tony Morrison / South American Pictures
7.7 University of Pennsylvania Museum, Philadelphia
7.8a,b, 7.11, 7.12, 7.18 © Justin Kerr, New York
7.9 The Michael C. Rockefeller Memorial Collection, Bequest of Nelson A. Rockefeller, 1979 (1979.206.1063). Photo: © 1980 The Metropolitan Museum of Art
7.10 © President and Fellows of Harvard College. All rights reserved. Peabody Museum, Harvard University. (T738–50-63-20 / 18487)
7.14 © President and Fellows of Harvard College. All rights reserved. Peabody Museum, Harvard University. (T1051.1–48-63-20 / 17561)
7.16 © Robert Francis / South American Pictures
7.19 John Bigelow Taylor / Art Resource, NY
7.23 Photo: © 2003 The Art Institute of Chicago. Kate S. Buckingham Endowment, 1955.2100. (E25477)
7.24 © Museo Arqueológico Rafael Larco Herrera, Lima, Peru
7.25 © UCLA Fowler Museum of Cultural History. Photo: Susan Einstein, LA
7.27 The Michael C. Rockefeller Memorial Collection, Bequest of Nelson A. Rockefeller, 1979 (1979.206.393). Photograph © 1982 The Metropolitan Museum of Art
8.1 Courtesy Museum of Anthropology, University of British Columbia, Vancouver. Photo: Bill McLennan
8.2 Photo: Explorer, Sylvain Cordier. HOA-QUI, Hachette Filipacchi Photos
8.3, 8.4 © Seattle Art Museum, Gift of John H. Hauberg. Photo: Paul Macapia
8.5a Image #:4480. American Museum of Natural History Library
8.5b Image #:4481. American Museum of Natural History Library
8.6 Ohio Historical Society, Columbus, Ohio

Index